THE
THINGS
I
CAME
HERE
WITH

THE THINGS I CAME HERE WITH

a memoir

CHRIS MacDONALD

Published by ECW Press
665 Gerrard Street East
Toronto, Ontario, Canada M4M 1Y2
416-694-3348 / info@ecwpress.com

Editor for the press: Michael Holmes
Cover design: Michel Vrana
Cover and interior art: Chris MacDonald
Author photo: Megan Tilston

To the best of his abilities, the author has related experiences, places, people, and organizations from his memories of them. In order to protect the privacy of others, he has, in some instances, changed the names of certain people and details of events and places.

LIBRARY AND ARCHIVES CANADA CATALOGUING IN PUBLICATION

Title: The things I came here with : a memoir / Chris MacDonald.

Names: MacDonald, Chris (Tattoo artist), author.

Identifiers: Canadiana (print) 20220230153 | Canadiana (ebook) 20220230250

ISBN 978-1-77041-641-3 (softcover)
ISBN 978-1-77852-014-3 (ePub)
ISBN 978-1-77852-015-0 (PDF)
ISBN 978-1-77852-016-7 (Kindle)

Subjects: LCSH: MacDonald, Chris (Tattoo artist) | LCSH: Tattoo artists—Ontario—Toronto—Biography. | LCSH: Tattooing. | LCGFT: Autobiographies.

Classification: LCC GT5960.T362 C2 2022 | DDC 391.6/5092—dc23

We acknowledge the support of the Canada Council for the Arts. Nous remercions le Conseil des arts du Canada de son soutien. This book is funded in part by the Government of Canada. Ce livre est financé en partie par le gouvernement du Canada. We acknowledge the support of the Ontario Arts Council (OAC), an agency of the Government of Ontario, which last year funded 1,965 individual artists and 1,152 organizations in 197 communities across Ontario for a total of $51.9 million. We also acknowledge the support of the Government of Ontario through the Ontario Book Publishing Tax Credit, and through Ontario Creates.

ONTARIO ARTS COUNCIL
CONSEIL DES ARTS DE L'ONTARIO
an Ontario government agency
un organisme du gouvernement de l'Ontario

Canada Council Conseil des arts
for the Arts du Canada

Canadä

PRINTED AND BOUND IN CANADA PRINTING: MARQUIS 5 4 3 2 1

For Frankie and Megan

The first draft of this book was written on a cellphone in a desperate attempt to do something productive with the thing. Although the experiment worked, I wouldn't recommend it.

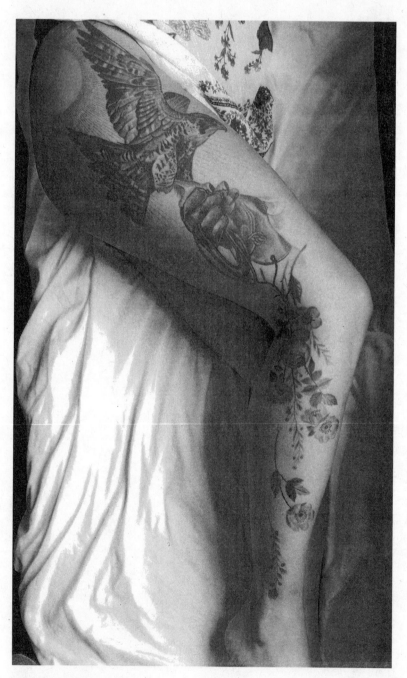

Amy's falcon leg piece, 2018.

I lower my tattoo machine and carefully dip the needle in ink. At this juncture the sum of all moving parts — my past mistakes, victories, knowledge, insecurities, faith, and ego — congregates around me. They've come to witness this flash in time, to catch a glimpse of themselves in the mirror I've held up, to see what I can do with what's been given to me. But levity is needed for viability, for everyone involved. "Ready, Freddy?" I ask rhetorically, smiling, before dropping my eyes. I press my foot down, activating that old, familiar sound. That's when everything vanishes, and the only ones left in the arena are me and this thing.

Bound by an unseen tie, we watch as the grains of sand fall at a pace so unnerving that to stay here without wavering would see me dead in a week. Every action from this point is calculated to maintain the balance. I set out with harmony at its peak, arcing, and try and hold it until the end. But it will likely begin to falter from this point, so to bask in this minute is essential. If I can hold this peace, both of us are free, and the tightness in my gut will dissolve. I'll relearn every time how nice it feels to be calm. If it gets away, inevitably I'll live that death over and over.

When I was younger, my hands used to tremble like the windows of a Dundas Street apartment when the streetcar blew by, but they don't anymore. So I lower the needle with precision and make contact. Below my tattoo machine and under my thumb, I can feel its vibrations in the fingertips of my opposite hand stretching the skin. The steady buzz is a powerful comfort to me, and lulls me into an alpha state. Ink pools as I push the needle along, and a fluid river follows. The pigment reflects the lights above like infinitesimal stars, and the

musty scent of carbon drifts up. What with everything I've learned, I wonder if it will work. Or was it just some bizarre dream? Some days, I'm certain I've lost my bravado, for in all my carelessness came an easy way to the finish line. These days there's a higher state. I've become a microscope, and my own worst, tyrannical critic. All I want is to complete my job with competence, to see this person elated, and create a cycle of positive energy. To have our exchange be genuine is all I desire. So I ask someone, *something*, like a quick breath out into the atmosphere, to please guide me through the process. As I lift the needle up and wipe the smudge away with a damp paper towel, it all comes down to this. It's all on the line, and happens in seconds. But the line of the tattoo is good, so for now, the day is as well.

It's here in the sprawl of evening that our house falls quiet and the trees sway outside the window in the royal blue of late dusk. It's here that I keep warm by the light of the lamp. It's here with a hope mountains high that I will try my best to paint this picture for her. As Frankie falls asleep upstairs in her mother's arms, I will try my best to breathe life into these visions, these old badges, these hearts and daggers. As I listen closely, I can hear uncertainty — or is it fear? — climbing through the dark night among the thorns.

I can see the road stretch before me, winding like a black snake across the land toward an unknown horizon. There's a sun buried in the haze, and I'm going to find it, even though there's a voice that rains down in me, deep with disquiet, the same voice that once assured me I didn't have what it took to make it as a tattooist. Time is short and things are volatile, so I'm just going to start walking.

PART ONE
Small Towns

PAINTING TREES AND STARS

I was born with an imagination. Many days growing up it was just me, the fields and forest, where I would let all my daydreams come to life. In our Alliston house, I was a spectator, always. I saw things that will be forever ingrained in me.

Here's one memory: I could hear the two of them talking and laughing in the next room. I felt a good vibe, and a ray of sunshine lured me down the hall. As I approached my oldest brother's room, I knew I was about to find something great. When I entered, I saw he'd pulled the furniture away from the wall and prepared paint brushes and paint cans. There were pencilled outlines across the surface of the wall, and he'd begun painting a treeline of dark pines from the floor up while our mom watched. It was amazing to witness this white wall slowly transform into the woods surrounding my home. I stayed there for a long time watching them, my brother and mother talking in the soft sunlight, their effortless laughter, effortless creativity. The world did not exist, and at that moment our hearts were full.

I haven't seen my mom in a very long time. And wherever she may be, I don't know if she's still alive. If she is, I'd like to think this is one of the things she remembers: her and her sons together drinking tea, with her oldest painting a forest on the walls of their tiny home among the maples and the firs, light filtering through the dusty curtains down across the floor.

For me, this memory is vivid, like a video I can replay in my head. It's a little grainy and it glitches occasionally, but the sound and picture are there. I have thought about that day a lot. Here in my tattoo shop thirty-three years later, I am still thinking about it. Everyone has been working hard to prepare the new studio, but today I am the

only one here, and I welcome the solitude. I have spent the afternoon masking off long arrows that will run across the hardwood floor, following the perimeter of the room, and have included a nautical star in the centre. The star and arrows have been rendered gold in the quiet, conscious of my actions. Neil Young's "Helpless" plays on the stereo. I think about the countless times I've painted the furniture in the past: a dragon on the side of my bookcase, a sacred heart on a table, another giant arrow on the floor of my old studio. And now here I am again.

I am aware of the cathartic process of painting like this. My brother transforming the walls that day could be one of the greatest moments I've witnessed. Though I've been searching, I've never reached that level of peace again. But there is a hope in the air. I am going to be a dad soon. I have a new tattoo shop. This afternoon is dedicated to being with that memory. I am going to spend some time with it. Yeah, I want to do what he did.

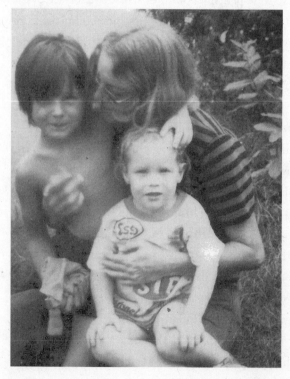

My mother, my brother Joe (left) and me, 1978 or 1979.

MATCHES AND HATCHETS

Before Alliston, we lived in a town called Beeton, located in southern Simcoe County, Ontario. The light in the kitchen was soft, dim — all forty-watt memories. This was an era of neatly weaved three-tone yarn diamonds, octagonal popsicle-stick lampshades and macramé. The year was 1981 or '82.

My memory holds this scene in the light cast down over the table like a streetlamp that dissipates into the darkness of its surroundings. Gathered around the kitchen table were my father, Bill; my mother, Lynda; my two brothers, Joe and Rob; and my sister, Kelly. I was there, too, of course. I was roughly five, Joe was ten or eleven and Rob and Kelly were both in their mid-teens. Rob was from another father, and Kelly was my mother's cousin's kid who our parents had taken in. I only assumed she was my sister because she'd been there for as long as I could remember. My dad called Joe "Goober" and me "Bunky," for reasons unknown. That kitchen, with its perfect lighting, was my one and only world.

Behind us, the kitchen was scattered with familiar things, papers on the fridge, glasses stacked near the sink, warm Tia Maria on the burner. Under the hood of the stove our mother created a faux flagstone pattern with oil pastels. She'd also tiled the wall down the stairs leading to the backyard with pages clipped from magazines and newspapers, one being an advertisement for the horror film *Black Christmas*. She loved making collages. There was a green toy car on the floor near the door to the living room, my prized possession. This was a room of comfort, a mid-sized room in a mid-sized bungalow. Amid the scraping of chairs, a cat weaved in between our legs, rubbing up against us, as if calling out, *Hey, don't forget about me!*

My father was at the head of the table, and we all formed a semicircle around him. I leaned over his shoulder to gawk at his ability to draw and watch what his fingers could create. My mother was crafting with my sister. I didn't know exactly what they were making, because my focus remained on my dad. As he pulled the pencil across the page, I could see it. I was young, but I still could find the connection between his thoughts and his careful execution. He was drawing a car for me, low to the ground and curvy like an old Corvette. He was so careful and honest, and I swore that I would be, too. I would make something from nothing, like he did, like magic. The thought came like a warm breeze in my mind, like summer and its anticipation.

Together, my parents held the universe there in that room, balanced upon their fingertips. Love was all around. I had been shown something wonderful, and it had stolen me.

Tomorrow, I would fill my bedroom wall from floor to ceiling with pictures I had drawn of big trucks. I would take all that I had learned from my dad, careful circles and razor-straight lines, and apply it to my own work.

At that time, I wanted nothing more than to be a truck driver. Or Hercules. I would sit in a ditch, jam a stick into the ground and pretend it was a gear shift. With the ring that my mom gave me pointed to the sky, I would imagine that lightning was erupting from it. Pretty cool, right?

I only have a few select memories from this house. It's where I began to fall in love with music. My brother Rob had a dark hole of a bedroom in the basement. It was a mysterious rock 'n' roll cave, where Thin Lizzy and Kiss posters littered the walls. I remember being perched at the top of the stairs staring down at his wooden door, bopping away with my shoes stomping on the linoleum steps to "We Will Rock You" by Queen. It's the first song I remember hearing, ever.

People got the notion that *maybe* the three brothers were in fact just a little different than some of the other kids. In our blood was

something uninhibited, and we howled like the wild mountain wind. Our untamed spirits didn't wear off on Kelly, though, whose calm and nurturing presence told me she had been sent here to keep us grounded. But not the brothers, boy. We were raised by wolves, I am certain, and there was always a bad moon rising at our house.

Picture this: I am at the neighbour's house for lunch. She has made us peanut butter sandwiches with the crusts cut off. Although she layered the bread with margarine before spreading the peanut butter, I have no choice but to forgive her for her sins.

Kelly comes running, and I can see the distress in her eyes from afar. As she rushes me away from my lunch, I feel the panic. This is my first recollection of that feeling. I know something is gravely wrong. She carries me back to our house as fast as she can, her blond hair in my face, and I struggle to crane my neck. I catch glimpses of the commotion through the spaces between the houses. Then I'm standing in the backyard looking out at the field that runs behind all the houses on our street and has just been burnt to oblivion. The whole area is dark and smouldering, whiffs of smoke drifting up into the air and small flames still fluttering from the charred, black remains stretching out into the sunlight.

We learned later what had happened: My parents had tasked Rob with raking the leaves in the backyard, which he did. When he completed the job, he asked if he could burn them, which they of course said no to. But both my brothers were born true metalheads, you see, and metalheads don't bag leaves, they burn them. So, that is what he did. It was late spring, and Rob recalls a stiff wind blowing. But, after trying to stamp out the spreading fire in a panic, the situation got away from him. Put leaves, fire and Thin Lizzy together, and the field was doomed. Finally, something exciting happened in that sleepy town, and it seemed like everyone from far and wide came to see what went down.

How the three brothers survived is one of modern families' great mysteries. I was too young to remember, but rumour has it that Joe

once singed his hair pretty badly in a closet fire after stealing a Zippo from someone. This would have been shortly after I was born I think, around 1979 or '80, and the closet was full of winter jackets and fuzzy, wool garments. I can just see him in there, holding the lighter inches from his face in the darkness, each spark illuminating his mischievous eyes. *Flick, flick, flick* — and *whoosh*. Just like the field — Joe's shaggy hair — went up in smoke. Worried, our mother then descended on us with a horrendous, lengthy lecture about how quickly fire can spread. There, standing in the kitchen, she lit an article of clothing from the bottom so we could see how fast it rose up the fabric. After it began smoking fiercely the alarm went off. She almost burned herself in the process.

It was when we lived in this house in Beeton that my brothers taught me how to fight, and I threw my first punch. It's not that I didn't like our neighbour Timothy Lent. I did find him annoying, though. Maybe it's because he couldn't pronounce Christopher, and just called me Kipper instead, which Rob still finds hilarious. I knew punching him for no reason was wrong, but I also knew Lent was not really my friend. Something about him bothered me. He had short, dusty hair that looked like it had been cut with a lawnmower, and strange eyes. When he ran, it always looked like he was about to fall forward. He was a grub. Truth be told, Timothy probably had it coming. But in the end, I only wanted to impress my brothers.

As I see the events in my head, I was walking up the driveway toward him and heard myself call out, "Hey, Timothy," just before I unleashed on him. The words came out distant, deep, as if they'd been slowed down. When I lifted my arm, it was like my body was made of liquid. My fist connected with his jaw, and I know it must have hurt him because he didn't see it coming. My brothers were surprised and proud of me. Really, that's all that mattered.

In retrospect, I had my reasons. I can remember sleeping over at Timothy's house one night. After playing with his knights and horses, which was the only reason to go over there, we finally hunkered down

to sleep. We were both in his bed, and he kept flopping his arm across my chest, very intentionally. That alone deserves a punch in the mouth. But that time, instead of coming to blows, I just got up and walked out of the room, out of his house and into the cool of the evening night, still wearing my ochre pyjamas with the brown racing stripe down the side and a compass-star design on the chest.

Guide me home, oh North Star, down that midnight sidewalk, loud with crickets, to my own bed.

It felt good, going home on my own, the cool cement and grass beneath my bare feet. My mom got a kick out of it after I explained why I left. I liked seeing her smile.

Sibling stupidity, in our case, comes in endless succession, so I will try to be selective with which stories I tell. I'll take you back to another bright, sunny afternoon: the day Joe chopped my finger off, right in our backyard. This was the same yard that backed onto the charred remains of the big field.

Joe and I were getting into mischief as usual when we found a hatchet.

I'm not sure what kind of household you have to live in for the kids to be playing with a rusty axe in the backyard. I can only assume our family unit was a little looser than some, though I should not insinuate that a lack of parental supervision would be to blame for this particular accident. I'm certain that even if you had put us on a leash, we still would have managed to get hold of a hatchet, or matches, or something equally illicit. In fact, our mom used to put Joe in a harness. Unfortunately for me, that day she forgot.

We were not ten feet from the house, and he was madly chopping away at some sticks in the dirt. Wanting to be a part of the action, I got right next to him and reached my hand in to grab at the sticks, unaware of the danger raining down toward the ground. *Whammo.* I pulled my hand out of the red dirt and held it up. My wail climbed slowly, like a siren revving to life. I watched as the tip of my index finger dangled from a ragged thread and jittered in the hot summer air.

Kelly was the first one out the back door running toward us. Shock took hold of me.

Brothers — seriously — who needs them?

FIRST CRUSHES

My first girlfriend was a safari-guide figurine. She wore a mini leopard-print dress and had a big, beautiful afro. I used to dream of her every night. In those dreams, she was my real-life girlfriend and together we lived on the wildlife reserve and drove around in a Fisher-Price Jeep. I've since tried to find this figurine but can't seem to locate her anywhere. I don't think she belonged to the safari set that I had, but she was *hot stuff* and my first real crush.

That is, of course, before I laid eyes on Olivia Newton-John, whom I can still see on that record cover, rising out of sparkling water, her bronze skin aglow and glistening in the dusky light. *Come On Over* was in my vinyl collection for a long time, and yes, I would listen to it from time to time. With Olivia, it was truly love at first sight. This crush was further ingrained after her role in the film *Grease*, where she shows us two radically different babes — the good-girl prep and the gritty greaser. And we all know we could never choose just one, so ultimately we fall madly for both. This was quite possibly my first lesson in juxtaposition.

THE FIRST SEED

A seminal moment happened for Rob in the Beeton house the day Joe scrawled all over the walls of his bedroom with every colour crayon he could get his hands on. The extent of his creation was intense enough that eggshell paint and a roller wasn't going to remedy the wall's crude new addition. So, our mother got crafty, composing an expansive Dr. Seuss–like mural of strange, gangly birds, and Lorax-like creatures over top of Joe's wild markings. Rob watched, soaking it in as she carefully incorporated the existing shapes of his markings into the new scene, using the existing lines to build something entirely different. Rob describes this day, without being aware of it then, as his first lesson in how to approach a cover-up tattoo. He says that during the course of his life, he's tried to escape from tattooing twice to no avail, and I believe him when I listen to this story, its principles were all around us, you just had to pay attention.

ALLISTON

When I was about six, we moved to Alliston. There, I was born under a bridge beside the hospital — just kidding. But it was under that bridge that I first listened to Def Leppard. "Photograph" soon replaced "We Will Rock You" as the best song I had heard.

I was excited to move to this house, a bungalow at the end of a long dirt road. Small barns and a long narrow stable nestled around it. To one side and directly across lay forest, and, to the other side, fields. The property also included a smaller wooden house.

Kelly was passionate about horses, and this was a perfect place to raise them. Our parents also gave Joe and me a small black pony, which we named Black Beauty (of course). We used to ride her all around the property. We have a photograph where Joe is up on her back and I am pulling her reins, leading her around the yard. It's a good photo.

A lot happened at this house that still resonates in me: many crucial events, a lot of smiles and a lot of tears. This place was magical for me, from the sun coming through the trees down to the shadows of the woods. The past lingered all around, from a rusted relic of a half-buried truck tangled in the thick bush to the old medicine bottles buried in the undergrowth. Our slender fingers gripped at what the past had discarded, and we felt wonderment at what might have been here before us. We'd pry the treasures from their mossy coffins in the dirt and hold them to see the prisms within, see the light dance through the different shades of emerald and sapphire. Such strange shapes, some with hard, defined lines, almost decanter-like, others corked and ridged and others still holding their tenuous scent.

We would walk along the winding dirt road, beneath the canopy of lush trees, toward the main road, passing Old Benny's house on the

way. I never did see his face; he was only folklore, one of the ghosts in our story. Joe told me he was real mean, and I believed every word he said. Once, Joe came flying into the house wildly spitting about how Benny had run over our dog Becky's paw. When we heard this, we knew there was only one thing to do. We snuck around his house through the trees, threatening to throw the rocks that never left our hands through his windows.

Past Old Benny's house, we would leave the road, hop down into the woods, where the ferns were plush and green and rolled across the forest floor. Deep into this section of the forest, the trees were weak. And let me tell you: there isn't anything in this world as satisfying as kicking down a dead tree when you're a young boy, from the thud of your first blow to the crack of what's left of the bark. The tree folds and slowly falls between its standing neighbours and is swallowed by the ferns.

We would bob and weave like soldiers through the trees until we found the skeleton frame of the old slaughterhouse. Remnants protruded like broken bones from the busted foundation. Mossy sinews hung from the rotten posts. My eyes were watchful there, where your shoes would break through the rotting floorboards to reveal the scattering centipedes and spiders. The structure had a heartbeat. There was never any wind, and it always felt as if there were shadows standing in the pines. But as long as my brothers were with me, I was safe. Under my breath I would sing "Photograph." Sometimes, on days of true adventure, we would press on past the slaughterhouse to brave the land beyond.

And if we did, then we would get to a place where the landscape began to change. The trees became denser, and we'd see more conifers. The forest floor was softened by a topcoat of pine needles. It was like walking on a sponge in an arboreal funhouse. The shadows lightened as we would push on until the trees opened up on a large clearing. The day Joe and I first found that place, it was early spring and we were frozen and soaked from trudging through the murky

forest. As we entered the circle, with the dense evergreens standing guard all around, we could see the last remaining patches of snow glinting like crystals among the field, little wafts of steam rising into the temperate air. Where the snow had melted, I could smell the warmth of the sun on the grass arcing out from the earth. We lay in those soft, earthy beds, letting the heat from the April sun dry our wet shoes and cold cheeks, listening to the wind. From that day on, this became our spot, and we returned many times. It was here that I would let myself daydream.

I would imagine a great white horse. I would lie in the grass, the blades brushing against my legs, and watch the trees bend gently against the blue sky. The horse would emerge from the darkness, a transcendent beast, but gentle and shy. I would hear its heavy hooves boom in the dry earth as it would shake its mane and snort. It would draw closer until its great head was looming over me, so close that I could see the deepness of its eyes like little black planets with tiny white stars glimmering in the centres. I'd climb upon the great beast and we would ride around the edges of the clearing. Minutes would turn to hours, or so it seemed, and the shadows would grow long and lean into the sunlit grass. When we could feel the cool on my skin, we knew it was time to return home.

THE DUMP

If you didn't dip down into the forest but instead followed the main road through the woods and over two small hills, you would find the exact location where Rob crashed the car my dad gave him. It happened literally ten minutes after he received it. The car, a red Chevy Vega, was payment for tearing down the mink barns, a job my dad had given him. Pretty happy about his new ride, he climbed in peeled off into the woods. It had only been a few minutes before he came driving back out slowly, but the Vega wasn't so shiny. He'd lost control just past those two hills and wrapped the Vega around a tree.

Directly across the street where the dirt drive met the main road was a gas station called the Oasis. Out back of the Oasis was a dump full of scrap cars, boats and all kinds of beat-up vehicles, where we used to play.

Somewhere among the chaos of junk sat a ripped-in-half boat. The wood was torn and shredded as if it been yanked apart. This was my favourite attraction. I used to pretend that the boat had been attacked by a massive shark, disturbing a date with Olivia (whom I still had a massive crush on). I would lie on my stomach on the damp wood, the smell thick in my nose. In my mind, we bobbed on the whitecaps under a burning Massachusetts sun when the bastard came along and took off half the boat in one bite. Now he had to pay. I would scramble to the cabin, fingernails clawing the wet wood. I'd find my submachine gun and pop a mag in it. Salty sweat stinging my eyes, I would make bullets rain. The supple marine flesh was no match.

Then all was quiet except for the lapping of sea water on the deck of a half-sunken boat and the carcass. The silence was broken by the

sound of the chopper coming to rescue Old MacDonald. I would make out with Olivia while the helicopter took flight.

Farther back in the wreckage was a tractor-trailer with a flat tire, sunken slightly in the dirt and leaning toward the tin fence. Inside it was a big wooden desk, so we made this our head office where Joe and I would hold our secret meetings. We found a big box of Cannon Balls in the desk drawer. For anyone who doesn't know: this is a terrible candy from a time long ago, hard as, well, cannon balls. But we still kept them in the drawer and even had one from time to time. Who eats dump candy? Wild wolves, that's who. Secret meetings consisted mainly of flipping through the pages of a torn-up *Playboy* we had found.

JOE'S ROOM AND FROG SKELETONS

In the Alliston house, Rob's room was upstairs with mine, and Joe's was now in the basement. Our parents put up wallpaper similar to the murals Rob had made. Dark brown silhouettes of tall, leafy trees reached up one wall to the basement window, which had a nice wooden shutter on it. Joe also had a large closet that we used to play in and, on the adjacent wall, a piece of chipboard large enough to draw on. We would see strange animal shapes and monsters within the small layers of wood and trace them out with markers and crayons. And because my room was directly above his, we would have secret late-night conversations through the vent and even pass each other things. It was like an underground tunnel.

We didn't have much money, I knew this, but while in this new house, we were happy. I used to hang out in the backyard and explore the massive potato barns behind our house. Yes, Alliston, home of the potato. Also home to a massive Honda plant. The two industries put the town on the map.

In early spring, I used to shovel the snow off the grass in the back-yard and try my best to turn it into summer again. While exploring the window wells in the damp, cool air, I came across a frog skeleton. It was perfectly intact, with not a lick of skin or organ on it, and completely undisturbed from its sitting position. How curious, I thought, that the frog died in such a posture, and how sad. The well must have been too high for it to jump out of. I was intrigued that this skeleton had been on the inside of the frog, deep beneath its layers.

I needed to know more, so Joe and I ended up sacrificing a few of them for science. I was experimenting with life and death. I took one frog out to the potato bin to execute. The sun was bright and hot, and

the tin walls of the bins were hot to the touch. I Band-Aided the frog's legs to the structure. We had found an X-acto knife. My first incision pushed his belly in slightly before it broke the skin. I slid the blade downward. His guts came folding out all black and pink, oozing with liquid onto the dirt below. I found a bit of his skeleton inside, poked around and then took the body down and flung it into the field. I don't know why I did it.

THE POTATO GOD

The potato barns were long half-cylinder buildings made of corru-
gated tin. Sometimes, we would goof around in them, but they weren't
really that exciting. However, we being bored and mischievous farm
boys, having to make do with what we had, we decided we were going
to use them to play a prank on a neighbour's kid, I think he was from
the big white house down the road, but am not entirely sure and can't
remember his name. Joe climbed over the big mountain of potatoes
and hid in the shadows so no one could see him. I stayed with the kid
outside, kicking stones, trying to act as natural as possible. To build
the tension, I told him we'd noticed some alarming activity in the
barn earlier that day, jarring noises coming from the shadows beyond
the potato mountain, and I needed his help investigating the strange
disturbances.

We crept in slowly through the tin door. The hot sunlight cast a
long, bright rectangle into the darkness of the barn. Dust swirled in the
air like a small cosmos, and the thick, pungent smell of spuds was heavy
like a cloud. Our shoes crept and cracked across the dirty cement floor.
By the look on his face, we definitely had the vibe dialled in. I began
whispering more about the strange noises we'd heard, trying my best to
keep the suspense, and then Joe rose up from behind the tip of potato
mountain with his arms raised in the air like a ghoul. In a deep, boom-
ing voice he proclaimed, "*IIIIII aaaam the Potato God!*"

He was imitating Gene Simmons when Gene declares that he
is the God of Thunder in one of our favourite songs. The light from
under the door lit his pale face, and I must say, it was chilling theatre.
For a moment, it made even me uneasy, never mind the poor sap who
didn't know what was in store for him. On his face was an expression

of horror. He didn't make a sound, but his body jolted strangely before he bolted for the door, for sunlight and safety, away from the menacing roar of the unearthly potato god.

BAD APPLES

At the bottom of the drive was the big white house, which was part of an expansive property with two barns, a silo and a small orchard. One afternoon, Joe and I decided to take our mom's Cadillac to the end of the road to pick some apples there. My brother, the pilot, must have been no older than twelve. I was around seven. I can't recall if we had been given permission to do this or not. I am going to assume not.

I had overheard my brothers talking about the man who lived on the farm, and by the sounds of it, he was a real nasty piece of work. There would be hell to pay if he were to find us picking his apples. I was already feeling nervous about the operation: there we were, two small kids driving possibly one of the largest common automobiles. The average Cadillac built around the 1980s reached more than five metres in length, a true "Ride for comfort" land yacht. We drove slowly and parked the behemoth among the orchard trees. There didn't seem to be any sign of danger, so we sprung the trunk and started loading her up, tossing in all the apples we could. That's when Joe ordered me to move it. The man had turned off the main road onto the drive, not far from where we were. He definitely saw us.

He was coming up quick and we needed to make tracks. We slid in the door and Joe popped the car in drive and dropped a brick on the pedal. His skinny arms had the wheel dialled hard right. The big brown beast took off in a cloud of dust and barrelled back onto the dirt road.

My little claw-like hands were practically tearing a hole through the sides of the seat. Forty-five hundred pounds of shit-brown V8 Cadillac ripped the dirt from the road, blowing out dust bombs behind us. I could sense the weight heaving from the front end and feel deep,

guttural revving as we blasted forward. We had been reaching top speed and couldn't even see past the dash, just the blue sky shaking above. The Cadillac began to swerve.

The Detroit steel careened up the dirt road like big fat bullet. Arms were vibrating like rubber pencils at the black wheel, and the grimace was still plastered to Goober's face. We veered wide and, when we couldn't handle it any longer, Joe jammed the brakes. We lurched forward as the boat skidded hard to a halt, half in the ditch on an angle. Then all was silent. There before us was a thick wall of dust, and above was the blue sky just as pretty as ever. The neighbour turned back when he saw the Caddy skid out. He must have been thinking about how those kids from up the road were bad, bad apples.

TRYING TO SPEAK

I was beginning to understand what life and death were about — or at least death. When terrible things happened to our dogs, I was shown up close how devastating and sad death really was. Living out in the country, wolves and coyotes were a fact of life. We had two Dobermans and one was attacked by a wolf during the night. When we found her, she was lying in the dirt road, bloody and shredded, mouth agape, flies buzzing in the heat. Our husky, on the other hand, died of neglect. My dad buried her out by the stable. I remember seeing the long mound of dirt surrounded by green grass; the disturbance in the landscape was so ominous. It rains inside of me when I think about that. If only I could turn back time.

I can remember the first human skull that I drew, and must have tried to mimic one from my brother Rob's sketchbook. The skull had sharp fangs and a chain below it, which I find to be an interesting choice. This picture may have unnerved my mom. She had to sit me down to ask me what it meant. Anyone would be rattled to learn their kid drew a skull with a chain wrapped around it. When asked what it meant, I made up a story about how it was a skull from the planet Argon. She was being a good mom, trying to figure out what I was thinking about. She knew I was trying to express something.

I was trying to speak, but I was just too shy most of the time. I would feel the words well up in my throat, only to be cut off by some unseen force. There were other things I wanted to vocalize but didn't know how to. But sometimes I was able to put those things into a picture. I'd use art to reflect things I had been experiencing that I didn't quite understand, but also to express complex feelings like love. This was important because I could feel tension between my

mom and dad. The balance was off, and we could all sense a discon-
nect growing. It was around this time that my mom slipped away to
Wasaga Beach for a few days to do some soul searching; instead, she
attempted suicide. Lucky for us, she phoned for help and was taken
to the hospital. It was a traumatic time for everyone. I remember
fragments — only that something bad had happened but wasn't quite
sure what. They probably didn't tell me much . . . because I wouldn't
have understood anyway.

We had a book on birds that I was always coming back to. I would
sit with it on the carpeted floor outside my open bedroom door, a
rectangle of sun pouring in through my window across the pages. The
book depicted all species of birds, perched among foliage and flowers.
It was illustrated with an earthy, muted colour palette. These birds,
in their homes among the forests and fields, seemed at peace and
untouchable, perched on bowing, thorny stems or gliding on the wind
above the trees, free. The book was like a series of windows offering a
view into another world. I would peer in at them. Like the birds on
the pages before me, I acted on instinct, unaware of the reasons.

I would try my best to replicate the birds with tracing paper, and
then I would give them to my mom. She would frame the pictures
and hang them in my room, which made me feel very proud, like I
was able to communicate. I would present this thing I'd made, and
she would respond. I was showing her that I thought these birds were
beautiful and that she was, too. She always paid close attention to
what I'd drawn, and it felt good to make her smile.

KINGS OF THE SIMCOE MOONLIGHT

I awoke one morning to a loud noise, a whirring and revving some-where outside. I opened my eyes and could see the sunlight through the sheets. I crawled out of bed and followed the sound, full of antic-ipation. As I crossed the living room, the noise became louder. I opened the front door and stood barefoot on the steps, then stepped down onto the dewy lawn. The excitement came from across the drive where the forest began, bordering the pastures and small barns. Just through the first trees I could see the commotion. My dad was build-ing something, and as I looked closer, I realized it was a massive tree fort. I don't remember how long it took him to complete. It seemed as if one day the fort was non-existent, then the next it was there, shining like a beacon. It stood like a castle in the trees, way up high, to keep undesirables out.

The fort was square and had a balcony that wrapped around to the side with a view of the pastures. At the back was a firefighter's pole, and at the front was a giant slide (which, of course, I attempted to ride my bike down; I went careening off and split my chin on some protruding logs, a minor setback that required a few stitches and a month of ice cream. From that day on Rob nicknamed me Crash.) The construction of the fort was one of the most exciting things I had ever seen. Like watching him draw cars when I was young, this was yet another pivotal moment when I realized my dad was a very capa-ble person. Inside the walls of our fortress, Joel and I were kings of the Simcoe moonlight.

A few times, we slept out there in the cool Ontario night, the tall trees bending and creaking all around us in the deep, dark forest. I felt safe and happy with Joe beside me, our words rolling and quiet. We

lay close, arm to arm, peeking out of the blankets. It was there that I learned to smoke cigarettes. We would take drags and listen to the sizzle, the heater glowing bright orange and red in the dark blue of the night.

We sometimes smoked Craven As because that's what Mom smoked when she wasn't rolling her own. Craven A, the cigarette with the heaviest Canadian connotation to it. I can only guess how many farm boys must have pulled out a pack, smiled and said, "I'm craven, eh." I imagine this spoken in that small-town Canadian accent that we all love so much.

We'd slide them from Mom's purse and smoke them in the fort. We were genuinely concerned for her health and didn't want her to smoke, so we would sneak them and bear her extreme irritation when she couldn't find them on the counter or in between the cushions. We were worried about her habit, but not for ourselves. We seemed to think we were indestructible.

The stars would blink bright as we exhaled smoke up into the night. With a blanket tucked up around my chest, we would talk and laugh. Somewhere in Canada, within the miles of trees and fields, the coyotes would cry lonesome at the moon. The smells of linen, freshly cut wood and smoke still hold in my memory. It would probably make my dad a little sad to know that my fondest memory of the tree fort was learning how to smoke. But it is a time that I cherish.

JOE

I'm not sure what I would have done if Joe wasn't with me in that period of my childhood. We were very close, and I felt like he really looked after me. He was the one I'd run through the forest, skip school and shoot BB guns with. My middle brother was always at my side. He had dark, fearless eyes and was always outspoken and gave me a voice when I had no words.

I remember once — was it a dream? — sitting on a frozen school bus in the middle of winter, the dreary aqua-coloured seats stiff and raw. My chin was tucked into my jacket, the zipper damp on my nose from my warm breath. I didn't have any mitts, and I remember saying quietly to Joe that my hands were frozen. He told me to put them up my jacket, under my shirt and against my skin. He said that it was going to feel cold at first but to wait: eventually my belly would warm them. After a few minutes — the old school bus bumping down those bleak country roads, past the black, leafless trees in the dim grey light, the frost like spiderwebs at the corners of the windows — my hands began to warm. I always felt safe when I was with him, for that exact reason.

The bus would drop us off by this big white house near the main road. When it was any season other than winter, we'd walk through the field sometimes, instead of taking the drive. My keeper, maybe, but he was no angel, this black-haired sibling.

"Don't look up," he would proclaim. "If you stare upwards too long, the crows will swoop from the sky and dig your eyes out from their sockets."

So I would tread carefully through the dried yellow growth and hard dirt trenches with my head bowed.

MORE FIRE

One afternoon we witnessed the neighbour's barn burning down — a terrifying sight. We had turned off the road where Rob crashed the Vega, and as we rounded the corner at Benny's place, we could feel a warmth as the car crept through the shade of the trees along the road. We began to see, way out on the other side of the forest and across the field, flickers and waves of red and orange through the black-silhouetted trees. The big barn beside the white house was burning.

My heart beat fast. Emergency vehicles were present and giant streams of water poured into the blaze. The heat was so intense you could feel it all the way up the road, across the hazy field. When we arrived, we got out of the car. Up into the heavy summer air the fire rose. Charcoal smoke into blue sky. The barn shook at its timbers and blurred beneath the flames. It crackled and whined at its knees, buckling and bending, inevitably to be buried beneath the tide of yellow light. And we were helpless in the heat, sad and frightened. I wrapped my arm around my mom's legs.

ROB

Rob really inspired me. His room was a secret garden, and us younger brothers were permitted no access whatsoever. But I just couldn't help my curiosity upon seeing the dark treeline that ran across his wall and his acoustic guitar leaning up against his unmade bed in the dim light. It was his sketchbook I was always after, though, and I couldn't wait to get my hands on it. It read a bit like a story, an image or two on each page, and often some words to accompany them. I remember a pair of women's eyes peering out from leaves and below it a cryptic and mysterious verse. There was one piece in particular that both Joe and I were fascinated by, a dragon that he had stippled with our mom's art supplies. My eyes used to scan this image over and over, examining the beast, trying to soak it in, all the while feeling a sense of pride toward my brother's talent. I had never been exposed to technique like that. The high contrast of black on white paper really spoke to me. Since then, I've gravitated toward monochromatic images. If I were to try and replicate his dragon today from memory, I could probably get pretty close.

Rob is an artist in the way that I wish I was. His ability comes naturally, and I have always been in awe of it. I wasn't born to be a maker. It was only with discipline and practice that I have gradually become a competent artist. Rob is an artist as the moon is the moon and the sun is the sun.

Rob also had a fantasy art calendar that I was drawn to, perhaps because it frightened me a little. Inside were paintings of dragons peering in through tower windows with their giant leering eyes or sleeping among piles of gold, with small, elflike creatures tiptoeing around

them, trying to sneak away with treasure. One depicted a dragon with a sword buried in its belly, blood pooling underneath.

Rob introduced me to a lot of music. He always had the television on in the background with the MuchMusic video countdown playing. He would frequently come get me out of my room to listen to a new song. The first performers I remember seeing videos for were the Eurythmics, Ozzy Osbourne, Mötley Crüe, the Cars and Michael Jackson.

Although Joe and Rob would fight a lot (in fact, I don't recall a time when they weren't arguing), Rob and I would sometimes have a great time together. I remember one night when it was just him and me at home. We played a game where I got on his shoulders, put my hands over his eyes and directed him around the house. We would crash into things and bump our heads. That night still resonates in me. It was the first time I experienced his true laughter.

Many years later, I watched *The Outsiders*, based on the novel by S. E. Hinton, and it made me think of me and my two brothers. I probably would have been Ponyboy, only because I was the youngest and most sensitive. Joe would be Dally. Rob would be Darry.

"I've been thinking about it, and that poem, that guy that wrote it, he meant you're gold when you're a kid, like green. When you're a kid everything's new, dawn. It's just when you get used to everything that it's day. Like the way you dig sunsets, Pony. That's gold. Keep that way, it's a good way to be."

Maybe one day, in another life, we three brothers will learn to stay gold.

THE DIVORCE

The first thing I can remember about my parents divorcing is the sound of dishes breaking. The noise echoed deep inside me as my heart spiralled into my guts.

It felt like some sort of transcendence happened to me during this, as if my spirit had removed itself from my body. I knew what was coming. I knew it was the end.

I ran and hid in the closet, hearing the muffled voices through the layers of coats that hung down, brushing against my hair. My knees were at my chest. Voices cracked and came apart with the sadness of falling rain. Confusion and hurt and all things broken. Outside the closet, my world was crumbling apart, that's what it felt like — destruction. I sat on top of the vacuum there in the shadows and cried as long as it went on. Until all went quiet.

I could hear my mother's voice like an animal in pain. I could hear nothing but quiet sobs. I could hear the panic regain momentum. I could hear the cupboard doors slam so hard it sounded like they were coming off their hinges. I could already taste the loneliness that would follow. I could hear my parents hugging, whispering, yelling.

My dad moved into the little wooden house located on the property for a short while, before packing up his things and moving to Toronto. We were on our own now. Just like that, my dad was gone, like a candle that had been blown out.

'Cause the night's getting' cold and
Everything dies, baby, that's a fact.

THE BRIBE

Life was hard after my dad left. Where was the strong figure? Where there had always been a chainsaw buzzing or a hammer banging — those sounds of security, those sounds that meant things were being looked after — now there was silence.

A shadow slipped across the fields like a thin black veil, gently floating down from the cloudless sky, draping itself across the top of our house and over the trees. It hung over the treetops like inky mountain peaks. The sun had grown dim, and the land had been washed in grey. I was realizing we were all alone in the middle of nowhere.

I was thankful to have Joe by my side. We were unsupervised a good portion of this time. Kelly had landed a job on a ranch. Our mom was working at a jack factory I believe, sometimes at night. Rob was working on a farm, and later also worked with my mom at the factory. This left Joe and me to our own devices. It may not have been exactly like this, but I can remember being with Joe most of the time.

Joe and I ended up being absent from school for long periods — so long, in fact, that the administration started to sending truancy officers to our house. We'd hide from these people in order to continue our hiatus. It sparked a fear unlike any other to hear the impending doom on the gravel road drawing closer. No one drives up through these fields in the middle of the day unless it's for something important.

On one such occasion, we scrambled through the living room, stepping over toys and clothes, over the couch and into my sister's room at the far end of the house. We slid under her bed as fast as we could, just like Bo and Luke from *The Dukes of Hazzard* sliding over their Charger. We lay, peering out from the darkness under the mattress, our eyes white in the dark, like two rodents hiding from a

snake. "Hello?" we heard a distant voice call out. With a click, the front door slowly creaked open. Imagine, hearing the door of your house opened by someone unwanted. We waited, our breath shallow, for the stranger to darken the door of the room we hid in. Time stood still as I watched the clothes strewn across the floor. Then I heard the soft footsteps. With every step, the carpet sighed, and my heart began to boom against the floor. There was static in my ears as I heard the front door close and after a minute the car pull out of the drive. The noise was cut clean, leaving only arid silence, the shift like the deafening following a gunshot, as we lay there until the coast was clear with fear ringing all around.

After some time, we were found out by the school and forced to return to a regular schedule of education. The case worker, when she finally got to us, was pretty nice. She made a proposal that was impossible to turn our noses up at: if we attended school every day for an entire month, then, on the final day, she would take us to McDonald's. Seeing as we had never before been to McDonald's, it was an easy decision. One million — and two — burgers sold, baby. So we shook hands, signed it in blood and spit in our palms. For one month, the only thing I dreamt about was the Golden Arches. I can't believe that's all it took.

After thirty long days and thirty long nights, the day finally arrived. I couldn't wait any longer. Chicken nuggets were the best-tasting thing I'd ever eaten. To this day, I still have a soft spot for the sweet and sour sauce.

FIRST TASTE OF DEFEAT

Joe and I continued to attend school and, dare I say, I think I even began to enjoy it. It was here that I met my first girlfriend. Her name was Cindy. She had a great big smile full of tiny teeth. Her eyes would light up when she smiled, and I really liked that. We would hold hands on the bus, and it felt strange and nice. I was feeling good about school, but I guess a pretty girl will make the things you don't want to do a little easier.

Kids in my class were beginning to take notice that I was adept at drawing. As the word got out, everyone decided I should be in a drawing contest with another kid who was making waves on the Baxter Central Elementary School art circuit. We were both really into cars and trucks and decided they would be good subject matter.

I had been preparing for this moment, and I was going to bring my A game. I went home and worked for hours on my design. I pulled out all the stops, applying the skills I remembered my dad using when he would draw cars. I drew a long blue dragster with great big back wheels, making sure my shapes were straight and round. I stacked the engine so high it would be a miracle if the nose lifted up upon takeoff. But of course it would: this was the clearly the fastest, most deadly speed vessel known to humankind. It was equipped with all the fixings, and I added flames down the side. I couldn't wait until the judging the next day.

As the minutes closed in on the event the following morning, there was a real buzz about the classroom. Everyone was excited and skipping and shouting. The time had come to reveal the artwork, the crowd hushed.

I was the first up. I lay my creation down on the table and all the kids leaned in to peer at it. They gasped and sighed and wowed

at the electric blue dragster before them. It made me feel good, as I knew I worked hard on this one. Girls cupped their hands over their mouths and boys uttered, "Coooooooool."

The teacher gave the cue to the other artist, a good-looking kid who resembled a (very) young River Phoenix. He revealed his artwork, a monster truck climbing rocks. It was a view from below, so that the only thing you could see was the two massive front tires and just a little of the back wheel. It was only a line drawing, and it had been traced from a colouring book I remembered seeing in the department store in town.

Everyone gasped at how dynamic his drawing was, but I was at a loss for words. I stood and stared at the two pictures on the table. When the tally was taken, Chris and his monster truck came out the victor. I went back to my desk and watched everyone gather around him, patting him on the back and congratulating him. I can still see his smile, but I can also still see him glancing at me, through the excitable crowd. It was only for a second, but our eyes locked, and he knew that I knew. The type of moment that makes the world slow for a moment, like a tiny jolt from an invisible source. He turned away, all smiles again. He had made his decision.

I sat down, and Cindy came over, took my hand, lacing her fingers in mine like she would do on the bus, and told me she liked my drawing more. She flashed her smile with her little teeth, and that made me feel better.

The world is cruel, my friends, and this was a hard lesson learned: sometimes the more difficult, more honest road is less triumphant. This taught me that if you're going to borrow (which we all do) then at least *try* and put a little effort into making it your own. Ultimately, you're going to get knocked around, so what are you going to do, just lie down and die? No, you get back up, dust yourself off and draw some more fucking dragsters.

ADORN THE ORDINARY

On another morning when I woke to an empty house, I opened the door with a creak and stepped down on the porch to find my mom doing something to the pickup truck resting in the green grass at the side of the drive. How curious, I thought as I walked across the lawn, past the concrete well in the corner of the lot and onto the dirt drive. With bare feet, I carefully stepped between the sharp stones. As I got closer, I realized she was painting the old Ford black with a roller. This was a window into how spontaneous she was: she'd want to do something — and do it that second — and she would use whatever was available. She let the paint dry, then she added red and orange flames across the hood and over the wheel wells. I sat in the sun and watched the transformation, completely fucking blown away.

Looking back, I realize a force inside her compelled her to do these things, to take the ordinary or the old and breathe new life into it, to change things as run-of-the-mill as a white wall in a dim room or a forgotten pickup truck rusting out in the grass in the middle of nowhere into something else. They were her blank canvases. Let's adorn the ordinary and make it special, her actions seemed to say, make it stand out and give it a home. I took this in and buried it deep inside myself.

A WINDOW INTO MY
GLAMOROUS FUTURE: PART 1

"So . . . what are you thinking about having done?"

"Three emojis," the kid replied from the other side of Tat-A-Rama's counter. I say kid only because he was short, skinny, with blond hair. The air conditioning had stopped working days ago and outside, the summer sun was cooking Bloor Street. Inside was a bit like a bayou. A few days earlier, workers had re-tarred the roof, and thin black lines where the goop ran down into the shop lay dried on the aging white walls.

"Sorry, some what?" I asked, confused.

"Emojis."

"What's that?" I asked.

"They're like . . . symbols, or digital icons, on the computer," he replied in a thin tone, his small eyes shifting inside his glasses. "It can express how you're feeling." I could only stare with a blank expression. The year was 2002, I had been tattooing for about three years, and I was almost illiterate when it came to computers. He then reached up and placed a printout on the counter. There was a cartoon smiley face on the left, a heart in the middle, and a cat's face on the right, all in a line.

"This is what you want to get tattooed?" I asked.

"Yup. So . . . the idea is, I'm the smiley face, and my girlfriend is the cat." Wild horses couldn't have held back the smile emerging on my face.

"Okay. I see. How old are you, anyhow?"

"Eighteen," he replied, seemingly accustomed to the question.

"Got some ID, dude?" He pulled out a thick wallet. Sure enough, he was eighteen.

"Okay, so you want these emo . . ."

"Emojis."

"Right. You want them with these colours, like this?"

"Yes, please. On my shoulder."

"Okay, grab a seat and I'll get set up. What's your name, by the way?"

"Dan."

"Nice to meet you, Dan. I'm Chris. I'll be back in a few minutes."

He took his shirt off, revealing his slim frame. He wasn't shy, and I caught the confidence within him. I like when people surprise me. After I shaved the single hair from his shoulder and tossed the razor in the bin, I poured some Dettol (old-school antiseptic for applying stencils) onto a paper towel and wiped the area. I held the stencil up, eyeballing it, making sure it was straight, and placed it to the skin. Then I pressed the image firmly down with the damp paper towel. Pulling the paper back revealed the purple outline of the emojis on Dan's shoulder. "Check that out in the mirror, friend, let me know if you like the position. It looks pretty straight." Dan peered long and hard through his glasses over his bony shoulders.

"Perfect," he stated.

"All right, take a seat here with your back to me. So, if you begin to feel light-headed, let me know right away, okay?"

"Yup, no problem," he said in a robotic tone.

"I'm going to just start with a little line to get you into it, then we'll go from there, cool?"

"No problem."

"Here we go." I picked up my Spaulding Supreme liner and pressed the footswitch, and it purred like a bobcat. As promised, I started with a small line and wiped the ink away. I could already tell it was going to be a long day. His shoulder was skeletal and uneven, which made it difficult to find the right angle. The air was hot — also, the smiley face was a perfect circle. Difficulties were mounting. "How's that feel — okay?"

"Fine," he repeated, but something told me it wasn't fine at all. I went back in with a longer line this time, *bzzzzzzzzzzzzzzzzz*. That's

when a pale sheet crept across his face. He went limp before his head pulled his body downward at an angle.

"Oh, shit."

With lightning reflexes, I managed to put my machine down and slip a hand around his gut. Though his body still slid forward and collapsed to the tiled floor, I was able to lessen the blow. His leg twitched while the happy emoji grinned up at me from the floor, a black smudge across its smile.

"Christ." I ran to the washroom and soaked some paper towel with cold water, ran back and pulled the kid up, but he was down for the count. After shaking him gently, he came around. His glasses lay unbroken on the floor. My good friend and fellow tattooist Joe poked her head in, concerned.

"Orange juice?" she asked.

"Yes, please," I replied, and she was off. I draped the cool towel across the back of Dan's neck, monitoring his state closely, waiting for the colour to slide back across his skin. He raised his head, and his vacant eyes looked at me with confusion.

"What happened?"

"You passed out, buddy. But you're okay; everything's fine. We'll get some OJ into you and get you back on track, promise." Usually there is a period of stillness and quiet after someone faints, but Dan was different. He reached across the tiles and dragged himself away from me as if he had no legs.

"Dan, you should try and be st—"

"Don't touch me," he warned. His tone was startling, and I wondered if he was still half out of it.

"Dan," I tried again.

"Don't *touch* me." He managed to claw himself to the corner of the tiny room, where he curled up. In the three or so years I had been tattooing, I hadn't witnessed anything like it.

"You'll have to phone my girlfriend. She lives close by. I want her here."

"Dan, this happens sometimes, but it's cool. We'll get this OJ into you and you'll be right as rain. You can get through this."

"No. I want her. *Now*." At a loss for words, I agreed and went to find the phone. My boss, Eugene, with his arm hanging off the back of the swivel chair, swayed and snickered. I shrugged my shoulders. As I got Dan's partner, Cynthia, on the line, he called out, "Tell her to make sure she brings the Harry Potter book!"

Later, when Cynthia walked into the room, Dan came to life and hauled himself from the floor before the two embraced. He was reborn, and ready to get tattooed again. Cynthia knew what her man needed, and promptly set to reading Dan's favourite book in full English accent as theatrically as she could muster, and the more she emphasized her delivery, the more strength it gave Dan. Joe walked by my room, glancing in with her big, saucer eyes. I sensed her inner Newfoundland self saying, *What in the holy hell is happening in here?*

It was damp and tiresome in the shop that day. We were sweating, tattooing and listening to Cynthia recite *Harry Potter and the Philosopher's Stone* louder than the Scandinavian death metal droning in the backround, and though we were lost in the throes of delirium, it was rather beautiful. I can remember thinking about how most of us are curled up in the fetal position, and not until a good partner comes around can we stand up.

NOT SO COOL ANYMORE

I began to make some more friends at school, which was making everything easier. When I was in grade one or two, my best friend was this kid named Gordy, who was just golden. He wore clothes that were too big for him and had curly black hair. Full of life and energy, he waved his arms about as he talked and laughed excitedly about things. I remember that laugh and great big smile. He had a good heart.

After seeing the video for "Thriller," I begged my mom to get me the red-and-black leather jacket Michael Jackson wore in it, the one he was famous for. Due to financial circumstances, getting that exact jacket was not an option, but she did get me a pretty sweet leather substitute. Whenever she knew I really wanted something, she tried her very best to get it for me.

With my new jacket, I could go to school thinking I was pretty cool, especially when my brother let me carry his boom box into the schoolyard. I guess you can't blame little Cindy for wanting to hold my hand on the bus.

There was this other kid named Chris, who also had a leather jacket, and it was only natural that we formed a gang. Because of my new alliance, I didn't see much of Gordy. The other Chris and I would hang around acting composed, and we began to draw the attention of our fellow classmates. I could sense a growing respect forming around us in the schoolyard. We oozed confidence. There was a girl with short black hair who decided she wanted to be my girlfriend. I would put my arm around her over by the fence, playing it real smooth. If I had been able to smoke cigarettes in elementary school, it would have completed the look. Secretly, though, I missed Cindy and Gordy.

There was a set of green dinosaur-shaped monkey bars at the side of the school. Faced with the pressure to keep up my newly acquired level of cool and equipped with nothing but my leather jacket and my bravado, I went walking up the tail of the dinosaur, hands free, standing upright. As I got to the top, I could see the kids taking notice of my showmanship. I was on top of the world, soaking in all the smiles like a rooftop soaking up sun. Then, not paying attention, I stepped in between the bars. A mighty, mighty flash of white light blasted through my eyes as my jaw came down on the steel rung, which rang and clanged in my ears like a gong. I bit a hole right through my tongue.

Later in life, when I first heard the Pogues' Shane MacGowan sing the line in "The Sick Bed of Cuchulainn" about someone being "kicked in brains," I thought about how it felt when my chin connected with the cold steel bar — *ponnnggg!* — while my rib cage shook like a rattlesnake. And I must have looked just like Shane MacGowan when I fell into the dirt, ragged and toothless, with a crimson mouthful of sand. However, the difference between Shane and me was that Shane would have been smiling and snickering, and I wasn't. I don't think anyone could believe the amount of blood coming out of my face. The teachers held stacks of brown paper towels against my mouth, and they were soaked red and sopping in seconds. I don't remember being in the hospital — just a month of sipping liquids and no talking, which was fine by me. I got too confident and wasn't so cool when I returned to the yard. But Gordy was still there waiting for me with a big old grin, waving his arms.

KELLY

Kelly was a warm and caring presence in the family, and I felt very safe when I was with her. She was pretty, with flowing blond hair and a gentle smile. She was always with her horses, tending to them and grooming them, which was a testament to her character. She had a large horse named Appy. Kelly would sometimes take me riding through the fields, although I didn't enjoy it that much. It was too bumpy, and I didn't like how it would jostle me.

Sometimes the horses would escape and disappear into the countryside. We would drive up and down every dirt road trying to track them down. The scene plays like a black and white movie: that dark horse, off in the distance, running lightning-fast along the trees, free and clear.

It came as no surprise when Kelly attracted the attention of the boy down the road after the new family moved into the big white house. His name was Martin, and I thought he was the coolest guy on earth. He was slim and funny and always friendly. I wanted to be like him when I grew up, driving tractors and cars, being important around the farm. Some day, I would wear a hat with a good curve in the brim like his and be cool enough to score the pretty girl up the road. We used to hang out in the basement together. Kelly was always drawing. I would hang off the back of the armchair, watching her sketch. She was interested in clothing and design, so she was always sketching dresses with different patterns and poses for the models. She was really good, and I was amazed at how effortlessly she was able to make these images. As long as she had a pencil and paper with her, I would be leaning against her and watching.

Kelly was around nineteen when she and Martin got married. I was seven, I think. The big day was one of the nicest I can remember

from my childhood, and brought some much-needed days of relief and excitement. The ceremony was outdoors, and everything about it was simple and perfect. I can still see Kelly dressed in white on that beautiful summer day, the breeze blowing beneath the trees, the boughs waving and the leaves shimmering. Martin was done up in a tuxedo, and there was love all around. I was the ring boy and wore a pale blue suit. I thought I looked pretty good and felt honoured and important. Following the ceremony, we went to a nearby hall for the reception. It seemed like such a grand occasion.

Because I was so filled with love, I asked if I could put on a break-dance performance at the reception. I came out with another boy and just went for it. We're talking moonwalks, backspins, the Freeze, the Worm and something of a Windmill. The music was pumping, and people were clapping. Everybody was cheering and smiling. I pulled out all the style and charisma I had learned from the videos I'd been watching: *Breakin'* and *Breakin' 2: Electric Boogaloo*, and, of course, Michael Jackson — all the good stuff. The performance was a wild success.

I enjoyed performing, all that surging energy and nervousness. The monkey bars incident was a big risk that didn't work out. This was to be my first successful leap, a first gamble, that paid off. I was such a timid kid, but I was swept up in the moment. I was so happy that I forgot how introverted I really was.

I think about this sometimes and try to teach myself what I knew then: to try to roll with my gut instinct, listen to my emotions and act on them, be expressive and spontaneous.

AND STILL MORE FIRE

It was only a matter of time before it was my turn to have a brush with fire, and the memory is branded into my mind (as well as my leg). My mother had left for town one afternoon, so Joe and I decided to make a fire at the side of the house, as children do 'round those parts when unattended for more than a few minutes. We got busy and doused the grass with gasoline and lit her up. Just another day in Alliston. At that time, they had switched from selling tobacco in metal tins to plastic, which was the vessel we would transport our gas in. We would often draw simple shapes in the lawn with the fuel before lighting it. Joe and I were watching the orange blaze against the green backdrop, dancing around, completely oblivious that our mom would be returning soon. That's when the fire spread to the container and it began to melt. Then, half a mile down the road, I saw her brown Cadillac pull onto the drive and start making its way up toward home. I panicked and, without thought, we stamped on the plastic that was burning, spattering gas up onto my leg, and within seconds, *poof*, my leg went up in flames. I didn't know what to do, so I bolted. Joe chased me, trying to put my leg out, reaching desperately for my burning appendage. By the time he pinned me down, my polyester pants had melted into my leg.

Imagine for a second: you've left for an hour, only to come back and find the side yard and your youngest child on fire. Yes, the one with the red hair is running around screaming, waving his arms in the air, while your other child is chasing him maniacally. My poor mom.

When it was all said and done, she fixed me up as best she could. I remember having my leg in the kitchen sink while she concocted some magic potion and spread it over the scorched skin. Eventually

she got me to the hospital. The burn was a bad one, and the skin is still thin as tissue paper today. It must have been so frightening to deal with these things without my dad around.

THE MANTIS AND THE OMEN

Our mom got a job as an upholsterer in a small town called Everett. She packed us up in the Caddy one morning and dropped us off at the house of a woman who would be watching us for the afternoon. I could tell even before we got there that my brother Joe and I weren't going to be having any of it, but we would try to be good sports for as long as we could. The moment I walked into this woman's house I felt uneasy, like Regan MacNeil being dragged into a church. It smelled of urine and acrid flora. The decor was old-world and very dated. We rarely entered another person's house, so anything would probably have seemed strange.

I remember sitting at the table while the woman prepared lunch, our elbows on the plastic-covered table, floral patterns underneath. She slid our plates in front of us and told us to eat our sandwiches. Joe, who was born a picky eater, immediately questioned the ingredients of the sandwich. We were horrified to learn that the meat inside the sandwich was horse and felt an instant disdain for this woman. We explained that we had horses as pets, and there was just no way that we were going to eat our pets for lunch. She tried to argue and was very stern and quite nasty. The disagreement escalated until we found ourselves getting our shoes on and walking out, just like that. We flipped up our collars, spit and hit the road.

Up the street we found a church and walked around to the parking lot in back, kicking gravel and being loud. We had time to kill until Mom got off work. It was a very hot afternoon.

We goofed around in the parking lot for a few minutes before we were joined by some younger local kids. They were like stray dogs. We threw stones and chased each other around, kicking up hot dust.

Eventually I wandered closer to the church, where I came across a praying mantis near the wall by the back steps. The insect was clambering slowly in the gravel and dry weeds that reached up toward the midday sun. In a moment of poor judgment, and still reeling from our protest at the sitter's, I thought it would be amusing to relieve myself on him and exercise my power even further. I stood up, unzipped my pants and released the beast. At first just a tiny tinkle drizzling downward in droplets, the spray became stronger and made a figure eight across him and puddled in the stones beneath. The mantis, brave and undaunted, reared up and glared directly into the stream with its tiny black eyes. It waved its V-shaped legs up angrily at me as the urine splashed all around. I could sense its anger and knew that if the mantis had been large enough to defend itself, it would have stood up and devoured me slowly. I felt a pang, the type of pang that hits right when you know you've done something wrong.

I have thought about this day many times with shame and regret. Torturing the mantis was different from the time I sacrificed the frog at the potato barn. I had been genuinely intrigued about the makings of the frog. Though my actions may have appeared cruel and emotionless, I was only a curious boy. With the mantis, I had masked my inner feelings of shame by laughing crudely and pretending I was something I wasn't.

The mantis bayed at me in the torrid sun and gravel as I pissed all over it. The steaming yellow pooled between the stones, turning the white, dusty gravel slate grey. The other kids gathered around to guffaw.

I wish I could go back to that hot day behind the church in that nowhere town so I could carry the mantis out of the sun and into the shade below the trees and let him down into the cool grass.

I often think about how one day that praying mantis will come for me. I imagine it appearing over the top of a church, only this time it's the size of a truck. Scraping shingles from the roof with its thorny, raptorial forelegs, it reaches out, beckoning to me. Bricks crumble

from the turret walls under the pressure of its weight. It stands tall against the sky, wearing a jewelled papal tiara upon its head. The sky quickly fades to black as it rears, silhouetted against the bright white moon. Its jaws click and its body jerks. Its wings unfold, massive and translucent, fanning out into the cold night. It's come for revenge, as I knew all along it would.

From the parking lot, we set out for the variety store beside where our mom worked to see if we could put some chocolate milk on her tab. As we walked down the laneway of the church, then turned onto the sidewalk, cicadas buzzing in the grass in the quiet of the afternoon we were presented with an alarming scene.

We ran closer down the deserted street with hearts racing to see a sandy-brown car, upside down in the middle of the road, teetering back and forth on its roof, the steel bending and moaning. The car was tough-looking, like an old Firebird or a Nova. Its thick wheels turned slowly as it bobbed and creaked in the shimmering heat, grass waving in the ditch in the background. Rivers of fluid leaked onto the rocky pavement. We smelled gas and deep dread. We were close enough to see a thousand shards of glass scattered across the road, gleaming and twinkling like diamonds in the sun. I don't recall seeing the driver; maybe I've blocked it out of my memory. Joe says there were emergency vehicles arriving on the scene, but I only remember the car.

This was an omen, a warning from a higher power. Or maybe we were saved. Was the driver drunk? I can't say. We'd been about to walk the same road, and if fates and timing were to have been slightly altered . . . I left that scene feeling very frightened, like someone upstairs wanted to teach me a lesson about ignorance.

THE WOODEN HOUSE

The wooden house, Alliston.

At some point around this time, we moved into the little wooden house that my dad had lived in briefly so that my mom could rent our brick house out for additional income — at least that's what it seemed like to me. Living in the smaller house was like being a pioneer. There was a cast-iron wood-burning stove propped on the dusty planked floor in the middle of the main room, a ramshackle kitchen and a loft upstairs where we all slept in a bed near the window. The wooden house had a lot of heart, and eventually I came to love it.

I'm more attached to my memories of that home than the brick house. The wooden house is where we had to learn to stick together. Things were more volatile with my dad gone, so the good things that happened after the divorce seemed really special. Still, it felt like we

had been demoted somehow. Maybe this is where I got my undying sense of loyalty to the underdog. I always stand with the team that is two goals behind in the third period, the horse who has the biggest heart.

The upstairs of the wooden house is where Rob got his first tattoo from his Indigenous friend, Chris, who lived in a group home in Alliston and went to the same high school. This new phenomenon of tattoos was making its way through the halls. Students were getting hold of mimeograph paper, which was used in schools then for duplicating classroom assignments, and would make temporary tattoos. Essentially, it was an earlier version of Spirit Master stencil paper widely used in tattoo shops today. It spread like fire across a country field. One kid, who stenciled the whole scene of Kiss's *Destroyer* on his arm, boasted he was going to tattoo it once he got home, then got expelled for saying so. He must have been excited to get home earlier than expected and get to work.

Chris tattooed "Roo" on Rob's arm with a bulletin board pin and our mother's Higgins India Ink they found in her art kit. It was an inside joke from when Rob tried to enter his name into the arcade game after beating the high score, and spelled it wrong. The two of them romanticized during the process about how the tattoo would bind them forever, and all that good stuff that pours out naturally when the tattooing process occurs. That was the same bottle of ink Rob spilled on our parent's bedspread and didn't get in trouble for. We never got reprimanded for anything creative that we might have tried. Rob was proud of his new addition, and when he rolled up his sleeve to show our mom, she said, "Oh, cool," and smiled.

Attached to the right side of the house was a large derelict tin shed I would explore, though there really wasn't much in it, just a dank dirt floor and rows of shelves lining the tin walls stocked with cans of motor oil. I was drawn to the gloom of the place. It felt like someone else's shed, like I was a visitor in someone else's world.

I came to love the upstairs of the wooden house. I had some of my best sleeps ever there and my happiest wake-up in the history of happy wake-ups. It was the perfect morning and the big saggy bed was the softest thing I can remember. We had heavy quilts, but when I woke, the window was open and a warm summer wind came blowing across my skin. I could hear birds chirping in the morning sun and my brothers and mom laughing outside. I lay there for what could have been another hour, letting my mind wander and listening to all the sounds. That was a good morning, the type that's full of promise, no darkness in sight. Then a guy named Rick came around.

WALK WITH ME, MY BIG BROTHER

Rick was the first person my mom rented the brick house to, and he used to beat his German shepherd, Nora, almost daily. As if the looming threat of tornadoes and the crows that would eat your eyes weren't bad enough, now I had this vicious, abused dog to contend with. Why did Rick, this piece of human garbage, have to move in next door to us, out in the middle of nowhere? Out of all the places he could have gone. But there he was, with his terribly angry dog roaming only minutes from my house, always rearing her head when I least expected to see her. Nora was often chained up, but many times she wasn't.

The place I lived was sacred and had once been peaceful, just me and my wild brothers, free to roam wherever we pleased, to pull up and make a lean-to in the woods, to kick back inside and eat a peanut butter sandwich. But *everything dies, baby, that's a fact*, and the kingdom had been compromised. Now everywhere I went, I walked with fear and wondered if that dog was going to creep out of the shadows and gnash her teeth. I was scared of the dog, and I was scared of Rick.

One day, driving through the woods toward our home, we emerged from under the canopy of trees to see Rick outside the brick house, yelling. His thin dirty-blond hair waved around as he yanked hard on Nora's chain and kicked wildly. The scene raged in the hot daylight. Nora cowered, her claws digging into the dirt as she barked and yelped. The chain whipped and tightened. Looking through the car window, I gasped. As we rolled by, with stones cracking below the tires, he glanced our way, the sun catching the whites of his eyes under his dark, scowling brows, before he turned back to reef hard on the chain around her neck. I could see her teeth; I could see her eyes. She

was ready to kill. Did anyone in the car speak? I think they were all as scared as I was, and I believe that's what Rick wanted.

Rick may have had a roommate, or maybe just a lot of visitors. One lonely night, my brother Joe and I had to spend the evening with him in our old home because my mom was working the night shift. We were there for a few hours, and I hated every minute of it. I hated that he and his friends were in what had been my house, kicking back so lackadaisically. Everyone was acting funny. It was making me uncomfortable. I may have been young, but I wasn't stupid. It was really smoky, and my eyes were burning. Someone rolled a black ball toward my brother, and I think I knew that black ball was hash — but it's just a dream from a long time ago, and who's to say if it even happened.

With burning eyes, I listened to the insipid hillbilly jive, knee-slaps and bellows of moustachioed, red-faced men echo through my old living room. I was relieved when it finally came time to go back to the little wooden house, to the quiet.

Something out in the night swallowed up time, and the usually short walk seemed to take much longer. It was the darkest night I can think of, and we couldn't see five feet in front of us. I stayed close enough to Joe that my shoulder was touching his arm. It felt nice to be out where I could breathe and to be alone with my brother. We shook, jangled and rolled along the dirt road, stumbling and tripping in and out of the wheel ruts. The wind was picking up, whistling eerily through the boughs and fluttering leaves. There was the distant rumble of thunder, like a big wooden barrel rolling across the sky's barroom floor. We were about halfway to the house when the sky lit up with lightning and cracked open in bright splinters across the horizon.

I kept having wild visions. From within the black came a great skeleton hand, reaching. I cowered against my big brother, clutching at his clothes. He put his arm around me. Another awesome flash lit the land around us, revealing waving fields and silhouetted trees, macabre and wild. It unveiled the ghosts standing out in the field, misty and translucent. I closed my eyes tight and felt the summer

wind against my cheeks. I could still see the outline of the lightning lit red across my field of vision. I had flashes of the figures drawing nearer and could not raise my eyes from the darkened road.

GOODBYES

After all this time, I wonder if those apparitions are still out there in the waving fields, standing, swaying, staring toward the little wooden house with the softly lit windows.

Separated from our father, our days passed in limbo. It seemed tornado warnings had increased, and I lived in fear of violent weather. My eyes, like a hawk's, were always peering at the clouds, keen for any sign or shift, sharp to detect the subtleties and deeply aware when those clouds revealed their dark green underbelly. Though Joe had warned me to keep my eyes low, I found the courage in those moments to look up.

I knew when those big clouds started churning and folded over into thick charcoal stacks that there was a bad wind coming. Below the wooden house was a well of deep water. I feared I would be forced to go to Rick's house, down to the basement with him and his poor, vicious dog if ever that funnel touched down.

Strangers had been coming around claiming we had stolen their dog. They were trying to take our Labrador, Becky. I didn't know who they were or why they had suddenly appeared. Their wild accusations didn't help with the uneasy feeling I was already experiencing. As they got closer up the drive with every day, we cautioned them loudly to stay away and fended them off with stones. And all the while, Nora continued to roam around out there, snarling at me, threatening to tear me up. My mom was off working all the time, trying to keep her shit together, and it wasn't working. I wished my dad was there.

I could sense a presence out in the land as the moon rose above the trees. It was in the stick snapping in the shadows and the barn door banging open and closed in the wind. It had chosen us, and I could feel it like a slow-moving force creeping between the blades of grass.

It had weight. It came with the sound your mind makes when you are scared, that resonating bass, like a slow heartbeat before the sinking in your gut when the minor chord is struck. I didn't want to be there when its long claw came reaching from the fog toward us.

I went about my days trying not to look too deeply into its eyes in the trees, which would shimmer like tiny stars. If I stared too long, those eyes would hold my gaze, and shapes would begin to shift and blotch and change shape and colour, leaving me disoriented and frozen. I waited out the days, kicking stones and medicine bottles through the ferns, shooting my pellet gun. I would build my lean-tos in the wet grass and pretend I was a brave explorer. I would watch the sun rise and set and would plead that the sky wouldn't turn red or green. I wished my mom would return home that night, for headlights to wash the road. I wanted my dad to come home and take me to the beach, where I could feel that great big sun on my back. Where he would throw me high in the air and the cool water would spray off me. Where, for a second, I was a bird, weightless and free. I would close my eyes and see that beautiful blue in the dark, hear the sound of the seagulls. I would feel his hands under my arms as he'd catch me and let me back down into the water. That's where I wanted to be. I wanted to stay there forever.

After what seemed like a long period of unease, uncertainty and loneliness, my dad returned.

Mom was sick, that's what my family tells me now. Mental illness was slowly creeping in. They now use words like schizophrenia. I was still too young to recognize any real dramatic shifts in behaviour, but my older brothers began to notice that she was experiencing paranoid episodes and delusions. I can only guess that my dad's calculated ways of reasoning couldn't unravel the puzzle she presented him with. The truth is that her mental state was affecting the quality of our lives because she was becoming incapable of doing the normal things that it took to be a responsible parent. Dad knew we couldn't stay there, and he made a decision. He acted on it the only way he knew how to.

We brothers knew as well that things couldn't go on as they were, but it's hard to face the truth with the eyes of heartache. It's hard to know the truth when you are young and blinded by love.

On the day that our dad came to take us to Toronto, he first picked us up from school, then drove back to the house in Alliston. As he packed some of our belongings up, I went to play in the field in between the two houses. That day, the grass was still green, considering it could snow any day, and Dad's eyes were dark. My heart sped up as I saw him walking toward me, to tell me it was time to go. He looked strong. He took big steps across the pasture and scooped me up in his arms. I could see his hair dangling over his ear as I rested my chin on his shoulder. He smelled smoky. We walked back to the wooden house, where he knelt down at eye level and put an arm around Joe and me. There were tears. There was relief, confusion and hurt.

I don't remember the actual hug I gave my mother the moment I said goodbye, in fact, I don't know if she was even there, and neither does Joe. Forgetting his toy robotic arm, Joe ran back in the house in a panic to get it.

A love once grew here in this haunt, but it went up in flames like the barn down the road, leaving ash blowing across the fields. It rocked all of us infinitely. The barns where speckled horses with dark, beautiful eyes once stood were now empty. In their place was just a lot of dirt, old, rusted cans and crude tools that never belonged to us in the first place. We can leave them be once again. Let the spiders coat them in heavy layers of silver thread. We can leave the wind hissing down from the grey skies, through the cracks between the barn boards, into the dank corners of these forgotten, wasted posts. And the years will break this place, just like they did the slaughterhouse out in the ferns.

These buildings will gradually fall to slivers. The dust will collect so thick on these windowpanes that newcomers who step foot on this land will hold their hands cupped to the glass and see nothing. They'll hear nothing but the eerie creak of the wooden step underneath them. They will try to wipe a clear spot with their sleeve to stare in. They won't

see the boy inside with his mother in the makeshift kitchen preparing food, laughing, with the sun soaking through the window across the counter and their faces. They won't know what transpired, that these parents once brought these kids to the fairgrounds in town and held hands in the darkness, with the Tilt-A-Whirl spinning wildly in the night, the lights all mad, yellow and red leaving trails in the darkness, and the Salt and Pepper Shakers, the main attraction, dipping and diving and ascending in the night, its white lights twinkling like stars and everyone in awe. They won't see the mom and dad buying their boys rock 'n' roll shirts from the vendor, even though money's tight — *Hell, you only live once, and these kids deserve it* — nor witness the boys run off into the dark, smiling and hollering, waving their souvenirs like flags of freedom, to then get back into the station wagon, everyone aglow and happy, and drive back through the darkness, windows down, cigarette smoke, giddy laughter, the dashboard's pale yellow radiance lighting my mom's hair, waving in the midnight wind. They won't see us pull onto our dirt road, and me tired, tired, tired.

We'd roll back to our house in the middle of the fields and forest, and I swear we just saw coyote eyes in the trees as we made our way inside, and I was put down, already half asleep, listening to the television come to life in the living room. Someone would come and see me off into the night. And eventually all the lamps and lights would go out and everybody slept.

No, whoever comes here after we've left won't see or hear that at all. They'll just see a wooden house leaning in the wind with the tall grass blowing all around it. They'll shrug their shoulders and drive away. And that's all that I saw as my dad drove down the lane with me and Joe. I watched until our home slid behind the trees. And when the dust rose up from under our car, clouding the last sight of the wooden house, my heart thumped bad as the voice inside of me whispered goodbye to my mom.

I have only returned to our property twice as an adult. I wanted to show my wife, Megan, where I grew up, and so on our way back from the cottage in 2012, we took a detour into Alliston.

I was surprised by how I could navigate through the town without assistance. I soon found the spot we used to go for burgers. Frank's, as I believe it was called, doesn't exist anymore, but I recognized the building and rough location. We followed the road out of town, straight between fields. I could see the trees up ahead and knew our old drive was coming up. I could see what used to be called the Oasis, the gas station that had the dump in the back. We turned into the pine trees and drove through the woods. This entrance was now blocked, so we backed out to the main road. I followed the roads that led to the other drive, where the big white house still stood. I turned off the main road, just like we did so many times.

We followed the treeline, with the dirt cracking beneath our wheels. I could almost pinpoint the section where the Cadillac came to a screeching halt after Joe and I took off with our bounty of apples. Soon the little wooden house came into sight on the right. It looked exactly the same. The last time I was here, someone was trying to fix it up, but on that day it looked just like it did when we lived there. It was surprising to see that it's still standing. It was a little overwhelming. Memories flooded back. After a short while, a man came walking down the lane from the brick bungalow that we lived in before moving to the smaller wooden house. He was old and wary of us. Like I said: nobody drives up here unless it's for something specific. I introduced myself and told him I lived in both of the houses when I was a kid. He warmed up a little but didn't have much to say. He said it was okay to look around for a bit, but I could tell he preferred that it not be long. He walked back down the drive.

I could hear the wind. I walked over to the wooden house and peered into the window. I could barely see through the pane. I made out some familiar things: the counter and the stairs leading to the loft. It felt like I was looking in at a diorama. It was surreal. The low

barns out back had lost their siding; all that remained were the skeletal frames. It seemed fitting.

I tried not to be sad, but deep down I was. It was dream-like. I saw the fence beside the house where my mom held me in her arms. I could still smell her leather jacket. She picked me up at the bus stop that day, and we walked back to the house together. We talked and she was happy. She brought carrots with her so we could feed my sister's horses. I remember Appy's dark eyes as she approached, and I cowered closer to my mom. She told me it was okay. I held out the carrot. Appy's big lips felt strange in my palm. Then she bit my thumb and I cried.

I hugged Megan and absorbed the scene for a while longer before we got back in the car and drove away. She held my hand for a long time afterward.

PART TWO
The Big City

COLD AS ICE

I was roughly eight when I came to Toronto. I started partway through grade three, and my teacher was Mrs. Poppeal. She was old-fashioned and very kind. She wore stretchy, shiny pants and dramatic ruffled blouses. A head of curly, poufy hair framed her smiling, round, made-up face. Mrs. Poppeal was the largest human I had ever set eyes on. I began to think that the people of Toronto were taller than the rest.

When I was seated in class, my eyes were at the exact level of Mrs. Poppeal's crotch. So when she would come down the aisle to talk to me — well, at times it just seemed as if her voice might have been coming from somewhere else.

I sensed I was a little different than these city kids, and I believe they sensed it, too. I stuck out something fierce, what with my long red hair.

In that first week at my new school, I found myself in my first real fist fight. Since we'd moved halfway through the school year, it was the middle of winter, and the snow had blown icy drifts all along the fences of the schoolyard. Everybody liked hanging around the skating rink on the edge of the schoolyard because a tall chain-link fence offered the troublemakers — and those who sought a little mischief — a place to exercise their revolt out of sight of the wardens. This was where first kisses happened, where I first heard "Paul Revere" by the Beastie Boys and where Phillip would show everyone who was boss. It's no surprise I eventually found my way over there.

I could see some commotion stirring, so I decided to investigate. When I arrived around the far side of the rink, I witnessed a scene that could have been from a Jean-Claude Van Damme movie called *Cold As Ice*. One kid in the centre of a hurricane of fists was fighting off attackers

as they came at him, just like Jean-Claude would have done. He was laying them to waste, sending them flying to the sidelines as if they were mere rag dolls. I watched the madness go on for several minutes.

The nerds and outsiders were rising up, challenging Phillip. We spectators stood with our backs up against the fence, watching him destroy his opponents one by one. When the last kid crawled out of the circle of death, he yelled, with his fingers clenched and eyes pulsating in winter fury: "Who wants a piece!?"

I stepped forward casually. I heard the words come out of my mouth, distant and quiet: "Hey, why don't you fight me?"

He just stood for a moment, taking in the new kid's proposition, and a long smear of a smile spread across his face. Then he came at me like a tiger.

With the snow falling from the pale grey sky, I dropped my gloves and cut my teeth with Phillip. I was going to give it my all. I could see his jaw tense as his steel eyes glared at me beyond my raised fists. He'd throw one and connect, then I'd throw one and connect. Like that we stayed for what seemed like an eternity, our winter jackets whizzing and swishing with every punch, the cheers from the spectators infinite.

The other kids raised their fists in the air and waved their tuques around like flags. Finally, we locked up like wrestlers. His arm slipped around my neck and squeezed tight like a constrictor on its prey. We flipped from our feet onto the ground, and I could feel the snow on my bare skin as my jacket rode up my back. Left and right we grunted and writhed, until finally he put me on my stomach. He had me pinned. Then he held me by my wrists and buried my hands in the snow until they were frozen. He had me. It was a dirty trick and it worked well. I held on for as long as I could, but my hands began to burn with cold. Blood trickled down into the white snow from my lip, and I gritted my teeth hard. Once I could feel my cheek come to rest in the ice, I knew it was over. I could see the boots of the kids against the fence from a sideways viewpoint and feel the weight of my victor finally get off my back. He had sat on me longer than he

should have, like I was some sort of a trophy. It aggravated me so much it almost gave me strength to go another round, but I couldn't.

When the scene calmed, the crowd came to my side to see if I was okay and tell me what a good job I had done standing up to Phillip. With my first busted lip dripping crimson onto the snow, and with the cold wind blowing up snowy gusts around us, I felt something glow inside me. I understood in that moment that it was perfectly okay to go down, as long as you went down swinging.

Oddly enough, Phillip befriended me. I believe he was genuinely impressed that I didn't give up easily. This can happen when you fight someone. A certain amount of respect gets transferred between the blows.

He really was the toughest bastard around. He would sneak up behind you and put one arm across your neck and another across your forehead, drag you down to the ground and whisper in your ear: "Shhh . . . I could have killed you there." Afterward, he expected us to be thankful for sparing our weakling lives. At any given time, he could be seen foot-sweeping or grappling someone. And I know that wherever he may be now, he has yearned to rip his shirt off at the company Christmas function and take his co-workers all down, one by one, just like back in *Cold As Ice*, when the snow was blowing down at the rink and he was the king.

I earned a level of admiration around the schoolyard after standing up to him, and that was better than being picked on. So, I played my cards right and kept the situation in my back pocket. We'd go to his house after school and watch movies, and we became buds. I enjoyed it because it allowed me to watch all the movies I wouldn't be allowed to watch at home. Some memorable titles include *American Ninja*, *Revenge of the Ninja*, *A Nightmare on Elm Street*, *Commando* and *Cobra* — all the good stuff. It was in these moments that I knew there was a connection between Phillip and me.

CATS, PANCAKES AND BANANA BOARDS

The first kid I met and became close with at this new school was Adam. He was one of the only kids on the street, and I can still remember him calling to me from down the road. Feeling displaced, I was thankful to make a new friend so quickly. He was a real Tom Cruise type, always in a polo shirt or a turtleneck, with a sweeping part in his hair. He was always talking about how many times he'd been to see the musical *Cats*, like it was some sort of exclusive club. I dreaded our morning walks to school those days after he had been to see *Cats* again. Always Macavity this and Rum Tum Tugger that. I found this irritating, only because I didn't know anything about musicals. I was from a farm in the middle of nowhere, and culture shock was very real.

He would try his best to one-up me on anything and everything. I'd tell him, "I ate ten pancakes last night," only to have him reply, "Yeah, that's cool. I had pancakes as well. I ate twenty, though."

In the end, there was something loveable about him. We used to play ball hockey and eventually started skateboarding together. We had these plastic banana boards that we would ride to school. Around the side of the school was a tiny ledge, about two inches high, which we would ride along really fast, holding onto the board and then jumping off. Sometimes we attracted quite a crowd. It appeared everyone was impressed by our charismatic stunts and our natural attraction to danger. We played it cool, like we'd been skateboarding since birth, no big deal. My greatest memory of Adam happened on a hot, restless afternoon of summer vacation as we tried to work up enough courage to phone the girls from school and invite them over to Adam's for a swim. I couldn't bring myself to do it, I was far to nervous. But Adam was brave; he dialled and made the call, He had a cool confidence

about him, always. And a smile came across his face when the girls agreed. He slammed the phone down, then we ran outside to the front lawn. That's when Adam bolted behind the side of the house. As I wondered what he was up to, I could hear him from above, singing the Pointer Sisters hit out into the summer air, "I'm so excited, and I just can't hide it!" I realized then that he had climbed up on his roof and was running toward the edge. Just as he sang: "I know, I know, I know …" he'd already leapt, the words trailing behind him as he plummeted. Adam sailed to the ground with a dull thud and twisted his ankle bad. He lay there holding it, wincing while we both laughed our asses off.

STEELTOWN AND THE LAST GOODBYE

Visits to see our mom became fewer and fewer. On occasion, she would come to pick us up and take us back to our old house for a weekend. It was so nice riding in the big Cadillac again, out in the dark, out where the lights were low, with only the dashboard glow and the moon to guide us. We would eat sticky buns; she made sure she was always well-equipped with some sort of yummy treat or pastry.

One long winter night, the muffler on the old Caddy came loose, and we dragged it, clanging and sparking, the whole way back to our home in Alliston. We tried to ignore it and remain positive despite the endless scraping as we pulled it down the highway. I remember wondering if we were going to make it. Somehow, we did. It was a tense ride, but we were just happy to be with our mom and to have her smiling.

At some point, she moved from Alliston to Hamilton to be closer to her mom and dad. It must have felt so lonely out at the farm with nobody there. This may be the thought that plagues me the most. Sometimes I try and imagine what that must have felt like, but I can't go there — it hurts too much.

Our first visit to see her in Hamilton would be the last time we saw her. My brother was old enough to take me on the bus with him. I am not sure how old I was, but I know I was wearing my Detroit Red Wings jacket, which would make it around grade four or five. It was spring, and we got on the Greyhound and headed west toward Hamilton. I was a little worried, but like always, I felt safe with Joe. I marvelled at the way he knew how to get us on the bus and all the way to another town. Once we were in Hamilton, we waited for an hour for our mom to come get us, but she never did. Somehow we got our

Grandad on the phone, who lived close by, and he picked us up then drove us to her house.

I remember the row of houses where she lived. It was across and over a block from a schoolyard. It wasn't a big house, and the block was mostly old working-class homes clad in faded mint-green or white vinyl siding, like you can still find in many areas of Hamilton today. There were a few brick homes, but the majority were modest wooden dwellings. We climbed the short, steep steps and knocked on the metal screen door.

When Mom opened the door, I was so happy to see her. It was strange, though, to see her in this new setting. She seemed surprised to see us and said she wasn't expecting us for another day. She quickly shrugged it off and smiled and shooed us inside. We climbed the narrow stairway in the dim light, the worn carpet peeled and frayed under our feet. She lived in a two-room apartment with a kitchen in the rear corner that looked out into the backyard.

Inside, we were confronted by what we least expected to find: two children, a little boy and a little girl, with short black hair. Mom told us she was babysitting them, but they remained in the apartment for our entire visit, which was at least a day or two. I couldn't help but feel we had been replaced.

The apartment was dishevelled and unkempt. In one room, a mattress lay on the floor and clothes were scattered everywhere. Garbage bags with more clothes spilling out sat in the corner. Dishes were piled up in the kitchen sink, and the lighting seemed too dim in all the other rooms. There were no pictures on the walls, just cracks and faded paint.

We had not seen her for quite some time. Everything was different. Everything was off. I was rattled by the extreme change of scenery, from our sanctuary in the woods to this gloomy apartment. I was rattled by these new kids. Though I was happy to be in her presence, I wondered, had she forgotten about us?

She went out to do a few things, and Joe and I cleaned the apartment. We picked up and folded all the clothes and washed the dishes.

Cleaning the apartment helped with the uneasy feeling in the air. When Mom came home, she was amazed at what we had accomplished in such a short amount of time. I remember how, after settling in, the apartment felt a little more welcoming. That night I saw her smile the way she used to. And as she smiled, with us all huddled together on the mattress in that strange room in that strange town, the place didn't seem quite so dim anymore.

The next day, I went by myself over to the schoolyard across the street. The sky was grey, and the air was cool. I could hear passing cars on the wet pavement, and the birds were singing. There was still snow built up in the corners of the fences like a small mountainscape with dirty little peaks. The pavement was grey and rough, and the grass damp and soggy.

The schoolyard was empty, and I made my way over to the playground. I climbed up on the jungle gym and started messing around. I was there for about ten minutes, beginning to feel a little cold in my Red Wings jacket and thin winter boots, before two kids came around the corner into my field of vision. I could hear them muttering about me and I started getting a little nervous. I was sitting up on the platform of the jungle gym with my legs dangling over the side. They made their way up to me, and as they got closer, I could tell they were older than me by a year or so. They were pretty rough-looking, with their scraggly hair and mean mugs. They spat a lot.

They asked me where I lived and what I was doing there. They closed the gap between us. Their eyes were glazed. The air between us seemed to reverse polarity. Something was about to happen. One of them reached out and tried to grab my boot and pull it off. I jerked my leg up and out, almost kicking him in his big head. His hair dropped in front of his face as he backed up a step. He smiled his ugly smile and stepped away in an embarrassed retreat. Just like that, they walked off as quickly as they'd come. Goons. I watched them with my heart racing and nerves rattling until they disappeared. I walked back through the

soggy grass, wishing it was summer, and tucked my hands into my coat against my belly to keep them warm.

Later that night, our mom needed to pick something up and decided to bring us out with her for the walk. We made our way under the streetlights toward the main drag, which wasn't far. The streets became noisier and noisier, to the point where it was unnerving. This was Downtown Hamilton. On the main street, we saw two men outside an eatery across the road having a heated argument, hurling obscenities at each other. It seemed at every darkened bar we passed, something like this was happening. When we reached the restaurant we were headed to, our mom went inside and Joe and I waited outside for what seemed like a long while. In the darkness, we watched the characters glide by with vacant eyes and warped expressions, whirling and careening. Once again, I leaned in toward my big brother to take shelter under his wing. The neon sizzled and flashed bright above the darkened doorways where shouts and the sound of breaking glass echoed in the Steeltown night. Two pretty girls bent close to me in passing, their makeup heavy and colourful.

"Hi, sweetie. Love your red hair," they said as they clip-clopped past, heels dragging and scraping on the sidewalk.

My eyes were stinging. I did not want to be there any longer. When my mom finally returned, I felt like I could breathe again. We went back inside and had something to eat.

This is the last memory I have of her. I don't remember anything after we left the restaurant. In the space where we must have said our goodbyes, there is just white noise. Joe seems to think that our dad came to get us, and he's probably right, but none of us remembers saying goodbye.

Since that time, I've gone back to Hamilton on only a few occasions. I like it there, but it makes me uneasy. The last time, Megan and I were on the way back from Niagara Falls and on a whim decided to pop in and have a look at antique shops. We pulled off the highway

near the lonely spit that juts out into the black water. A single black tree twisted upward from the centre of the grey, ashy spit like a broken wrist. A flock of cormorants perched, fixed like props, in the tree and stared, silhouetted black and demonic against the peninsula, toward the dark grey tide moving in.

The dismal westward view from the Burlington bridge was almost Hieronymus Bosch–like in its wretchedness. Far off, the cylindrical smokestacks towered, some spitting smoke, some spitting fire up into the pale grey light. In the distance, beyond the rusted tin fences, the citadels of industry rumbled the earth, exhaling smoke from their black lungs.

As we drove farther into the scene, the dust created a dreggy brown veil across the battered old streets. When the busted roads smoothed out, the powdery dirt dissipated, gradually revealing a suburban setting, with tiny, dated shops lining the sidewalk. Ghost signs reminded us that others were here before us, and the boarded-up storefronts showed that hard times were still everywhere.

We drove slowly, and the feeling grew weighty, like water seeping under the door. My eyes scanned each corridor we passed cautiously. I saw the old row houses, with their weathered vinyl siding and screen doors. I stared down them and thought of her — of all things, good and bad. I thought of the dashboard light in the Cadillac. I thought of the ring in her laugh and light in her eyes. Those two things are burned into my heart. I thought of my blue snow boots on the damp pavement, the soft muddy grass on that spring day when I last saw her. It slipped away like sand between my fingers. I heard the birds on that broken street.

Now, when the snow turns to water, then into rivers that run down along the gutters, and the sun begins to warm the land, I see her eyes gazing back from that spot far away, that spot where the rain is constant and soft, that place only I know of. No maps lead there. It's a shrine. A place that is finally tranquil after years of wind hissing at my

shutters. A place of quiet, where the heartbeat steadies, way down low. I think of everything.

I am grown up now, but I think of that morning and our misplaced goodbye. For so many years, I've held on tight to the thread hanging into my past. For so long, I've hoped she was holding the other end, out there somewhere. And I've waited — like a fisherman at sea, waiting for his line to tighten, out in the swells — to feel a pull. I've waited only to have the line finally loosen and drift weightless in the waves.

She stopped writing a year or two after we moved to Toronto. I waited for her to come back, but she didn't. She was defeated.

One of our cousins told us that he saw her once, and she was living on the street. My brothers and I can only assume that's where she stayed. Joe tried to find her, but to no avail. And even if we did, the thought of what we might or might not find was too frightening. It's easier to tell yourself you're angry, that it was her job to come find her sons. But that's a lie. The truth is our remorse is too large to bear. Deep down, we regret not trying to do more, not trying to find her and help her. That's the cross we brothers drag everywhere we go.

EDDIE

My new friend's name was Edson, and he was born in Luanda, Africa. He was seated beside me at school and snarled a little bit like Johnny Rotten when welcomed by our grade four teacher. He had bushy hair that reminded me of Gordy from elementary school. I knew I liked him immediately.

The first time I talked to him was when we were assigned to do an illustration. I was excited because I was finally back in my comfort zone. Out of curiosity, I looked over to see what the new kid was making. I leaned over, but he had his arm wrapped tight around his drawing, protecting it. So, after a moment, I stood up to get a closer look and asked him what he was drawing. The new kid eyed me suspiciously and then reluctantly moved his arm and revealed his secret to me. He had drawn some sort of panther, or a large cat, with massive guns attached to its back, exaggerated blasts firing from the barrels. The guns were intricate, with lots of different parts. His attention to detail was impressive, but his drawing surprised me because it was far from what I'd assumed the teacher was expecting from us.

"That's really cool," I told him. "Why did you draw that?"

He shrugged.

"You might get in trouble," I said cautiously.

He paused for a moment. "When animals are killed by humans, I wish they were reborn with weapons attached to them, to seek revenge on those who mistreated them."

Immediately, I thought of Nora the German shepherd — with a rocket launcher on her back. She bows her head down. Above her raging eyes comes the hiss and poof of the rocket launched from its

sleeve. It swerves initially but steadies. It finds its target, and just like that, the asshole we called Rick is incinerated.

I gave Eddie a grin, and he stared back down at his paper. After a second, he looked back up at me and asked what I had drawn. I showed him, sheepishly, wishing I'd had the guts to draw whatever I pleased. Unlike when I had the drawing competition back in grade one, this time around I could see that this kid had created something much better than I had, and my admiration was from the heart. I was jealous of his amazing drawing, but also genuinely impressed with his skill and bravery. He said he liked my picture, too, but I knew he was just being kind. I was certain I had made my first true friend.

It turned out Eddie's family had moved into a home just down the road from where Joe and I now lived with my dad and his girlfriend, Karen. Rob lived on his own somewhere in Toronto. Karen was seen by Joe and Rob as a replacement to our mother, so their acceptance of her was hard to come by. I was younger and welcomed the stable environment, although it was a difficult adjustment. It took time for me to get used to her face, it was so different from my mom's. She did have a friendly smile and she was kind to me, but I was wary.

The first time Eddie invited me to his house, he offered me cookies, chocolate and pink wafers, which was the second tell that we were going to be friends. I had a sweet tooth and was laying waste to the package as his mom came home from work. He promptly introduced me as the Cookie Monster, and I smiled a big smile full of crumbs.

Eddie was bigger than me. He wore cool clothes and was quick on his feet. When he laughed, it sounded like he swallowed air. His laughter always began with words "What the fuck?" or "Yo, Magoog" (which was his nickname for me). The guffaw would often turn wild, and it sometimes had a long sigh at the end of it. It was so infectious.

Eddie felt like my blood brother. He had an intense love for animals, and I loved being out in the woods. And so we spent a lot of time down in the ravine that ran directly beside the street that I lived

on. A big hill led down into the valley that was only several houses from where we lived. We would hike along the Humber River, play war games, make forts and build fires. Luckily, none of our fires got out of hand like they did back in Alliston. We would pack up our jack knives, canteens and binoculars, then tromp through the forest like soldiers. There were evenings we would watch the sun descend behind those big houses on top of the ridge on the other side of the water. Off the trails and into the shade, cicadas buzzing in the cool heat of autumn, we would talk about everything.

I still can see us walking that September, fallen leaves crunching under our feet. Another kid, Paul Kim, came with us. He was always good for a laugh. The sun was pouring down in pale yellow beams through the big maples, and long shadows came across our path like Nosferatu, his long claws threatening to drag the sunshine back to his tomb. With the last heat of summer on our arms, the three of us walked together. Eddie's heart was full of lightning. I would see it flash in the shade of the forest, like a light bursting through the cracks of a wall.

While down in the ravine, if you followed the Humber upstream, it led to an adjoining creek that flowed out from a small waterfall nestled in between two steep hills. The three of us crossed the river toward the falls in search of adventure, jumping carefully from rock to rock toward the other side. We climbed the hill beside the cascade and soon reached the top. Once on top, we discovered a meadow with long grass and thin birch trees. It felt like a secret spot, and it reminded me of Alliston.

We built a ramshackle fort back amid the thin trees, away from the path. It had escape passages, just like in our favourite movie, *The Dog Who Stopped the War*. We built a small fire to warm our hands in the glowing light. Paul had brought meat that we dipped into the flames on a stick. With the smell of Korean pork crackling on an open fire, our stomachs grumbled. Our breath was crisp in the shade. We

devoured the meat, smiling and grateful, our bellies warm and our clothes full of smoke.

Then we heard a branch snap and footsteps approaching. The enemy was near. We caught sight of them, a group of teenagers. They were clad in jean jackets. I could smell their cigarette smoke. They were all Iron Maiden and discarded mickeys tumbling down into the bush. They spotted us among the trees, and we took off like bullets down the dirt path, our feet thumping and clapping, the tall grass whipping at our legs. We could hear the waterfall as we drew near the river. Faster and faster, our dirty sneakers took us down the winding path, dodging land-mine rocks that would pulverize us at the slightest touch. The path widened at the lip of the ledge above the water.

I saw you ahead of me, Eddie, go sailing over the ledge to the stars. I was right behind you, friend. I closed my eyes and jumped. I felt the wind on my face and the water beneath me. You rolled on the bank on the other side, and all was quiet for a moment, before I went tumbling into the dry grass and mud alongside you with a big thud. I lost a shoe and my sock dangled from my toes. I saw your eyes shining like stars through the grass and your bushy hair moving in the wind. Blood brothers! We did it — what beasts.

"That river ain't got nothing on us!" Eddie yelled.

But there was poor Paul, still up on the high banks on the other side, "I can't do it, guys."

"Paul, you can do it. C'mon."

"We'll meet you at the bottom," we called up to him.

So we shimmied down the sides of the waterfall where the grisly shale crumbled, slid and splattered into the water below. From there, we made our way down to the watershed, where the falls joined the Humber River, and tried to skip back across the river to our side, our balance challenged on the slippery rocks. We stepped over the crayfish and minnows, past the half-buried shopping cart that dripped green shit, back to our turf, safe and sound, with laughter echoing through the trees.

We would spend many days like that. It would get late, but we walked bravely with mud in our hair and our shoes. Those evenings we feared no evil. I would see those beams flashing from inside my friend. They lit the path home.

On those long days in the ravine, Eddie delivered to me a feeling like what my childhood was like with Joe before the divorce. To find a true friend is to find home.

INVINCIBLE

As friends, we grew in the forest, but we learned to fly in the streets. We were twelve or thirteen when we found skateboarding. Eddie and I started to skateboard all the time. Skating captivated every part of me and became an engulfing lifestyle. That feeling I used to get riding off curbs on my banana board with Adam came back quickly.

My dad and Karen couldn't afford to buy me a pro board. I had to start with a Variflex, a brand that has a long history within the skateboarding world. Variflex came into existence in the late seventies, but couldn't keep up with the trends of the industry and ultimately struggled with identity. Despite starting with a quality product, by the time I was skateboarding with Eddie they were no longer taken seriously. They were still making boards through the eighties and nineties, but because of the drop in quality, they'd been demoted to being sold mostly out of Kmart and other box stores. They didn't have the long, high tails of the newer boards. The wood vibrated and was heavy.

My board was a slug, but my folks did what they could, and they didn't know the difference. I had to learn to use what I had. I was determined not to let a board that wasn't as nice as my friend's prevent me from being a good skater. It only drove me harder. Eddie had all the good stuff, new decks and T-shirts, and always looked legit. Adam also had everything brand new. The difference was that Eddie was a natural, and Adam gave it his all. Eddie and I improved faster than the other kids because we were actually into the sport, not just riding to do what everyone else in the 'hood was now doing.

Back when contacting someone via telephone was a real thing, we were subjected to the horror of speaking to the person on the other end of the line. You'd insert your index finger into the dial on the top

of the telephone, swing it clockwise all the way to the top, and repeat this six more times, just to get through to someone. You'd received a phone call bright and early: "Yo, Magoog, wanna skate? Meet me at the school."

And we would skate all day long, until night. We would ride west, up across Kipling Avenue, weaving through the streets, power sliding, ollieing up and down curbs. People tending to their lawns or watering their gardens would look up at the approaching racket. We would race by, trying our best tricks, making sure we looked cool and confident. Some would just stare; some would shake their heads and glare in quiet disapproval. Up past the middle school, we ran the whole way parallel to the river. The badlands of Jamestown Crescent stood dark and looming. The suburban landscape would give way to the factory district, where we would duck under the big trailers and across endless rough concrete. We flew past buildings with names we didn't know how to pronounce, where, inside, industry pounded away.

Eventually we would come to the place we had been searching for. We called this skate spot The Banks. The loading docks slanted down toward the doors of a warehouse, and on either side of the driveway was a cement bank that got taller as it sloped down toward the building. It was the perfect ramp, the thing that wasteland dreams are made of, reminiscent of photographs in the magazines we read. These banks had just the right amount of transition. There were even two large gashes where a truck had scraped the concrete with its bumper backing into the dock. They were positioned right in the sweet spot, so we knew exactly where to hit.

We would ride for hours at The Banks. There usually wasn't anyone there, and when there was, they didn't mind us skating. The workers just went about their business and let us do our thing. Eddie and I seemed to learn at the exact same pace and were always pushing one another. It was here we became skilled skateboarders. We would come at those inclines as fast as we could possibly go, pushing twenty or thirty times, leaving just enough room to get our

back foot in place, hit the transition with knees bent and jump as high as we could. It was just like when we would jump the river, only this time over picnic tables and tall garbage cans. To be up with the board beneath my feet, feather-light, drifting through the heat, and then connect with the ground and hear those wheels rolling — I can think of no better feeling.

We were invincible there in that concrete square with the big rusted trailers and the chain-link fences with vines clawing their way through the diamonds. We could taste salt on our lips, our faces hot with sweat. We took in the haze of summer with our stinging, sunburnt eyes. We pressed on, climbed higher; we were both Icarus reaching for the sun. Our wheels rolled over the rough concrete, our feet stomped to a rhythm. It was beautiful. With our hearts full of blood and our palms full of gravel, we would ride on and on. To the sound of urethane on pavement, we coasted through days. All that commotion and effort and attempt after failed attempt.

The noise in my head was a static I just couldn't shed, a surging current of all the unpleasant things. The noise that my heart made was like plugging in a guitar, turning up the amp and strumming. The unbearable and impossible social situations, broken homes and broken tones and deep-down rain. I was knee-deep in trouble, I could have told you. I had problems miles high. So I would drag them all down toward that ramp, heaving my chains, all of them. I'd speed toward my marker, and when that anticipated moment arrived — *boom!* — I could hear nothing but the air on my cheeks and the rocket at my feet. And for a few moments there was silence, and I was free, just like the birds up in the sky and in the trees, all the fear and noise finally gone.

I transformed those surroundings for a moment, took what seemed normal and turned it into something else, just like my mom and Rob used to do. It was art, and it was gritty, and I loved it. There was no adult here waving their finger at me, shouting on and on about things I didn't care to understand. I knew what I needed. I needed to be lit

up, but most of all, I needed the breeze on my skin and peace inside my heart.

My bushy-haired friend and I smiled in the wind, waiting for that big hot sun to start falling in a blaze behind the restaurants that lined the main drag. Sweet urban desperation. We would stop to buy a cool drink for the way home. We would walk the rest of the way and watch the trees fade to black as the orange turned to darker and darker blue and the streetlights flashed to life, illuminating the underbelly of the trees. The crickets chirped, and we would talk about good things, about how high and far we ollied that day. We would talk about things that made us laugh, our voices echoing through the streets. Inside the brick houses, televisions glowed. The winding streets would lead us safely back to Eddie's. I would say good night and hop back on my board to take a slow ride through the streets back home, soaking in light and then darkness, light and then darkness. As I passed beneath one street light to the next I would try a trick or two, just something easy, something to make myself feel good. When I could see my house, good old Pop would be there on the porch, sitting in his chair smoking. I would tell him about what I'd done at The Banks, and he'd smile as he listened. I would go in and head to my room and lie back on my bed and think of all the cool things we'd done and how I couldn't wait to do it all again tomorrow.

A SUBTLE ANARCHISM

Early skateboard art was something that captivated me from the very beginning. There was something magical about these timeless designs. And I loved the concept of each rider having his or her own personalized graphic, eternalized on the bottom of their deck. These skateboarders were like gods to my friends and me. Mike McGill, Tommy Guerrero, Corey O'Brien and, unforgettably, Tony Hawk: they all had iconic images to represent themselves. Mike McGill's in particular resonated with me. When I first saw this graphic, I was certain I hadn't laid eyes on anything so cool in my life. It was an illustration of a skull with a green snake in its teeth, coiling around the top of the cranium. Above, convex yellow lightning bolts followed the contour of the image.

And Guerrero's: a dagger with bright orange-and-yellow flames. Corey O'Brien's: the Grim Reaper holding a fire ball. Tony Hawk's: the famous bird skull. I was enamoured with how simple and stark some of the images were, like a stamp or a sticker. Almost like a tattoo.

The first time Eddie and I made the trek to a skate store was like going to the moon. It was so far away and exciting. I can remember pushing the door open. As I looked up, there they all were, the graphics that I'd only seen in magazines neatly displayed in rows across the wall. Their colours were so vibrant. My eyes and heart were ablaze. I took in all that I could, basking in their colourful light. It was like being at my very first art show.

In the final pages of skate magazines you could find ads for punk rock merchandise — mostly monochromatic T-shirts and patches. That's where I first laid eyes on the Misfits skull, also known as the Crimson Ghost. The Misfits were a punk band formed in 1977 in New Jersey who mostly borrowed from old pulp movies and rewrote them

into brash punk songs. I remember squinting at the logo, white on black, the Crimson Ghost's grin crooked, as if its jaw had been dislocated. It looked so spooky and made me feel uneasy, but I was also curious about it. In these same pages I found other iconic band logos and emblems, such as the Black Flag bars and the Dead Kennedys monogram. I also remember the SNFU shirt, which had a decomposing face emerging from the dirt, its skin half peeled off.

What was this notion I had begun to recognize among these subcultures, this common thread running through all of this? Just like the professional skateboarders, these bands had their own artwork, something they had chosen to represent themselves. I was drawn to this idea of characterization and how an image could dramatize these personalities. I believe this was when I had my first brush with what a tattoo might actually be, even if it only registered subconsciously. A defining image that told a story. I was also drawn to the hidden icon, one that is not always in plain sight, like the graphic on the underside of the deck.

I was also attracted to the idea of defining yourself before being defined. I was beginning to realize that people all around me wanted to have a say in who I was. They had ideas about who I should be and what I should become and thought they knew what was best for me. And maybe they did, but that wasn't the point.

In a society built on capitalism and consumerism, it only makes sense that companies should develop logos and insignias instantly recognizable to the consumer. Those images are seeds that embed in our minds and give these companies a way to keep their brand inside the psyche. I was drawn to the way this idea worked in counterculture. It seemed that these punk bands made a conscious effort to take this business device and flip it, using antagonistic and unnerving images to make a statement. It was a comment on individualism, and I liked it. I could feel the wildness in me rearing up.

These skaters and musicians were my heroes, and they seemed to live above the law in their own way. It was a subtle anarchism.

They rode a skateboard for a living or played music — or in Steve Caballero's world, did both. They defined themselves through these images, words, actions and sounds. What a beautiful thing.

Looking back, it's amazing how much skateboarding has changed. When we originally became immersed in it, it was a sport that was far from socially accepted. It wasn't until we made the move into middle school that we noticed this. Everything changed, and the kids became mean. We were in the grey area of adolescence, when you are growing up fast, but not fast enough. Everyone was pushing their boundaries. Middle school in many ways resembled a penitentiary: these kids were cold, and you had to find your place with your group and learn fast how to deal with it.

Skateboarding truly did embody a rebellious attitude, and my friends and I had begun to show it in the way we moved, how we talked and how we dressed. We started shaving the side of our heads and dyeing our hair. We wanted everyone to know what we were about. We wore anything skateboard- or band-related. And though it felt right and normal to us, we were laughed at in school. We tried to keep to ourselves as much as we could. Most of us were actually pretty easygoing and kind to other students. Having already been what some would consider "nerds" in our younger years, we were built with a certain empathy inside us. All the other kids were the ones who decided *they* didn't want *us*, the jocks and preps who didn't seem to like anybody who didn't fit their mould. I wasn't a punk rocker yet, per se. I was just a kid who liked skateboarding.

BALANCE

Everything changed when I first opened my ears to the band I had been seeing in the back of those skate magazines. Before that, I wasn't sure if the Misfits were a band or some sort of Surrealist art movement. Even though it wasn't art in the literal sense, they were part of a large movement that I was about to discover.

I was sitting in my grade eight geography class, wanting to take my ballpoint pen and slide it into my eye. The teacher was a short, rotund guy who wore his corduroy pants pulled up high over his round belly. He had messy black hair, a bushy moustache and large Coke-bottle glasses. He had a snivelling tone that would drag on and on.

So there I was, staring blankly into space, when my good friend Aron, who always sat directly in front of me in class, turned around to face me. Aron was as much of a punk as he was a skater and had long bangs that he would hide his face under. He handed me his headphones. "Listen to this," he instructed me. I put on the headphones, and after a moment, this song came on and rocketed into my brain. Keeping my reaction in was like trying not to laugh in church.

Having two brothers who both listened to heavy metal when I was young, I naturally grew up with an affection for heavier music. I also listened to some hip-hop and even folk music, but what I heard that day was unlike anything I had ever experienced before. The Misfits song Aron played was called "Where Eagles Dare." Those buzz-saw guitars and pounding drums backed by gruff, melodic vocals had the quality and melody of sixties hits, only rougher and tougher. These were straightforward songs with big choruses, filled with words I'd never heard used in any song: "I ain't no goddamn son of a bitch / You better think about it, baby." Man, oh man, was this ever the sound for me.

I no longer wanted to take my Bic and slide it into my eye. The music was transcendental. I had been enlightened. And from my seat, I looked around at all the other kids, some with their chins in their palms, their eyes half-closed, the smart kids sitting upright, waving their hands in the air, and our strange-looking teacher tapping his yardstick on the chalkboard. I turned away and stared down at my desk, held my hands over my headphones and listened to every coarse note careening in the fuzz. I listened to the booming, relentless drums and sank deeper and deeper into the aggressive melody. I closed my eyes and was very much aware of the smile on my face. I could feel my heart racing, as if I just spotted the girl I would marry.

I suppose that if I hadn't been listening to punk rock that day and was paying closer attention to my teacher, then I may have learned the things I should have been learning. Instead, what had been given to me that afternoon was the idea of what seemed to be a fine balance.

Yes, balance — everything in moderation. I may not have been exactly aware of what was being revealed to me that day, but it left a bell ringing inside. It was the idea that something harsh and something pretty could inhabit the same space: a symmetry between grit and refinement. It would be an aesthetic that I would go on to chase forever.

MIDDLE SCHOOL HELL

We skated and listened to heavy music while other kids were playing football, listening to U2. They shouldered us in the hall and narrowed their eyes in passing to assure us what side of the line we were on. We were always on watch, especially when opening our lockers. I was constantly expecting to be spun around and pinned against mine, or even worse, locked inside it, the equivalent of being buried alive. In our school, those types would sneak up behind you and slap the back of your neck as hard as they could. You had to fight to keep back the tears because if you couldn't, you would be done. Our survival mechanism was to laugh it off — "Oh you, you got me good this time" — flush with pain and embarrassment. I would drape my hair down so no one could see my face.

Intimidation was the name of the game. *So you want to step out of line? And not dress like us? And not talk like us? Well, you'll just have to pay the toll. Because we are terrified of everything that is different, and we're never going to admit it to you or ourselves, so you're going to suffer the consequences.* We needed shelter.

I would have my books slammed from my hands. I would hear the laughs ring from those who have just realized that they wouldn't get hurt as long as someone else was. I would see them standing on the sidelines where it was safe, pointing, with their binders pulled tight to their chests, smiling.

I would stare up at one of those laughing faces, tension rising, and there'd be no words to speak; they were cut from me, and all that escaped was a gasp. But in my heart of hearts, the one that thumped in me like a fist on a wall, there was a calm. And our eyes locked. I knew that person laughing. I could see them in there, hiding. We were all

just animals in a cage, licking the blood from our hides. That was the nature of things. This is the nature of youth.

When I went home at night and was alone with my thoughts and fears, I would stare blankly in the bathroom mirror seeking solace from it all. And I would see those thin, blue eyes, sad and scared, staring back at me in the gross light and ask myself, "What kind of animal am I? Why was I created this way?"

I would wonder what kind of horror tomorrow would bring, not just at school, but at home. I would wonder when my stepmother would secretly coax some church troupe into paying me a friendly visit to drag me out in hopes of getting some sun on my ghostly skin and Jesus into my heart.

I had no other choice but to accept Karen in my life. She took us in and took care of me. I knew she wanted me to have a stable life. She was nice to me because I was young and did what I was told. Rob and Joe just couldn't accept her, and I can't blame them. Although it was reassuring for me to have another maternal, nurturing presence around me, a part of me resented her. I was thankful to be in an atmosphere that wasn't so volatile as things had been before she married my dad, but I missed my mom. I could make my mom laugh.

And so I would dream of a place far away, like the places I saw in all the skateboard magazines, with the backyard ramps, with the trees towering overhead, silhouetted against the sun, and family and friends are one.

Growing up was hell.

Joe had left home because he had become far too wild to control. He had never been easy, but his high school years had become especially hard for my dad and Karen to deal with. Joe and I were also at each other's throats when they were out for the night. He found himself in and out of youth shelters during this time. Him being away was hard on me, as it was the first time we had ever been separated. I missed my brothers immensely.

Around this time, Karen was in a car accident. She was rear-ended by a fire truck. She was pretty banged up. As she recovered, somewhat, from her accident, she began to experience symptoms of multiple sclerosis — likely triggered by the impact — and her body began to shut down. The disease eventually left her in a wheelchair. Witnessing her health struggles was very hard on my dad, but he stepped up and took care of her. I felt sorry for her. I used to have dreams that she could walk again. She remained positive and became more and more religious as time went on.

She was relentless in her attempts to get me to join the youth group from the local church and even convinced me to go to a Christian camp. It was to be the worst and longest trip to Algonquin Park I can remember. I went to the church a few times (wearing my Misfits shirt, of course) only to humour her, but it definitely wasn't for me. I was developing my own set of beliefs. I knew that there was something out there for me, but it just wasn't Jesus.

She tried her best with me, and a lot of what she taught me stuck, the most important being that I should work hard and that if I didn't have the money in my pocket to pay for what I wanted, then I shouldn't buy it. That was probably the most useful thing I've ever been taught. For that I am thankful.

A WINDOW INTO MY GLAMOROUS FUTURE: PART 2

From the drawing desk, which was built into the counter in the front room of Tat-A-Rama, I could see a large man keeping dry from the pouring rain under the awning of Six Points Plaza across the road. The sky was heavy with grey. It was 10:30 a.m. and I was alone in the shop. The man was huge, wore a hood that shadowed his face, and stood like a statue. His gaze never seemed to leave the tattoo shop. When I looked at the schedule to see what I would be tattooing that day, the first appointment in my column had little information. It only read "Teenage Mutant Ninja Turtles" — nothing else, no name or phone number. "That doesn't sound good," I said to myself, but I also wasn't surprised. Because Tat-A-Rama was located at Bloor and Kipling, the shop catered to a vast and colourful demographic — you could never be sure what was going to happen from day to day. Looking out across Bloor Street at the figure, I made myself a bet that he was my first appointment.

I settled down to begin sketching a dragon (which I was terrible at) for the coming week, pencil on tracing paper, listening to the rain and B.B. King's *Live at San Quentin*. I was surprised as noon approached that I was still the only person in the shop, but chalked everyone's lateness up to bad weather. And then the man broke from his frozen state and trudged toward the shop. As he did, I congratulated myself on a bet well played, and could already taste the cold beer I owed myself.

Soon, he was standing right in front of me as he slid a lined piece of paper across the counter that read in thin capital letters: "TEENAGE MUTANT NINJA TURTLES."

And here we go.

"Okaaay. Did you want a picture of a Teenage Mutant Ninja Turtle, or did you want these words, written out like this?"

"The words," the deep voice boomed from under his hood.

Oh, man.

"All right," I said, trying to be polite. "There's a book of fonts over there on the table, have a look through it and let me know if there's one that you like, and I'll draw it up."

"I want to keep it just like that."

"Just like this, stick letters?"

"Yeah, I had a dream, and when I woke up, that was the first thing I wrote down. So, it needs to be exactly like that."

This is a juncture at which tattoo artists often find themselves. In that moment, I couldn't help but question if the man was of sound mind. A small part of me thought maybe not, but in a shop where every other tattoo I made was a Tupac cross with "Only God Can Judge Me" in Old English font, I knew better than to cast stones. There are times when we're challenged, when our moral compass is called upon. Though beauty is in the eye of the beholder, we've seen the lasting effects a crude tattoo can cause, and we try to guide people through this — that's our responsibility. However, we aren't in charge of another person's body, as I wouldn't want anyone in charge of mine. So, I began with the only place I knew where to start.

"Do you have any other tattoos, friend?" If he had some, I would feel better about continuing, if he didn't, that would have some weight on the decision. The reality of it is, if you refuse service, they will only find another place that will take them. Tat-A-Rama being a reputable shop, doing the best job that we could do often seemed to be the more responsible route, because then at least — and in this man's case — the stick letters would be tidy and straight.

"Oh yeah, I've got some," he replied, taking off his wet jacket. He slid up the sleeves on his sweatshirt, revealing a collection of scattered script, dates and other images. He was calm, collected and had more

than enough tattoos. He was on a mission, this was clear, and I was one of the bridges for him to get to where he was trying to go.

"Oh, cool," I said, and smiled. Still, an uncertainty lingered. Though he was big, and not the friendliest, I decided to give him what he came for. Thunder cracked overhead.

He pulled his sweater off, revealing his hulking, hairy body, his belly folding over his belt. I could sense some muscle in there, though, and knew he could pulverize me with little effort. I felt lighter about the situation after learning he wanted to put it on his very hairy shoulder blade. With the letters being as thin as they were, once the hair grew back, you wouldn't be able to find the tattoo if you tried. I shaved a perfect rectangle out of the growth and put the stencil on him. As we set to tattooing, with the rain pounding down on the flat roof above, I asked him what he did for a living.

"Ah, you wouldn't believe me if I told you."

"Oh yeah, try me," I offered. "Look at what I'm doing right now — some people wouldn't believe that." I smiled, enjoying where the conversation was headed. I thought I got a small grin from him. The man, whose name was Vito, loosened up. He paused for some time before replying.

"Well . . . I'm the heavyweight champion of the world."

As you can imagine, an appropriate response was difficult to find at first. I scrambled for a few moments.

"You mean, boxing, right?" I asked, careful not to sound like I wasn't taking him seriously.

"Yes, boxing," Vito assured me.

"Well, no doubt. You seem like a pretty tough dude. I wouldn't be surprised in the slightest." Hell, maybe he was. "So, if you're the heavyweight champion of the world, you've gone toe to toe with the greats, yeah?"

"I retired Lennox Lewis and beat Mike Tyson in a street fight," he swung back at me, without hesitation.

"No shit?" I replied. "Well, what was your boxing name?" That's when he turned toward me and I lifted the machine. He showed me the tattoo on the bicep of his left arm. It was a lion, and overtop it read, "Super Assassin Lion King."

"That's quite the handle, my friend, hard to forget that one!"

"That's the idea," Vito said, proud.

"Damn, dude, I'm honoured."

His demeanour made me want to believe there was this rogue boxer out there defeating all the champs, and I entertained the thought for some time. Vito confided in me about the corrupt world of contemporary boxing, where athletes were secretly being dosed with LSD to skew their judgment, to make them animalistic. I thought about the soldiers of the Third Reich, blitzed on methamphetamines. I thought about the film *Jacob's Ladder*, about a drug designed by the military to increase aggression in Vietnam.

After we finished the tattoo, I watched as Vito walked back out of my life and into the thundering rain; I thought about reality, how vague everything really is. As eccentric as the experience was, it had me thinking, and thinking was good. It's a wild world, and we're are all standing in the ring waiting for the bell. We're all walking a thin line, some just disguise their madness better than others.

HIGH SCHOOL

We all blinked, and before we knew it, we had graduated middle school and climbed up the ladder to the dreaded ninth grade. We were all afraid to enter a new environment with new rules, but surprisingly high school was easier than middle school. The bullies, who had grown used to being King Shit of Turd Mountain, were now hanging like spittle from the lowest rung. They had, at least temporarily, been humbled by this new way of life. Some, however, managed to withstand the blows and claw their way back up the ridge to fully embrace their assholeness.

But we had a good crew, though it was a little ragtag. All in all, there were about fifteen punks and skaters; enough to make our presence known. We commandeered an entire hall of lockers, where we hung out and breakdanced and goofed around. I had become rebellious, following the path of my older brothers. The jocks made fun of us, but we didn't care too much — and some of them were too dim to even bother us most of the time. They would throw their weight around and then go play football.

I didn't dare go into the cafeteria. In all of high school, I think I only went in twice, once to write an exam and once to paste a big Misfits sticker that I'd made onto the menu board. I didn't want to know what kind of hell lurked beyond those doors.

It is human nature that the bullied often becomes the bully. We either re-deliver the mistreatment that is served to us, seeking revenge, or we become empathetic toward others. Being young and part of a crowd, individuals in our crew were often too afraid to say what we really thought. We acted like lemmings and just followed suit, even when we didn't agree with what our buddies were doing. It's unfortunate, it's common and it's just how it goes. We ended up bullying a

kid named Dave. He was tall, lanky, wore thick glasses and was very bright. Every day, Dave would go home for lunch, and what started as a spontaneous crabapple-throwing session when he sped by us on his bicycle one afternoon soon became a part of our daily routine.

Every lunch hour, we would sit and wait for him, and sure enough, Dave would soon come flying down the road and around the corner on his ten-speed. As we gathered our ammo and positioned ourselves appropriately, he would begin to hunker down with his game face on. As he drew near, he would lean into the wind and speed up as fast as his bike would carry him while we unleashed a fury of mushy crab apples. They'd splatter through his spokes and bounce off his shoulders, and we'd laugh because it filled us with a sense of power. But the thing is, he was becoming quicker and quicker as the days went on. It reached a point where it seemed the whole episode was over before we knew it. The window had become just too small to get any enjoyment from it.

Eventually, the crowd tired of pegging Dave with crabapples, and no one seemed to think too much about it when we stopped. But all of this really stuck with me. It is a memory I regret. I always knew what I was doing was wrong, but still I followed through with it. Clearly, the whole experience was the second coming of my praying mantis. Needless cruelty is such a stupid human thing.

I think about Dave from time to time with admiration. He taught me something very valuable and I have carried it with me. A lot of kids would have given up and changed their route, but not Dave. He wasn't going to just roll over and take another course or go and tell his parents or his teachers what was happening. He only rode faster, and just when we thought we'd seen his fastest, he rode faster still. We told ourselves that the whole thing was just getting boring, but in reality, we stopped because he was telling us he wasn't afraid. That was something we couldn't admit to ourselves.

Our high school was a rough place. It was at times violent, and when a fight broke out, the whole school gathered around. Seas of

kids would follow the fights up and down the blocks, chanting in the wind.

Our crew spent as much time away from school as we could, and by grade ten I was really only coming to school to hang out with everyone. I tried my best in my classes, and though I was in mostly advanced classes, I would usually only scrape by. The classes that came easiest for me were art and — thanks to the time I spent reading *Voyage to the Bottom of the Sea* — English. I liked all my English teachers, and despite knowing I was trouble, they liked me, too. They introduced me to some very influential writing, and I believe they could sense my genuine interest. The teacher I had for grade ten English was inspired by short stories and had us read many written by Ray Bradbury; "The Veldt" and "The Pedestrian" were two of my favourites. We also studied "The Lottery" by Shirley Jackson, as well as novels such as *The Stone Angel*, *The Chrysalids* and *To Kill a Mockingbird*. I loved every one of them and began realizing I had a passion for words.

I would never have told my friends, but sometimes when we were hanging out, skating and smoking pot, I would sneak off to the library and read poetry and random books from the shelf. I remember once stumbling on an African poetry book. I had a pretty good glow from the weed and was entranced by its words. I was hanging off those perfectly written poems that were at times quite ominous. "Like when knives slip in and out of people." That line has stayed with me ever since. "Ofay-Watcher Looks Back" was the name of the poem, written by Mongane Wally Serote. *Black Poets in South Africa* was the name of the book. I borrowed it permanently and still have it on my bookshelf. (Shhhh.)

The artists in the school, bit by bit, gravitated to one another. Even though we all came from different walks of life, we stuck together. There was Galo, a skinny Filipino kid with a big smile full of teeth. He had spiky black hair and listened to industrial music. Through Galo, I was introduced to other artists within school, Voltaire was one of them, who played in a band called Wad, as in a wad of gum, which was

a perfectly appropriate name for a snotty teenage punk band. Voltaire and I got along well. We were interested in music and art and had a lot of fun together. He was smart and wrote sophisticated stories for class that were beyond what any of the rest of us were attempting.

Galo and I clicked, and he influenced me with his complicated ballpoint-pen illustrations, blue ink on white paper. He was so dark and fearless, and I was impressed with how little he cared what people thought about his illustrations. I will always remember one in particular: It depicted a person in the absolute thralls of grief, sullen and tired, with pleading eyes and hands raised above their head, wrists pressed together. The wrists had been slashed heavily and blood poured downward. I was in awe of the intense emotion it captured. This was one of the first pieces of art I can remember that truly made me feel uncomfortable. I can see it clearly in my head twenty-five years later. The illustration spoke to me about the importance of impact, and I was floored by Galo's brave use of feeling. The picture also showed me an alternative to what we generally perceive as beauty. This was no vase of flowers on a table or Impressionist landscape. This was real, immediate and emotionally provocative.

I was jealous of this piece, and I actually tried my best to recreate it, hoping some of the magic in it would rub off on me. I suppose that's what we all secretly hope for when we borrow a little too boldly. You might capture the light, but you are left with none of the feeling. We must find our own voice. It's down in there somewhere, just takes longer for some to dig out.

I hope the picture wasn't a cry for help, because if it was, I should have tried harder to stay close to Galo. But I didn't feel like it was. He was such a bold character, and I couldn't sense any feelings from him that were as harsh as what the illustration depicted, especially when he first showed it to me. He grinned his devilish grin while his eyes lit up like headlights in the dark. But thank goodness the teacher didn't see that one. They would have notified the authorities pronto.

Much later in life, when I was roughly thirty-nine, I ran into Galo, hiking in the Badlands. The Cheltenham Badlands is a formation located in Caledon, Ontario, where thousands of years ago a river flowed. When it dried up, it left the land severely eroded. The formation is mostly red in colour, due to the iron oxide deposits. It is the closest thing you can get to Mars in Ontario.

I was with Megan at the time. We walked up the red dirt path, hand in hand, amazed by the intensity of the natural wonder before us. I looked up, and there was Galo staring at me.

"Chris!" he shouted.

"Galo!" I shouted back. We hugged, and I introduced him to Megan.

It was amazing to see that he hadn't changed in the slightest. He was full of anarchy, talking about living off the grid and things of that nature. I was happy he hadn't strayed from his morals. It seemed they'd only solidified and become stronger. I felt proud to have known him and was thankful for the little time I spent with him in high school. As we reconnected that day, I reminded him of the picture he'd made. He only vaguely remembered the illustration but snickered his mischievous snicker, because he knew I wasn't making it up.

I thought about how a person can so easily affect and influence someone else's life without being aware of it. We drift in and out inside our own heads and are oblivious to how our presence is passed off to those around us, like osmosis. Galo had no idea that an illustration he had whipped off as a kid had burned itself into my psyche.

FIRST CRUSH

Adolescence was creeping around and pounding on my door; I had no choice but to let it in. I had developed a crush on my friend Bobby's cousin. She was from another town and was different from us. The night I met her, she emerged from the shadow into the streetlight, smiling, with her dirty-blond hair falling across her face. She was wearing an oversized red-and-black lumber jacket with a Cure shirt underneath. Out of the corner of her eye she saw me staring, so I looked down at my shoes. We all skated in circles, silhouettes in the moonlight. I was too afraid to speak, but I kept catching her eyes as the moonlight caught hers; every time they gleamed, it made me stumble. We began to talk as the circle pushed us closer together. I was hooked. She was the girl from a movie who didn't seem real. The one all your friends secretly thought was much too good-looking for you.

I was only able to see her occasionally because she lived so far away. Anticipation was part of what made it exciting. Absence makes the heart grow bolder. When it happened, when she breezed back onto the street, it was magic. That was my celebrated summer.

Bobby's family was much more jovial than mine. They would have massive family get-togethers where siblings and relatives from far and wide would gather. Cars would be parked all around their house, and you'd notice a buzz in the air. The windows would be lit in the summer darkness, and you could hear them from outside on the street. The adults would be inside eating and drinking wine. You could always see Bobby's father through the kitchen window. It was obvious that he was in love with this life.

That window was like a painting in a gallery, offering its story to the eyes peering at it. From his father bellowing with laughter, cheeks

flushed with wine, to a woman smiling, bouncing a baby, it was a slide-show that put the myth of suburban discontent to rest, or so it seemed to my young eyes. The kids, just like every other pack of kids from every other town, wanted to be outside and away from the adults. This was our hour, our time to be young and whisper in the shadows. And that's when I'd see her. We would sit under the streetlights with safety pins on our jean jackets. NWA and Misfits forever. We'd sit on skateboards on the curb, her voice ringing like a bell in the quiet night, wind on my arms. We'd sneak drags from cigarettes. And when no one was looking, she would touch my hand or kiss me, and I was helpless.

But again, *everything dies, baby, that's a fact*. It would all pass. She would have to go back to her home, in a whole different city. I would lay awake in my room with the faint glow of the streetlight in the window and crickets chirping, the record player spinning. I would imagine her coming to knock on my window, and I would hear her voice through the screen.

Oh man, all these young hearts keeping warm by their radio lights, trying to hide the hurt. Rain falls in these rooms. All hail wasted, love-sick youth.

END OF DAYS

Things became blurry, like looking out of a rainy window, the city lights washing together. I began smoking a lot of pot, and as much as I had originally enjoyed it and thought it was calming my anxiety, the effects began to turn on me. Smoking started to make me nervous, paranoid and withdrawn. Everything hit a turning point when I accepted some weed from a local dealer without having the money. I just couldn't say no to the proposition, which resulted in me ultimately owing a hefty amount of money. It was more than my paper route and chore earnings could afford, and my efforts to pay it back all came crashing down in a landslide.

A paper route was my only real source of income, but I was too embarrassed to deliver the newspaper. It was called the *Pennysaver* and was the bottom of the barrel of local newsprint. So I would pack them all up, ride over to the elementary school, toss them in the dumpster out back, then skate for an hour before returning home. I never felt too guilty about it. I thought I was smarter than I was. I didn't think anyone would ever miss the *Pennysaver*, but I was wrong about that.

It didn't take long for me to become too lazy to take the papers to the dumpster. I couldn't even bother to take them out of the house. I would sneak them past my parents and hide them. My room had a good-sized closet, and deep, too, so it could hold a lot of bundles. A plan so brazen it seemed foolproof.

I began to get desperate as the pot dealer started coming around. I had no idea how I was going to get the money I needed to pay up. The only way I could think of was to steal it from my dad. So I forged his name on a cheque and went down to the bank. I was so naive, not to mention stupid. Standing in line with my heart racing,

I knew it was wrong and I was scared. When it came time for me to go up to the teller, I could tell the outcome before it happened. Long story short: they caught me (of course), sent me home and phoned my dad. Taking that cheque is one of the hardest-hitting regrets I have. The mantis really sunk its teeth into me that time. The ordeal started a long descent into the worst summer of my life.

Walking into the house after the bank was difficult. I was full of shame. When I opened the door, it creaked just like it always did. I took off my shoes like I always did. I remember wishing I could experience those two things without being shredded by guilt.

The bank had already phoned. My dad turned the hall corner, and a primal man took charge. It was the angriest I had ever seen him. He was fuming. He stormed down the hallway toward my room as I sat on the sofa in the living room trying to prepare myself for Armageddon. It's hard to describe how I was feeling that morning, but it was a lot like burning to be sitting there, waiting for the inevitable to come crashing down, knowing it was over, that I was doomed.

Big Papa is pissed. He's climbing up on your back, and he's going to put your hands in the snow, just like Phillip at the ice rink.

My bedroom door slammed shut so hard it sounded like a shotgun went off down the hall. I was surprised it didn't fall off the hinges. I heard the closet door slide open, then more banging. I could hear him curse, which was followed by an eerie silence. That's when I knew he had found the *Pennysaver*s. I could tell by the sounds from my room that I was in serious trouble. It was the sound of a bear rummaging through your campsite in the dead of night as you cower in your tent. Putting aside all the angst, awkward sexual behaviour, being stoned and aloof, taking his Fiero for joyrides, sneaking out of the house, performing half-assedly in school — you know, the casual teenage stuff that I had been torturing him with — now I had become the little asshole who wasn't even delivering the *Pennysaver*.

Then in the midst of his looting, he found a small bag of stems and seeds, which was more than enough for him to confirm his suspicions

that I was smoking pot. I knew, as my room turned to shambles, that this was undoubtedly the end of days.

Why did I steal from my dad? I did it to get those dealers off my back. I thought that if I could pay them off, then I could be rid of some of the negative energy surrounding me. I didn't want those type of people in my life and regretted being involved with them. I made a mistake. I was selfish. I wanted to feel better, and I hurt my dad in the process. That was now weighing on me.

RABBIT IN A TRAP

Because of all that had happened, my dad and Karen thought it would be best if I volunteered at the retirement home a few blocks away from my house during this time. This was the only place I would be allowed to go to for the entire summer. *Kill me now. Wrap me up in a thousand* Pennysavers, *light me up like a great big bargain burning in the night.* Sweet Jesus.

I tried my best to stay put and do my time. I read books and started using my dad's woodshop to cure my boredom. My stereo had been confiscated, the vintage receiver with the blue lights, which was definitely the hardest part of it all. I realized just how important music had become to me.

Deep into my grounding, I was going into withdrawal. I was desperate for tunes. I had a Walkman my dad hadn't found during the shakedown, but it had no earphones. I needed something more discreet, anyway. (I needn't remind you that this was an era before earbuds.) If my parents were to come in my room and find me with a giant pair of headphones on, the bear would surely come back through the woods to tear the place apart again.

I began looking around in the basement. I've always been resourceful and made do with whatever I've had. I was rooting around in my dad's old workshop in the furnace room when I found a pair of black speakers that he never used. So I opened them up to see what was inside. I discovered that the tweeter was exactly what I was looking for. I found some extra wire and a jack and connected them, then attached those to the tweeter. It was a long shot, but in theory it made sense. I put everything in my pocket to sneak it past Karen and headed back to my room. I popped a tape into my Walkman and plugged in

my contraption. And there it was: the angels were singing to me from some far and distant land, and instantly a small part of the void in me had been filled. That was all I needed for the time being. Music had always been a drug to me, and it felt so good to be reunited. Now I could lie on my side, put my ear to my secret tweeter and keep it nice and low. If either of the parents were to come in, they wouldn't see anything. Things got a little easier.

Next on the agenda was something to take the edge off. I hadn't smoked cigarettes since I was young, since back in the tree fort with my brother. But if I couldn't smoke weed, cigarettes would make a suitable replacement. When my dad wasn't looking, I borrowed a few of his menthols. I smoked one on the way to the retirement home. It was so strange-tasting. The pure mint flavour almost made it seem healthy. The smoke felt nice going in and out and calmed my nerves and gave me a bit of a head rush. I enjoyed the dizziness. It made my walk to work pleasant, and I liked not being high. With the sun shining, I would walk through my old elementary school, past the skating rink where I fought my first fight, smoking my minty smokes. How strange to be here and how far I had come, I thought.

But a deep sense of regret for what I had done was beginning to surface in me. I knew I had hurt and confused my dad and Karen. I was dying to show them I could grow up and grow out of this awful phase of lying and stealing.

Even with music and cigarettes, it seemed like all the bad things were closing in. I could almost hear walls scraping the pavement, drawing nearer every day. The leaves in the distant treetops shook as if a giant was approaching. I was experiencing anxiety. As my world was constrained to a five-block radius, the feeling of claustrophobia was heavy.

And as much as I enjoyed volunteering at the retirement residence, it was hard to be there. It could be a lonely place, and I felt sorry for some of the residents. In retrospect, I am glad that I was made to volunteer for the time I did, because it did teach me something. I had

read *The Stone Angel* in English class, and one theme was the direct connection between old and young, families, their isolation, loneliness and confusion, at least, that's one of the things I took away from it. That book showed me a shadow of what I experienced volunteering at the retirement residence. Recognizing the connection with what I'd read was surreal for me, and it felt like the home was where I was supposed to be at the time. I stuck it out for as long as I could.

What made working there easier was that I had a crush on my supervisor. She was easy on the eyes and very tough. She had a friendly face and walked with a limp. I'm not sure what exactly I liked about that, but I know I liked it. I guess it was that whole idea of balance that I was coming to appreciate in my life. She was different.

But far off in the distance, the walls were coming for me. What transpired next was to be a turning point.

My friend Aron was having a party. At first, I told him I wouldn't be able to make it, but as the date drew closer and the feeling of confinement grew stronger, I began to formulate a plan. I would see out my grounding with my parents, but I couldn't live under the same dark cloud in that house any longer. I needed something different. I needed to show them I was a person capable of living on my own terms and didn't need to depend on anyone.

Youth — full of romantic spirit and naivety, right? It's beautiful and true. I thought long and hard about an escape plan. Just like I did when escaping with Eddie, I was going to make the jump over that deep river to the other side.

The afternoon finally came for me to make my last exit for my shift at the retirement home, and so I packed a few things from my room, light and inconspicuous, only essentials. I didn't need anything, really, just a change of clothes. Terrified and relieved, I said goodbye to my stepmom and stepped out the door. I knew I wouldn't be turning back. Instead of going to do my shift, I went to Aron's house and began hatching a plan. His mom said it would be okay if I stayed there for a week or so. After a beer or two and a few cigarettes, I got enough

courage to make the dreaded phone call. It was getting late, and they soon would be wondering where I was.

I remember exactly what it felt like dialling the number and hearing the ring tone reverberating lonely on the line, the sound of impending doom. Karen answered the phone. My dad soon came on the line, which made it harder as he was rarely unable to shed the disappointed tone from his voice and was exercising tough love with me, for good reason. The words seemed trapped inside of me, but I choked out that I wasn't going to be coming home. The words echoed in the silence. I remember twirling the phone cord around my trembling finger, ravelling then unravelling, repeat.

The only thing I remember from the remainder of the conversation was how my dad's heavy tone turned to hurt. I had never hurt him before on this level, and this is something I have never forgotten. I knew he wasn't going to cry, but he was close. His relationship with Rob had practically dissolved, and they seldom spoke. Kelly never tried to contact any of us. Joe had moved out. Now here was the youngest son, who was supposed to be the good one, choosing the great unknown, surely to be swallowed whole and spit back out. Hanging up the phone was like hanging my heart on a stake. It took a couple of minutes for it all to fully sink in. I could hear the party beginning beyond the door as I sat and listened to my beating chest. *That's it. That's all she wrote. It's just you and me, old sport.*

The moon was sinking behind the houses. It was strangely reassuring to be with my old crew. We drank beer and smoked, and it felt good to be out in the night, with friendly faces, the radio on. It felt good to lock up all the bad things and forget them, even if just momentarily. In the clouds of smoke, I dreamt of art and words while we talked about punk rock and skateboarding. I dreamt of independence.

That night, the music sounded sweet as I stared at the speakers and thought about my dad. I had a lot of time to make it up to him and show him I wasn't a bad person; I just got mixed up and was trying

to find my way through the perils of youth. Little did I know, things were about to get way worse, and I sat, unaware of the dangers that lingered around me, like a rabbit in a trap. On that night, ignorance was beautiful bliss.

ART AND PUNK, REPEAT

I stayed with Aron until I knew my presence wasn't as welcome as it had been in the beginning. I had no plan as of yet, but I was lucky enough to have my artist and musician friend, Voltaire, invite me into his home when he learned of my circumstance.

Voltaire and I had a lot of fun together. He had the whole basement of his parents' home to himself, so there was a good amount of space for the two of us. He and his sister, Vanessa, were so nice to me when I most needed kindness. She would cook big meals for us, and in turn I would try to help with housework. Even though I had no money, I did what I could. She had such a friendly smile, a big, beautiful laugh, and I was always glad to see her. I often think about the generosity the two of them showed me, and how grateful I was to have had such a comfortable place to stay. With them, I caught a glimmer of the things I wanted in life. We were always making things — paintings and drawings, anything creative — and would have nights where other artists came over. We were continually challenging and influencing one another, in more ways than I suspected. We recommended books to one another, and we actually read them. Voltaire introduced me to Henry Miller's *Tropic of Cancer* and his namesake's *Candide*, both of which blew my mind. We used to get high together, and the pot always helped us come up with amusing and often questionable ideas.

At that time, our principal at Thistletown Collegiate Institute was Mrs. Roslin. She was a Mickey Mouse fanatic. Her entire office was packed, floor to ceiling, with Mickey Mouse paraphernalia. So we had decided to make some anti-school stickers depicting Mickey Mouse up against a target board.

Voltaire was a capable illustrator, so he mocked these up easily. The target board Mickey was on mimicked the circular backdrop from *Looney Tunes* and was riddled with bullet holes. Voltaire also drew a version with a burning joint that read simply: "T.C.I. Sucks." Another version featured the school crest, but he replaced the school motto on the banner with "Instilling Submissiveness and Apathy."

I was blown away at how eager he was to be rebellious, and I was definitely on board with this style of shenanigan. I helped him make stickers and cut them up. They were bright yellow and unmistakable on a grey locker. We started handing them out to all our friends at school. It seemed like we had only blinked before they were everywhere. I mean everywhere: on lockers, on doors, binders, in the smoking section. I even saw one on a teacher's desk.

The feeling of rebellion was high, and we were creating on its wave. The art, the hair, the way we dressed, the way we talked and the music we listened to all spoke of how we were throwing off the shackles. A spirit was surging in me, and I let it fill me up. I felt free and alive. We were walking our own path and thinking outside of the box they were trying to force us into.

Voltaire took me to my first local punk show. I had been to see two or three other larger punk shows, but nothing on a smaller level like this. Because he played in Wad, he had many friends in the downtown punk scene. I thought it was so cool that he could just phone up Jon Harvie, the singer of a band called Blundermen, whom we had been listening to at school, and ask if he would put us on the guest list. Jon said sure, and just like that we were off to downtown Toronto. I couldn't have been more excited.

Blundermen were playing at a place called Classic Studios, an infamous punk hangout tucked away in a basement at the end of an alley at Ossington and Queen. Directly across from CAMH, the Centre for Addiction and Mental Health, this intersection was gritty back then. Between the punk rockers and day patients, the wildlife roaming the streets was colourful, as you can imagine. Farther up Ossington, it

became very dark, as if there were no streetlights, though I know this wasn't true. It just appeared ominous, and there wasn't much up there except for the creeping shadows and Vietnamese gangster bars.

I was both excited and nervous as we walked down the alley toward the graffitied door that led down into a basement bar. Inside the club, it was dim, alive and awesome. The walls were painted with bright colours and abstract designs. The room was full of punk rockers — we're talking real downtown punks — standing in the shadows and leaning up against the bar. After another band and a few beers, Blundermen came out, and I knew just by their look, tough yet clean-cut, they were going to be good. Niall Carson played guitar and Pat Laso played bass. There was a real buzz in the place as they were getting ready, and you could tell everyone had come to see them.

Their sound agreed with me as soon as they began. It was like the punk rock I had been exploring. Unlike the first band, who were rough through and through, this band had melody and having heard their music previously, witnessing it live was a great moment. Such an energy emitted from the small stage. It lit me up. Jon, the lead singer, went on to be someone I admired for many, many years to come.

I loved words and it was clear that so did Jon. I think that's what separated this band from all the others. Because the words were so carefully chosen and were backed by such a strong message, it seemed to rein the music in. They were hard, fast and loud, but they had a way of embodying folk music. The juxtaposition was natural, effortless and beautiful.

Jon Harvie is a great songwriter and was a huge inspiration for me in my younger days. There was care and craft in his music. He had something to say, and I really clung to that. Like Galo, Jon may be unaware of the true impact his music had on a mixed-up kid from North Toronto. Sometimes, it's easy to tell yourself nobody is listening when nobody is speaking. Well, I was just too shy to speak then, but for the record, Jon, we were all listening, and your words and passion

meant more than you'll know. Even though this line came from Blastcaps, one of Jon's bands that followed Blundermen, it's always been one of my favourite lines by him.

> *Would you want to die*
> *Not knowing what your life was worth?*
> *With a chip on your shoulder*
> *And somebody else's number on your shirt.*
>
> — JON HARVIE

THERE COMES A DARKNESS

My time with Voltaire helped relieve the unease. We would get really stoned, and in a matter of minutes he'd fall asleep. I loved to play pranks, so when I knew he was snoozing deeply, I'd very carefully stack things on top of him. He slept soundly, which made it quite easy. I once stacked a mountain of things — chairs, books, clothes, whatever I could find — on top of him, and he didn't wake. Strategically, I placed branches he'd collected from the park all around his head, forming a cage. It was amazing. I sat and read, waiting for him to wake up. When he did, his expression was priceless — because he was so groggy, he couldn't figure out what had happened to him. A look of total bewilderment, followed by panic. Then I walked over unable to control my laughter, and he just smiled his sleepy, stoned smile: *Ahhh, you got me again!*

I had been getting into trouble at school with Mrs. Roslin, the Mickey fanatic. She had let a few of our antics slide until she finally suspended me for a few days for skipping too many classes. She was a really nice lady, and knowing my story and that I wasn't at home any longer, she even gave me bus fare so I could continue coming to school. I sometimes feel bad for being involved in making the Mickey Mouse stickers, but I hope she knew we were just kids being mischievous, trying to get a rise, not to hurt her feelings. On the day of the suspension, I headed back to Voltaire's house feeling down about it all. I had zero money, no job, and had just been asked to leave school. The realities of being in grade eleven and living on my own were beginning to show themselves, and they were stone cold.

It was about a half an hour walk to Voltaire's place through rural North Toronto, past the townhouses and strip malls. As I made my

way through the Rexdale Mall parking lot, the same parking lot where Voltaire and I sometimes collected half-smoked cigarettes, dread was pooling in my stomach. I had been staring at the ground because I could have used a smoke. If I saw one that was only half smoked, I would have picked it up. And that's when I saw it. There before me, glowing like a beacon in the sunlight, was not a half-smoked cigarette, not even a full pack of cigarettes, but the biggest bag of marijuana I had ever laid eyes on. Right there, and people were walking all around it, practically stepping right over it. I clamped the bag firmly between my shoes so it wasn't as noticeable. I was positive it must be a trap, so I scanned my surroundings, trying hard to scope out any signs of danger while looking as natural as possible. After making sure the coast was clear, I stood there for a minute, trying to figure out what to do. Then I just quickly picked it up, stuffed it in my pants and kept walking.

I moved as quickly as I could through the mall, bobbing and weaving, trying to get lost in the crowds. With my eyes peeled and my heart racing, I hurried through to the other end. It was almost like when you turn off the basement light and go running up the stairs because it feels like there's a ghost reaching out for you. The baggie made it hard to walk, and it looked like I had elephant balls, but I finally reached Voltaire's house. I couldn't believe, as I closed the door behind me, that I was back, safe and sound. I was sure I hadn't breathed in ten minutes. I stumbled downstairs, where I found Voltaire working on a letter to Benson & Hedges about how he had been very disappointed with a purchase of one of their tobacco products. He was writing that he had been a loyal smoker of their cigarettes for nearly fifteen years, but upon lighting one recently, he found himself very displeased with how stale and unpleasant the product had been. I loved this guy. (Believe it or not, it actually worked: they sent him a whole carton of smokes.)

He could sense my nervous energy. I was flushed and jittering. Then I yanked the giant bag of weed from my pants and dropped it on the desk. It was so big, it made a thud. It took a moment for the

sight to sink in. Then a look came across his face, similar to when he would wake to find himself buried beneath a mountain of chairs and books.

This was to be the greatest and worst thing to happen to me at that time in my life. Now we had money, and quite a bit of it, for that matter. We now could afford all the luxuries in life: pizza, beer, smokes — you know, the finer things that any red-blooded teenager would like. Eyeballing the stash, I divided some of the pot into sellable grams, packaged them up in tinfoil and went back to school the very same day, even though I had just been suspended. I had intentionally made my packages bigger than what you normally buy at school: Business 101. Not only was it a quality product, but I was generous with it. The word spread quickly. We were in the money. But where there is success or good fortune, there also comes a darkness. Balance was everywhere, the scales constantly sliding in favour of one or the other, good or bad, light or dark. What goes up must come down.

The circle that I ran with at school had begun to slowly crack and crumble. We were sliding away from one another. Too many drugs were being taken and, sadly, relationships were breaking under the weight of delusions and paranoia. I hung on to these friends, because at that time I didn't have anyone else and needed the closest thing to what felt normal and comfortable as I could get. But what was once enjoyable had become more and more tense. In the words of CCR, "I see earthquakes and lightning . . ."

The afternoon that it all burned down, I could sense trouble, like when you smell the rain before the wind starts blowing in. The late spring sun came easy, but our smiles were forced and nervous. Straightaway I caught the sideways glances and was deadly aware of the distracted vibes. We talked of going to skate at the underground garage near Voltaire's house. I didn't want to go because something wasn't sitting right, but I reluctantly went anyway. I agreed because I didn't want anybody to know I was feeling nervous, but also deep down I was clinging to the shred of what this crew had once had.

We're all good friends here, right? I thought. *We have each other's backs, right? This is a gang, right? Together we'd fought those kids in their fancy cars when the wheels came screeching into our school parking lot. We'd flung our jackets to the ground and went in swinging like brothers. With a hundred faces shocked and cheering, we'd fought those kids from the other side of town. And when one of them pulled the shank from his jacket, when the crowd gasped and people went scrambling, we stood our ground, grabbed the scruffs of their collars and dragged them to the concrete. We were friends, and we were lost in the haze of youth, and I'm all homeless heartbreak and need a shoulder. I need a blood brother here in this desolation. Where is that brother who should be standing next to me?*

The car door closed, and we were all crammed in there in the heat, the sun shining through the windows. As we began to drive, everyone was silent, and the air was uneasy. When I tried to shoot the shit to break the silence, I stumbled on my words, and they sounded as if they were being spoken through a megaphone. I swallowed hard and was mostly ignored. One of them mustered a half-smile, but it was quickly wiped away. The girl in the front seat had a good heart. She was the shotgun girl with eyes of fire, and she peered at me through the rearview mirror and rarely looked away. So I stared back, and could see why her boyfriend was in love with her. I could tell in that moment that she knew something, she was warning me.

We pulled into the underground lot, and the sun was replaced by shadows, just like the changing of a scene in an old movie. As we drove slowly under the steel gate and over the speed bumps, the small car rose and fell. When we parked, my haste to get out and light a smoke must have been a tell. I turned and concealed the fumbled lighter in my nervous fingers. I tried to exhale long and natural, but was really gasping for life. Some long strides on my board gave me some momentary relief as I slid a nice long curb, smoke dangling from my lips. To take a break from the heavy feeling, I moved out of sight behind a wall and found an island where I cracked off some tricks. But I couldn't hide much longer, so I came back around and ollied up on

the curb near the exit doors. I had been thinking about Eddie and how he would think it would be smart to have an escape route.

(Where was Eddie when I needed him? I missed him. We had lost touch because I had gotten into drugs, and he wouldn't touch the stuff; his engine was clean and revving.)

Just as I tossed my cigarette across the dirty pavement, they all came walking swiftly, the sparking butt disappearing behind their marching shoes. I was surrounded in a semicircle. They were so close and tight, it was like the overhead fluorescent lights in the garage all went out. All I could see were their faces before me, their eyes cold, fierce and locked on me.

They started accusing me of stealing a pellet gun from our friend's room when I was at his house last. I knew the day was going to bring something bad, but I hadn't expected anything that heavy. Their words, unreal and yet so real, like stone, came crashing at my feet. The shot-gun girl turned, biting her thumbnail. I could see she knew the truth and couldn't bear to watch. They claimed I had been alone in his room to get something, and that's when I must have taken it. I couldn't believe what was happening. They said there could be no other way I could have afforded the big bag of weed.

I pleaded and argued that I would have never done something like that to one of my friends, but they had made up their minds and clearly needed someone to frame. Just like that, many of my friends turned on me. If only I could make it out of this eternal summer.

With a skateboard beneath my feet, I shot off like a bullet from the underground garage. Wheels on concrete, dead-end streets. I easily avoided uneven cracks in the walk, where the weeds grew up toward the hot sun. I pushed harder and faster. Past the apartments with laundry folded over balcony railings and flags for curtains. My heart was black, and I felt it beat in unison with the cracks I was crossing on the sidewalk — *ba-boom, ba-boom, ba-boom*. Dialogue ran through my brain, over and over, and there was a fire in my guts. I lit a cigarette

and took slow, heavy drags and began to feel tears streaming down my cheeks. I skated the day away, long, long into the night.

The next day was just as bad. I ran into my old crew again in the school's smoking area, where the confrontation continued. We were all like scared dogs, barking and growling. My plea of innocence was passionate and full of heat, but there was no use. They all walked away together and spit behind them as they went, and any witnesses just stared down at their shoes and flicked their cigarette ashes. I walked away feeling empty and broken. My friend Lukas caught up to me and told me that he sensed the truth in my eyes, that he could see it, that it was real. I knew Lukas and I would be friends for a long time.

Sometime later, after the weed was gone and money was scarce again, this kid Lukas showed me a kindness I had never seen before. I showed up at his house after my only meal had been a stale bag of chips from a dumpster. He read the embarrassment on my face and didn't even ask, just went ahead and made me some soup and toast. The morning had brought the rain, and I was hot, my clothes damp. My stomach was empty and knotted, but the soup and bread saved me. He was a friend who believed me, a friend who filled me up when I needed fuel, even though his family had little money, and this was clear. He was a friend who took me in, and we played guitar and wrote our first terrible song in a Jamestown townhouse where we listened to the Ramones until the sun went down. That radio sounded so good, blasting all of those fuzzed-out guitars and raspy words in his little bedroom. He helped me forget all the bad things. We would share a cigarette and watch it burn like a little red castle as the sun came through the window.

YOUTH SHELTER

My crew had turned on me, and I had overstayed my welcome with Voltaire. I was out of options. I had to get away from North Toronto. The feeling that my dad was never going to trust me again was also weighing heavily on me. My dad may have preferred that I come home, but I needed to show him that I could stand on my own two feet. It wasn't going to be easy and I felt desperate. After a long deliberation, my dad, Karen and I decided that a youth shelter would be the best option. Because my brother had spent so much time in them, my parents knew how to make it happen quickly. I ended up in a shelter at Broadview and Danforth called Clifton House, where Joe had also done a stint. It was located right beside the giant park that runs down along Broadview Avenue. It was named after the amazing view that it offered of downtown Toronto from an East End perspective.

I moved a few of my things in. I had my posters, books and tapes. Once I was settled, it began to feel good to be in a safe place where I knew I was going to have a bed to sleep in and be fed on a regular basis. The prospect of getting a job also filled me with hope.

I met some good kids in Clifton House, one of them being this kid Alazar. We clicked immediately. He was cool and had a genuine smile. We shared a sense of humour and would crack each other up. His laugh was infectious, and he made that whole transition easier.

I was still going to school and doing the best I could in my classes. Soon things began to level out. The staff at the shelter were so caring. When Christmas rolled around and snow blew in from across the park, they gave me a garbage bag full of plaid shirts. There must have been twenty-five shirts in there from Buy the Pound. It was amazing.

(Anybody who knows me knows that the key to my heart is plaid.) They also gave me a vintage, cast-iron typewriter, which surprisingly worked. It was a bit of a slug and not the best for typing, but the fact that they knew I was interested in writing and tried to encourage me meant a lot. I still think about their generosity and patience with me, and I try to pay it forward.

I stayed at the youth shelter for about a year and made enough money to afford basic necessities. I was in some photo shoots where they needed "hard"-looking kids for ads that went into transit shelters, which made me a little money. A lot of the kids at Clifton House were way worse off than me, though. My dad had to leave my mom, and my mother's estrangement messed up my head, but my family situation paled in comparison to some of theirs. They came from really broken places, where both parents weren't functional at all, or even around.

When the bad blood had begun to subside, a few of the old friends who had turned on me came to visit me at the shelter. I tried not to hold a grudge, but I just couldn't forget what they'd believed about me. I know I wasn't the person they thought I was. When times were toughest, I'll admit, I lifted change and fivers from a few people, but only for food and bus fare. I intended to pay everyone back. But they had accused me of stealing that pellet gun, which was a wound that didn't heal in me for a long time.

I had begun to make a lot of friends in my new home, like this kid named Dennis, who lived a floor below me and is someone I still talk to today. The first time we talked was when I heard some good music coming from directly below me and went down to investigate. He was standing in his room. He looked like a man already, and was three times my size, although friendly. I asked what he was listening to, and he told me it was Nirvana. I was surprised because everything I had heard by them so far I hadn't liked. This was an earlier album, a little rougher, with a punk influence. I had no idea that I was going to befriend this large Croatian, but I did.

THE SQUAT

Eventually Dennis moved out and managed to get an apartment, if that's what you would call it. It was located one block away from the shelter, just north of Danforth and directly across from the subway station. When my term was up at the shelter, I didn't have anywhere to stay, and I asked Dennis if it would be all right if I stayed with him. The deal was I didn't have to pay anything, I just had to get him high — a lot. I thought I could manage that rent, so I took him up on the offer.

Dennis's apartment was barely fit to be a squat. There was a hole in the living room wall so large and round it looked like the Kool-Aid Man had crashed right through from the kitchen — only in this case his big, round jug body would be filled with methamphetamine. Through the broken drywall you could see a series of exposed pipes and, beyond that, clapboard. It was scary as all hell. It was a bachelor apartment, so there was a living room, a bathroom and a small space to put a bed beside the kitchen. And when I say beside the kitchen, I mean when you walked out of the kitchen you were basically in Dennis's bed.

The kitchen was a horror show. A strong electric charge ran through the sink, so if you touched it at the same time as any water on the counter, you would get a shock that would rattle your bones like a maraca. The landlord wasn't going to do anything about it. So needless to say, if we had any dishes to speak of, they were never washed. Instead of cooking, Dennis ordered from Pizza Pizza every single day. They knew him by name. It's a wonder he survived without getting scurvy. His complexion may have turned grey, although it would have been hard to tell, because of how dim the lighting was.

I don't remember, but knowing the dangers of the kitchen sink, I doubt I ever risked my life to take a shower there. If I did, maybe I was electrocuted so badly the memory has been fried permanently. The apartment was dire, but we were just relieved to have a roof over our heads, free from curfews and authority, so we made the best of it and had fun, most of the time.

I was still going to school somehow. Making it to class made me feel like I had accomplished something in my day. There was a rocker in my one of my classes who I got along with. He had long blond hair and was perpetually high. We were into heavy metal and both loved marijuana. He and his dad grew a seven-foot weed plant in their living room. He told me they used to decorate it around the holiday season, and that cracked me up. I can only hope that holiday tradition is still alive; the thought warms my heart. The homegrown weed was really weak, but if you smoked enough, you'd catch a buzz. So we used to be pretty liberal when spinning one up. He would sell me shopping bags of it for really cheap. So that kept my rent paid for quite a while.

I didn't have much communication with my dad during this period. I didn't get to see my brothers much at this time, either — Joe once in a while, Rob almost never. He had been playing in bands for years, and I heard he'd become a tattoo artist. I missed them both.

Most of my days were spent trying to go to school, skating, getting stoned and finding ways to feed myself. I somehow stayed alive on coffee, donuts and cigarettes, just as Dennis did with his pizza. I was so skinny that when I turned sideways, you could barely see me. Nights at Dennis's were spent in grim light, smoking cheap weed. On a good night, we would have some Johnnie Walker. We would listen to punk, CCR and Simon and Garfunkel. When Dennis got misty-eyed, he'd put on Tracy Chapman. I liked Dennis in that sense: he had, when he wasn't listening to awful things like Green Jellÿ, good taste in music.

He could be trying, though. He would sit with his index finger along the side of his eye as if propping up his eyebrow so it wouldn't

fall off. He would look at you sideways, like he was suspicious of every-thing you said. His mouth hung slightly agape when he was thinking. Once, in mid-conversation, he asked, "Do you like this shirt?" He was wearing a bright yellow T-shirt with a small logo in the centre.

"What do you mean?" I replied, already bored of the conversation.

"I mean, do you like this shirt?" he said again, this time in a tone that suggested the question wasn't anything out of the ordinary, just a couple of slobs talking about shirts. A moment of silence passed between us. Most people would have just ignored him. I didn't.

"I don't know, Dennis."

"Well, do you like it or not?"

"What does it matter if I like it or not?"

"I just want to know."

"It's too bright for me, but if you like it, then that's all that matters." There was silence while he looked down at it.

"You think it's bright?"

"Like the sun."

"So you wouldn't wear it?"

"Maybe if I was out of clean clothes," I replied, lighting the roach I was holding.

"You *are* out of clean clothes, you fucker," he said, his voice rising an octave.

"Well, I wouldn't wear yours specifically, because look at the size of you, and look at the size of me."

His eyes twinkled before he began to laugh. He liked when you told him how big he was; it made him feel like the big dog. Passing the joint to him provided a distraction. Like turning the channel. He was insecure and needed reassurance, but I think we all were then. When I was in a good mood, I gave him what he craved. When I wasn't, I would sometimes raise my voice at him.

Dennis had a dark side and some turbulence going on within. Every now and then his eyes would let you know, but we never talked too much about those things. Neither of us wanted to.

I was just coasting from day to day, trying to figure things out. But as hard as I tried, I never did, and things were feeling desperate. The East End was a lonely, foreign place. Still, I was amused at how alive and clashing it was: a different beast than the west. This animal had a different odour and was a little wilder, its claws longer, its fur pricklier and its eyes gleamed brighter.

I used to skate beside the big ravine that ran along the Don River. I'd sometimes go to the parking garage on top of the nearby Loblaws and sit on the highest spot I could find to stare out at the cityscape. Even though things were uneasy and unsettling, I lived on a small reserve of hope; I always have. I liked to believe things would all come around and even themselves out. It seemed like a nice dream, anyway.

On the way to the parking garage, on the west side of Danforth, down a discreet alley, there was a recording studio. It may still be there today. I sometimes wonder if anyone ever saw me standing at the top of that alley with my skateboard in my hand. I would stare down and think how amazing it would be to do something as cool as record music in an alley studio for a living.

Those long evenings on top of the garage, watching a giant sun fall over the Don River, I felt at peace. I would watch the skyscrapers twinkle like crystals in the dusk. I would watch the clouds drift in off the lake and disappear behind the buildings and think about stories I wanted to write and hum melodies of the songs I was going to sing when I got better at guitar. It all helped calm my spirit down.

Though I tried to remain positive, the weight of everything began to creep up on me. In a desperate attempt to capture some of what once was, I started going back to my old 'hood in North Toronto. I would visit with the friends who had cast me out. The clouds had somewhat cleared, and I was hopeful things would be different, that maybe they'd realized that I wasn't the one who had stolen the gun. But the old days were done, replaced by cautious eyes and shaky hands. My nerves were shot, and I had begun to tremble so badly I could hardly take a drag from my cigarette. I was wracked with anxiety, and it was unbearable.

SKATE OR DIE

I soon came to understand that the relationships with my old crew were broken beyond repair, and it was surreal to be with them again. The panic was reminiscent of seeing Nora the dog come out from nowhere. I felt as if I was waiting to be cornered again — it was just a matter of when. Pretending everything was cool took a toll. I was feeling disconnected from them, though I longed for everything to be as it was. *Everything dies, baby, that's a fact.*

The final night I spent with them was painful. We all did too many drugs, and everything that was happening in my life collided in my mind. I was distraught. I couldn't hang in the circle around the coffee table, so I sat back in the bed up against the wall. The shotgun girl sat with me and tried to get me to tell her what was wrong, but I could barely speak. I didn't need to say much; she already knew. Everyone knew I was upset, and why, and all but her stayed on the couch, laughing and ignoring me. Finally, I couldn't bear it any longer and left. I found my way to the bus and took the long ride from Finch to Bloor. The 37 South had carried me in this direction so many times, and I was grateful to have something from my past that wasn't completely destroyed. I was lost in thought under the warm blue lights. When we finally reached Bloor, I transferred to the subway and headed back east, over the Don to Broadview, the subway train swaying and lulling the rogues and lost ones across the deep downtown ravine at night.

When I reached Dennis's apartment, my fears had been realized. The apartment had been turned into a full-out squat. Dennis had decided to have a party, which was surprising because he just didn't do that. There were strangers strewn across the floor. Everybody was half in the bag. The only illumination was the thin blue light of night

peaking in through the window. I lay down on the floor nearest to the door, lit a smoke and tried not to think about how uncomfortable I felt.

Across the way, the giant hole in the wall stared at me relentlessly, like a gaping eye that never blinked, its lashes ragged and its pupil dark and bottomless. Gathered at the base of the eye, across the floor, lay all of the wasted bodies. One of them was still half-alive, and moaned low. Bottles and ashtrays were everywhere. The walls seemed to be breathing heavily. A dark depression slowly unfolded its wing around me. I missed everyone: I missed my mom, my brothers, my dad, my friends. I lay back on the hardwood floor and used my shirt for a pillow, staring at the ceiling for what seemed like forever.

I was having visions of a giant scorpion attached to the ceiling above me. Its shell was transparent, and you could faintly see its insides were a mixture of gears and organs, working together, pumping, turning, pulsating to make the machine work. Its mechanical movements were limited, one leg forward, one leg back, tapping and scraping the plaster from the ceiling. Crumbs landed on the hardwood beside me. I watched while the rest of the room faded to black. Soon, it was just me and the scorpion, it's stinger bobbing and sparking. With an overwhelming feeling of dread in the room, voices from the last year swirled in my head, shouts about the stolen pellet gun, my dad's voice on the phone, sad and angry. My stomach ached for tea and fuel.

I picked up my crumpled plaid shirt from the floor and grabbed my skateboard. I quietly opened the door. The hall light spilled in, revealing the bodies cast about the room, the one still rolling and moaning. I could see that the hole in the wall wasn't a giant eyeball, just a massive ugly opening with its exposed pipes rattling and sweating. Open season for the roaches. If this were my place, I would at least hang a goddamn flag over it. Why was there not even a fucking picture on the wall, or a plant? I hated this place. I quietly closed the creaking door, shutting the strangers, the broken wall, the scorpion and the electrified sink in together. Good riddance.

Let me out of this building, into the breeze that swells up from the valley, where I can feel alive. I need to breathe, and I need to skate.

I threw my board down on the pavement, jumped on it rolling and was comforted instantly. I knew that if I was going to get through this night, I was going to have to keep moving. Across the Bloor Viaduct I headed. The East End just wasn't for me right now. As I made my way across, I couldn't stop thinking about how I would have to return to that apartment, and couldn't bear the thought. It terrified me because I had no other place to go. There came waves of hurt and sadness. I was nearly out of cigarettes to keep me warm and had no money for tea.

I made it to about the middle of the bridge and stopped. I leaned over the hefty ledge and stared down where the chasm of the Don Valley stretched dark and peaceful below. *Here we are, ol' friend, up on Suicide Bridge, just like many before me, and many more to come.* I propped my board up, hopped onto the block ledge and dangled my legs over the other side. I sat there a while, staring out into the deep night, listening to the cars behind me, rubber tires whizzing over the creases in the pavement. With it came the occasional honk from a car, either trying to reassure me — "You're going to be all right, kid!" — or saying, "Come on, then. Get on with it already!"

For quite a while I couldn't seem to untangle my thoughts. Everything was mixed up and broken. I thought about how much I missed my family and about all the things that had led me to this moment. The giant city was growling behind me. I sat in that strychnine dream, choking on the acrid taste of my empty belly and slipping grades. Hearts of fire, hurt, punk rock and LSD. This massive dark cavern below beckoning to me with its brooding voice. *Let's sleep together and end the pain. Spread your arms, Jump the old river with Eddie, only this time, go down into the deep, let the water wash away the damage beneath its blanket.* All would be still. The final half cigarette was lit and savoured down to the sharp burn of the filter. It slid out of my finger

and tumbled like a little flare into the dark, and I watched until its little blinking light was gone and there was only darkness once again.

Should I stay or should I go? I was calling on you, Mr. Strummer, and I needed an answer. I kept my head down until I could hear the distant chirping of birds. That told me it was 4 a.m. After a long period of consideration, I finally decided that maybe I didn't want to flicker out in the dark like that cigarette, go quietly into the night without anyone knowing. Maybe I wanted to keep on burning, maybe I wanted to keep skating and maybe I wanted to keep smiling. Maybe one day I would have a window of my own, with a desk and a typewriter where I could say all the things that needed to be said. Maybe I would play in a cool band. Maybe I would land a job and be able to pay my way and fill my own fridge. Maybe things would get right with my family, just maybe. *Maybe.* That was a good word. I liked it. It had a good ring to it.

I dragged my thin legs back over, had a look around and assessed my situation. Downtown Toronto stood off in the distance, looming. What was I going to do? Where was I going to go? The East End wasn't cutting it, and clearly the west wasn't on my side, so I'd have to find a middle ground. I pushed off and ran my fingers along the viaduct ledge, heading for Trinity Square to try to get backside heelflips off that four-stair down before dawn. I would take everything else from there. I needed the sun, but I was going to have to wait. Kill some time, instead of myself. I skated all night and into the next day and had backside heelflips locked in before I returned to Dennis's. Skate or die.

EASTBOUND AND DOWN

Two of the people who stayed at Dennis's place that night stayed for good and commandeered his bed. Seriously. They never left. Their names were Will and Brandy. Brandy: large, round, queen of the world. Will: moustache, skinny, agreeable servant. Dennis's squat got too small for all of us, thank God, so they moved out to Scarborough, and seeing as I had no place else to go, I tagged along.

The Scarborough place was a definite step up. The amount of space seemed luxurious, and you didn't get electrocuted in the kitchen. The basement apartment was a half-hour walk to the Bluffs, an escarpment running through Scarborough along the edge of Lake Ontario, its highest peak upwards of 300 feet.

The apartment was big enough to house more than a few people, so my brother Joe moved in, as well as Brandy's brother Cecil, the serial killer. No joke, Cecil was scary, with his scraggly, black, Manson-like hair, blank stare and army coat. I'm not sure how he walked around in daylight without getting continuously picked up by the police. I took one look at him and assumed there was a sawed-off shotgun under his jacket. All in all, things felt better moving out there, being a little closer to nature and having Joe near again.

We spent a lot of time at the Bluffs. Being nature boys at heart, the two of us saw it as a giant playground. The view is amazing from there. It's one of Toronto's best-kept secrets. Joe and I would horse around, rolling big stones down and climbing among the trees and sand. We carved thrones into the clifftop and would sit up there like lords. We would smoke and drink beer with the sun in our eyes and the lake before us as far as we could see. Things were easier when Joe was around. He always made it feel like things were going to be okay.

We sat in our seats at the top of the Bluffs, hundreds of feet above the water. The great blue lake shimmered below. Relief washed over me. I felt as calm as the sky before me. I had been thinking about the previous weeks, the events that had led me here. I thought about the night on the bridge. Not so long ago I had been staring down at my demise. I wouldn't forget the taste of LSD and cigarettes on an empty stomach. I had been lonely, but that day at the Bluffs, I wasn't. I had my big brother with me and the big sun. That was all I needed at that moment.

Joe was the only one in the house with a job. The days were long for me. I would travel across the city to school, mainly to cure the boredom. When I wasn't going to school, I would walk the East End streets for miles. I was looking for something, anything: cigarettes, a ten-dollar bill blowing in the wind, a new skate spot. I was always hungry.

One night, I saw an oasis in the hazy streetlights. I'd found an empty pool between three apartment buildings. It was paradise in a moonlit desert. I would skate it until people threw pop cans at me from their balconies. I drank one that hadn't exploded and loudly thanked the person who threw it.

I wasn't a great ramp or pool skater, but I kept at it, dodging missiles in the night. It was something to look forward to. Each night, I'd slip out of the Scarborough house and greet the moon and wander. I kept my head down, stayed in the shadows. Make art, skate, get high, repeat. In the meantime, I stayed as close to Joe as possible.

Because we were living in the East End where Rob was working, we began to connect with him again. For me, hope was on the horizon, having this filial closeness reinstated in my life. I could sense a turning point around the corner. A shift was coming.

PART THREE
A New World

FIRST BLOOD

Ever since I heard Rob had become a tattoo artist, I had been curious. It called to me. I had been to the shop a few times to visit him and had been impressed by the watercolour images he had been painting: abstract, cubist shapes; thorns; heavily sculpted lines with bright colours. Again, Rob was showing me something I'd never seen before, and it made me feel so inspired. I began to realize that, for me, inspiration was like a mild panic, an urgency. That feeling hit whenever I was in his presence.

I wanted a tattoo. After some deliberation, I decided to get something that represented Pisces. It made sense to me simply because I loved fish and nature. I wanted the design to be edgy, of course, so I drew up a fish head that looked a bit like a piranha with long, spiky teeth and a jagged fin coming off the top of its head. I tried to give it the feeling of some of the skateboard graphics I had been so influenced by, as if it were a sticker you'd buy from a skate shop.

The entire process captivated me unlike anything I had been through before. It was a collaborative experience that had an immeasurable impact on me, a memory I hold dear. I got great gratification knowing my brother thought my art was rendered well enough to become a tattoo.

Once I felt like the drawing was as good as I could get it, Rob took it to fine-tune. He made it a strong tattoo.

When the night finally came, I was filled with nervous excitement. I watched Rob closely as he prepared all the instruments — from the way he checked the needle through a loupe to how he carefully inserted it through the tube and prepared the machine. He was like a surgeon or a dentist. I was impressed at how clean and professional

the equipment seemed. Everything was methodically placed, and caps were filled with bright pigment. He prepped the area on my arm with antiseptic and positioned the stencil on me. Anyone who has gotten a tattoo knows that peeling off a well-applied stencil is one of the most satisfying feelings. I checked it out in the mirror. I was like a kid on Christmas morning.

I decided to put the tattoo on my forearm so I could watch the whole procedure. When he started, I couldn't believe how little it hurt. This was probably because the forearm is one of the easier spots to get tattooed — that and the fact that I had been waiting for that moment for quite some time. I watched how precise my brother was when applying the tattoo. I knew he was trying to set an example and show me how careful you must be during the procedure. Just like when I was a little boy at the kitchen table, watching my dad draw cars, I was filled with anticipation and warmth. Here were two brothers who loved art, lost in the moment. It was very special to have Rob gift this strange and beautiful thing to me, this thing that is often difficult to explain to those who don't understand. To place your trust in someone is an enlightening experience, and it calmed me. We were in the shop after hours, after everyone else had retired for the day, a dim light washing over us, Polynesian masks casting shadows along the walls. Two brothers having fun and smiling, making something that would last, that couldn't be washed away or swept under the rug. There was a pure closeness, and the memory means the world to me.

That night I was shown something powerful, and as far and wide as my mind would sometimes wander, this would be the memory that kept tugging at my sleeve.

Rob and I have gone long stretches without seeing each other. He's never been one for family occasions or holidays. He keeps to himself.

It's Mother's Day, and I am roughly thirty-five. I'm on my way to pick up some spring rolls from the Thai restaurant at the top of the road.

Mother's Day is always a little hard. I try not to think about what the day means, but I am aware that I am trying not to think about it. The leaves on the trees are blooming, and it's warm out. It feels like summer is around the corner. I walk through an elementary school's yard, and it reminds me of the school I went to when I was young. My phone rings. It's Rob. I pick it up and say hello. It's like he's already mid-conversation with me. It's early, but he's already had a few. This is nothing new; we've had plenty of drunken telephone conversations. But something is different about this one. I have never heard him sound quite like this. He's sad. After a while, I ask him if he's okay.

"I'm okay, brotha," he says. He pauses for a while, which he almost never does. Whenever he does, the silence is usually followed by the laughter of a madman. But there is no laughter.

"Just needed to hear a familiar voice, ya know?"

"Of course, man. What's going on?" But I already know.

"Just miss her."

"I know, man. Me, too."

If he's not crying, he's on the verge. I can tell he's hurting bad today. It hurts me to hear it. I sit down with my back against the wall and look out at the soccer field. Even though we don't say much, our thoughts are one. The silence isn't uncomfortable. It's a quiet that tells me that even though we don't have the same father, he is my brother. The conversation is an S.O.S., one person reaching out through the wires.

Since I moved to Toronto, there has been a feeling that I shouldn't speak about my mom. So when conversations like this happen, it's like I am home. Like I've walked through the door, and there's a fire going. Sometimes I feel so lost. But I'm not alone. Someone else, in a sea of people, understands what I've been feeling. When I realize this, a wave of relief washes over me. The conversation with Rob doesn't last long, but I can tell that we both feel a little better. Sometimes that's as good as gold.

THE SEED

The shop Rob worked in was called Lower East Side, located in a strip mall on Kingston Road. At the time, it was a heavyweight establishment, considered one of the leading tattoo shops in the city. The name in yellow and orange against black reminded me of a magazine spread I'd seen as a youth about the movie *The California Kid*, where Martin Sheen plays an amazing outlaw who drives a black hot rod with orange and yellow flames across the doors.

I was shy, and that place could be intimidating. That shop was different than a lot of the ones you find today. Those guys embodied the early vision of tattooists: long hair, denim, motorcycles, bike gangs. Over many years, the appearance and attitude of tattooists began to change as they struggled to be accepted. It's amusing to see how things come full circle. Now, upon finally being ushered into mainstream culture, the younger generations are trying to capture some of the rebel spirit that seems to have slipped away. Many tattooists in my city may look the part of the outlaw biker, but those rough-and-tumble fellas from yesterday were actual outlaws. So, until someone sells custom shanks out of their shop like Lower East Side used to do, then we'll just say they're another dude on a motorcycle.

Bruce was one of the co-owners, and he had a very gentle demeanour. He always smiled and tried to talk to me when I came to visit, and he was filled with honest, good vibes. Bruce was a great painter, too, and I loved that he was so skilled outside of tattooing, just like my brother. I once went down into the basement of the shop and saw many large-scale paintings that he'd made, some leaning in stacks, some hanging on the wall above.

One I remember in particular was a huge nature scene. I remember the colours: purple, deep reds, burgundy and yellow. It had elements of nature against an abstract, washed-out background. It looked like something that could have been hanging in any art gallery, part of a Group of Seven collection. I am not sure how long I stood in front of that painting, with only the light from the room down the hall pouring into the dark basement, but it was quite a while.

The rest of the guys were always pleasant and amusing and seemed like they had a fun time doing what they did: listening to cool music, creating art and making everyone who came through the door happy, or so it seemed.

Rob had designed a shirt for the shop. The thought of working in a place where you might be asked to design the shop shirt was exciting, and a thread connected that vision to my early ideas of skateboarding. Wearing the shirt was reminiscent of sponsored skateboarders riding for their team. For a kid who grew up drawing all the time, the tattoo shop was one of the most inspirational places I had ever been. A whole section of the studio offered tattoo suggestions, known as flash: pre-drawn designs ready to go for the eager customer. I used to pore over them, studying them intently. They hung on the wall with the same stunning visual impact of the first skate shop I'd walked into, with my heroes' boards all on display.

For me, the seed of tattooing had been planted, and it was pushing up through the dirt, catching its first rays of sun.

EAST END MORNINGS

Though I was still managing to get to school in North Toronto, the gruelling two-hour commute began to wear on me. I talked to the principal, and I was able to transfer to a high school at Broadview and Gerrard. Just like that, I said goodbye to Thistletown. Eastdale was more focused on the arts, and I was happier there.

I immediately made friends in art class. For the first time, a stranger came to me and told me that she liked my art and wanted to commission me to paint her leather jacket. I didn't even know what "commission" meant at the time, but agreed nonetheless and was surprised to learn that she would pay me.

There were lots of skaters in the school, but they were different than the skaters I had known. They were similar to the jocks and pretty rough around the edges. Not that I was the pillar of refinement, but they were too loud for me. They laughed at everything but had no real sense of humour.

I made friends with the other artists and punks and was beginning to feel pretty good. I felt like maybe I was slowly mending. The skin was still sensitive, but the stitches had been taken out, and I wasn't bleeding any longer.

I really enjoyed that part of town in the morning, listening to it come to life. Eastdale was in the heart of Chinatown East, where Asian markets lined the streets with big baskets of fruits and vegetables that would spill out over the sidewalks. I would walk along to the sounds of the storefront gates opening and water splashing across the sidewalk, watching the morning hustle and bustle and preparation, waiting for class to start. It was vibrant and gritty, and I felt at home there. I loved being near Riverdale Park, seeing the city across

the way. It made me feel like I was in a new town, making a fresh start. My old haunt just lay across the river, watching over me like a big brother, reassuring me that I could come back across the bridge anytime. I would often spend time at a beautiful library on the corner of Gerrard and Broadview. And when I was in need of cheap coffee, there was only one logical solution in that neighbourhood: the infamous Galaxy Donut.

At that time, the order of the food chain was Tim Hortons, the undisputed king, followed by Coffee Time. Then there was the lesser-known dark horse — my personal favourite, Tea Time. Their croissants were superior to those of their competitors. Sprinkled on the outskirts of the city was the Yankee outfit Dunkin' Donuts. And finally, gripping the bottom rung, though easily possessing the most charm, the revered home of every man without a home, hotel to every drugged-up punk waiting for the sun to rise, the mystical yet underrated home of the two-day-old sugar twist, the iconic and chronically grubby Galaxy Donut.

Inside, sunlight washed the worn tiles. It was a hot morning in Chinatown East, and the pickings were slim. A damp fritter had to suffice. Some lucky duck had got the French cruller. I sipped my coffee, which tasted like shit. I usually got tea and was regretting my decision. The cigarettes tasted better. A skinny, tired woman worked behind the counter and was sweating beneath the useless ceiling fan. I watched two flies on the wall. The entire interior was stained yellow. Clearly, a million smokes had been lit inside those walls. But it was a good life for the time being: warmth, sugar, smokes and coffee. Survival at its finest.

LIKE A ROACH IN A TUB

Although Joe and I were going to miss the Bluffs, we soon came to a juncture where departure from the wild, wild east seemed necessary. So Dennis, Joe and I packed up our garbage and split. Will and Brandy, I'm sure, are still lying in bed, a sea of empty lube packets strewn across their stained, sheetless mattress, with crazy Cecil, high as shit, on the sofa, eyes blank, mumbling quietly.

We found a single room at Dundas and Dufferin in the West End. It was in a rooming house one block south of Dundas, directly on the corner. I remember the day we moved our things in and walked by the landlord's unit at the front of the building. He was a large, round, one-armed Serb named Sasha. As we walked by his open door, we saw a man holding the refrigerator tipped back against his chest while Sasha vacuumed cockroaches from the coils. That's how many roaches were on the back of this thing. Sasha looked up at us through his thick, sweaty glasses as if it was no big deal. I didn't feel anything besides pure shock. I wasn't even grossed out, just shocked. I had never seen that many bugs in one spot.

With the three of us all packed in one room, it was tight, and in a weird way I felt like we were the roaches on the back of Sasha's refrigerator about to get vacuumed up. I kept thinking how a giant whirring vacuum nozzle would slam through the door and suck us up into oblivion. But as crowded as we were, we somehow made the rooming house work. We had no choice, really. Joe still had a job, but no money to spare, just enough to keep us alive. I felt thankful. I was on social assistance at this point, so I had just enough money to buy the bare minimum of groceries. I tried to do my part by keeping the place tidy, and I would do the majority of the cooking — when there

was food. Lukas, the friend who'd helped me out when I was hungry, moved into a room upstairs. A guy named Henry started hanging out with us, too. Together we were all poor punks. It was fun when it wasn't hard.

There were days near the end of the month, before we got paid, when we realized how hungry we were. Survival was a real thing. One afternoon, our empty bellies couldn't hack it. Each floor had a shared fridge, and that day, one of us snuck upstairs to see what was in the other floor's fridge. One pack of bacon, that was it. We were hoping there would be more so we might be able to take some food without the owner noticing. We took the bacon and fried it. We ate like wild dogs.

I remember walking up to Tulip Donut, at the northeast corner of Dufferin and Dundas, where they used to sell single cigarettes for a quarter. I would walk in with twenty-five pennies and hand them to the lady.

We would go to punk shows down at Classic Studios and party until sun-up in our little rooms. I started playing in a punk band called Spanky with two friends, John and Jason. The punk community didn't like us very much because we were so different, and I loved that. I believed in those songs, and to be able to play in a band was healing for me, even though I was sedated most of the time. Jason was a charismatic songwriter and John has a beautiful heart, and unfortunately for them, I was the worst drummer on the planet because I'd only just learned. All the punk rockers would hang out at a local bar called Bistro 422 at College and Bathurst, and one night, I walked up the stairs to the back and saw spray-painted on the wall above the stairs, "Wanky Spanky, cut your hair and get some pants that fit you." It was pretty amazing.

It was in the little room on Dufferin that I began to find inspiration. I had a lot of time on my hands, so I started working on my art. I was rendering larger illustrations, practising cross-hatching

and stippling, my brother Rob's stippled dragon always in the back of my mind.

Around this time, I met a punk girl named Angie. She had a Chelsea cut, a few freckles and a cute little nose. She had been dating a guy who played in my friend Cactus's band, The Rejected. It wasn't working out with him and she needed a place to crash, so Dennis invited her back to our room. She wasn't interested in me at first, because I dressed more like a skater than a punk, but then something clicked, and we started hanging out. She was younger and shy and apologized for everything. She loved McDonald's and old ska. When she finally got a few bucks one day, the first thing she did was treat me to her favourite restaurant. To this day, I don't think I've ever seen someone as happy as she was when eating a Big Mac with fries. It gave me a glimpse of what my expression must have been like when I ate McNuggets for the very first time.

Angie was cooler than me. She had great taste in music and dressed way better than I did. I fell for her shaved head and weird sense of humour. She was sweet and genuine. It felt good having a girl sleep over who didn't leave come morning. In fact, she hardly ever left. I didn't mind in the slightest. Joe moved to Mississauga, leaving me, Dennis and Angie. I don't blame him, it was far too crowded in there for everyone. Things stayed relatively the same for some time. We spent the days scraping up money for food and smokes, and occasionally beer. Angie would roll her eyes at our awful taste in music.

Angie had been avoiding going home but had started talking with her family again. They urged her to come back full-time. She decided to give it a shot and see if things could be repaired. It was a good decision. I had next to no money and neither did she.

I used to spend time alone skateboarding at night and walking smoking and daydreaming. Anything to not spend the night with Dennis. I loved him but I needed space. Often, I would go down to the railroad tracks, where the green steel bridge crossed over Dufferin and Queen. I'd sit in the tall grass with the honking and yelling of Queen

Street below, crack a beer, smoke cigarettes and wait for the passing trains to roll by like steel ghosts. I'd walk through Little Portugal, down and around the side streets, and look into people's windows and see them lit up nicely with warm lamplight. When the wind was blowing, you could smell chocolate from the two factories close by. I'd walk by the lofts across from the park and think of how amazing it would be to one day have one of my own. *Ah, maybe in another lifetime, bud. You can barely afford a case of Arctic Wolf and a pack of darts at the moment, let alone your own loft.* I'd skate on and dream about it anyway, howling at the moon.

Soon, Dennis moved out, once another room became available in the house. I was relieved. I felt lighter being alone.

If only my place hadn't been infested with roaches. I once felt one crawling on me in the middle of the night. I snapped awake, cold, snatched it from my leg and threw the bug into the pitch. I heard it click off the wall.

One night it became too intense to bear. I used to go to bed and listen to records in the dark. My stereo receiver was directly beside the bed, and the dial across the front would light up seafoam green when the power was on, which made a nice, soft glow when the lights were out. Anyone who has spent some time with roaches knows they are attracted to electronics as well as heat, hence the gathering on the back of Sasha's fridge. That night, I watched them inside my stereo, skittling across the dial — tiny little silhouettes scurrying across the green light. Every so often you would hear a pop when one of them crawled across the wrong component. I panicked, turned on the lights, unscrewed the case on the amp, carried the chassis into the washroom and shook it vigorously over the bathtub. There were probably a hundred roaches, and two or three different species. I stared at them scattering across the bright white tub. My heart sank. Black on white, check. My crawling skin, check. They scrambled for darkness. Some images are like photographs stored forever in my psyche. Unfortunately, this is one of them.

I felt like I was sinking. The life I wanted was far away — too far away. I was one of those roaches, running from the light. I was always looking for a shadow, wedged in my crevice, scared and brittle. Looking back on it now, I see I was also resilient like them. I just wasn't aware of it.

NO FEET TO PLANT

I thought I should try to make the place feel more like home, add something pleasant to try and offset the filthy night of roaches. During that first week of my new bachelor-pad life, I was walking home late, past Dufferin Mall, intoxicated and inspired. Outside the mall was a large garden centre, and in my loose state I decided that what my place was missing was a plant or two. There's nothing better than a couple of nice plants to pull a room together. I can't imagine most eighteen-year-olds having this sort of reasoning, but I was cut from a different cloth. So I seized the moment. *Carpe diem — carpe plant.* I looked around, made sure nobody was walking through the parking lot and waited for a break in traffic. At this time of night, it was as quiet as Dufferin Street was going to get.

I was agile and bounded over the chain-link fence with ease. After surveying my options, I found some plants I liked and tossed them as quietly as I could over the fence into the parking lot. It didn't seem like anyone was around, so I went back to have a more thorough look. I found a larger tropical plant, climbed up a pile of sod, leaned way over the fence and dropped it to the ground. It fell to its side and dirt spilled out into the parking lot.

As I jumped down, my fears were realized. I couldn't believe how fast the police had come. I didn't realize the fourteenth division was right around the corner. The first cruiser pulled up between the pallets of sod, followed by another . . . and yet another. The blue and red lights flashed and flooded in through the rows of greenery, and my heart beat hard. At first, I ducked down, but I knew they were just going to shine their flashlights and find me anyway. I decided to climb back over the fence into the parking lot.

There was no way out. They closed in around me, making a horse-shoe, forcing me against the garden barrier. The first officer asked me what I was doing there. I thought hard for a few seconds. In the end, I figured it was best to be honest. Below the moon, there in the mall parking lot with my skateboard upside down and plants strewn across the pavement, I heard the words echo in my head as they came to life across my tongue: "I was stealing some plants . . ."

In the long moment of silence that followed, I looked up from my grubby Converse to catch one of the officers smirking. The look was quickly wiped away. He then asked me why I was stealing the plants, to which — after another lengthy pause — I replied that I had just moved into a new apartment and was trying to "spruce the place up."

I delivered the line with the pun and all, which was not in any way planned. If only I could be so savvy under pressure, but sadly, it was a fluke. I looked up again from my feet to find the officer who had been smirking before once again with a slight look of amusement on his face. He told the other officers that he'd take it from here, so they all left the scene, leaving only him, his partner and me.

He and his partner escorted me over to the cruiser. I had resigned myself to being put into the back of the car. But as we reached it, I breathed a small sigh of relief when they just had me stand outside. They looked me up on the computer and found I had no previous record or charges of any kind, which cleared the air a little.

"But seriously, what are you doing, man?" the one officer asked.

And so I told them again, this time in depth. I explained how I lived in a room in a house down the road and how my brother and friend had moved out, and as of now, I had the place to myself. I told them I honestly just wanted a few plants to take the edge off the place. I think they believed me, ultimately, and knew that I wasn't a bad kid. They were enjoying the scenario quite a bit, considering what they had to deal with on a regular basis. After a brief lecture about how I shouldn't steal any more plants, and me complying — "Yessir,

absolutely" — they instructed me to go straight back to my bachelor pad and stay out of trouble.

Man, oh man, was that close — by the skin of my teeth. I felt so happy that the universe had delivered me such kind officers. The situation could have so easily gone south if I had been dealing with the wrong type of authority, or if I had reacted differently. I did as I was told and went straight home and burned roaches with a lighter and hairspray until the wee hours of the morning. There in the acrid stench of charred bugs, I stared around my room, wishing I had some sweet plants to complete the zen vibe of my cozy roach motel.

FLOWERS MACDONALD

It was in this room that I was to meet the man who would eventually apprentice me in tattooing. Paths cross and cross again, and we never recognize the signs we are being shown until they come back around, like déjà vu.

I was throwing a little shindig at my place. By then I had managed to scrounge up a few plants from somewhere, so needless to say the vibe was on point. I even had lamps. Both Rob and Joe came. At that point, Rob had been immersed in tattooing for some time. I didn't see him often, but I was always happy when I did. It was warming for me to have my brothers in the same place at the same time. When the trifecta was complete, the hijinks came effortlessly. Rob was the funniest person around and would quickly have everyone laughing.

That night Rob had brought a friend with him from the shop. His name was Eric, and we got around to talking about art. I showed him some things I had been working on while we smoked, drank and listened to music. He was friendly and said, with a reassuring smile, that he liked them a lot. What a feeling that was, a tattoo artist looking at my drawings and telling me he liked them. I had been coasting through a long desert on fumes and someone finally put a little gas in my tank. I caught a glimpse, a flash. A small ray of light through a cracked wall. On the other side shone possibility.

Little did I know that years later, he would be the one to teach me how to tattoo. It was a momentous night. I played them a live recording of Spanky, and they said that they dug it, even though it was some pretty gnarly stuff.

Soon after, Lukas decided the rooming house wasn't for him and moved in with his brother up at Christie and Bloor. He asked if I

wanted to come live there. It was a great opportunity to get away from the bugs and the weirdos, so I took him up on the offer.

I moved into a nice clean room at the front of the house, relieved to have such a good little spot, free of infestation. It felt like I hadn't breathed in months. The house had a full basement, so we used to practise down there. We all played in punk bands, which worked out perfectly. We got up to a lot of mischief in that house and threw a lot of parties. One crazy party, however, will go down in the annals of party history — it was the time when I was paid a visit by two new friends . . .

Summer was in full swing, and we didn't have a care in the world. We had two kegs of beer, three or four bands playing, and about fifty punks and skaters ripping the place a new one. Lukas's girlfriend was offering piercings in the corner, jamming a safety pin through everyone's nose. It was probably around 11:30 p.m. when someone came downstairs and told me the grim news that the police were at the door.

Even though I felt a pang of fear, I didn't hesitate and headed upstairs through the hordes of punks and skaters. I came down the hall, punk music blaring up from the basement behind me. Outside the screen door, I could see two silhouetted figures on the porch standing ominously in the shadows. I slowly opened the door.

"Hello, officers, how are you?" I said, trying to sound pleasant without sounding drunk. I could hear my voice shaking from the inside, revealing the truth, revealing the fright.

There are times in life when somehow, someway, against all odds, the stars align to deliver to your doorstep a fate so strange that you can only conclude life imitates fiction. I opened the screen door, casting light across the darkened figures before me and revealing their true identity. I was standing before the same two officers who had caught me stealing plants from Dufferin Mall two months earlier.

And what came out of their mouths was the last thing on earth I expected them to say. As big smiles spread across their faces and their

eyes lit up, their words rang out in the dark of night: "Hey, it's Flowers MacDonald!"

Now, I don't know if you've ever been given a nickname by the cops, but it truly felt like I was receiving a prestigious award. I hadn't prepared my acceptance speech.

"Flowers, what are you up to now?" the one officer said. They both laughed.

So with the same honest, matter-of-fact approach that kept me out of the clink last time, I told them exactly what was happening, although this time I was smiling. "I'm having a party."

They laughed again. "We can see that!" one of them replied. "Your neighbours have called several times. You have to turn it down, okay? Whaddya got, live bands in there?"

"Yeees . . . Would you like to come in?"

More laughter.

I told them we'd be shutting it down ASAP. They just laughed, turned around, told me to stay out of trouble and walked out into the night. I called out to thank them once again, and then just like that, the two best policemen I had ever known drove off under the streetlights. Yet again, by the skin of his teeth — or by the tips of his petals — Flowers was off the hook and running free. Much later in life, when I watched the film *Superbad*, it became clear to me that I may have been the McLovin of my generation.

I have thought about the officers from time to time and wonder if they still tell the tale of Flowers. They must. My only hope is that this work of blood and sweat you're reading may help me find them one day so I can buy them both a drink, and a bouquet. And just in case they do read this: thank you for making my youth more fun, and for believing in me enough to keep me out of the big house.

YOUNG AND DUMB

I was nineteen and moved so many times in the next year or so that it was a wonder I even bothered hanging pictures on the wall. After living in the punk house at Christie, I moved back into the neighbourhood I first lived in when I came to Toronto. I rented a room from some guys I knew who had a house. At the time, I was one of the only ones with a job. I was at a temp agency, being placed in a new spot every day, doing odd factory and construction jobs, building parking lots in the burning sun, unloading trucks of crumpled boxes. Angie would come to the house and stay for extended periods of time. It upset her family, but she was going through some things and needed to be anywhere but with them.

But the atmosphere of that house put a strain on our relationship . . . The place was full of bummer vibes, and no one who lived there was comfortable in their own skin. She had been through a lot, and I knew she needed to feel numb, as did I. Her mother's death haunted her. Before we met, she had watched her get carried out of her house in a body bag, and I can't imagine what that must have been like. It had rocked her bad. So we were both dealing with the loss of our mums. We were messed up. As a couple, we were crumbling. We didn't break up, but after a long stint of her being there, I wound up contacting her family, and we convinced her it was best that she try again to work it out with them.

A few months later, I landed a co-op placement through a program that the employment agency offered, meaning I could find work within a field I was interested in and the business that signed on to the program wouldn't have to pay my salary. Essentially, it was free labour for them. I decided this was a good opportunity to try to get myself

into a tattoo shop. I had been working on some drawings I thought were pretty decent. I didn't know if I was ready or not, but the opening was there, and I had to try. I decided to start in the East End, and hit every shop I could, heading west from there. At this point, Rob would not help me get into the trade. He likely believed it was only a fleeting desire for me. Although I resented him for this, I was determined to show him I could commit to tattooing, and knew if I was going to get a placement, I was going to have do it on my own.

The first shop I chose to approach was between Main and Woodbine on Danforth. Little did I know it was owned by a pioneer and dark horse in Canadian tattooing history. His name was Lannie Glover. I took the long ride out to his shop. The place had airbrushed walls and lots of flash. I was filled with excitement the moment I walked in. I explained how the co-op placement worked, and he seemed receptive to the idea. He asked if I had any artwork with me. Most of the things I had been working on were abstract, in a sense: weird faces, goblins and other strange, Surrealist-inspired stuff. He hunched over the counter, poring over my art. He was the king of mountain men, like the dudes at my brother's shop, only bigger, with longer and scragglier hair. He flipped back and forth between the pages, then kept going back to the beginning and starting again. I think he could see I had some understanding of shading and colour. He stared so long it began to feel uncomfortable. I examined the flash on the walls while I waited. *What was he thinking about?* They were just a bunch of goblins and faces. Even I didn't think that much about them. After what seemed like an eternity, he pulled his mane out of my drawings and looked up at me with his wild eyes. He said after a long pause that my artwork was pretty good. He said that he *might* be interested if I came back with some different drawings. *Different drawings?* I thought. "What sort of different drawings?" I asked.

He explained that people didn't want to get weird imagery like my goblins tattooed on them. They wanted "more birds and bears." I scoffed internally. I told him I'd be back and thanked him for his time.

I felt wounded. *What a crazy old man*, I thought to myself, *he had no idea about this new wave rolling in*. My generation did not want birds and bears. We wanted to push the limits. I felt like shouting at him, "Punk's not dead!" I'd show him. *I'm going to change the trade, man, turn it over on its side and show these old-timers what's what.*

To be young and dumb. I could have sped my career up a good couple of years if I had listened to Lannie Glover. I also would have been a much better tattoo artist if I hadn't been too stupid to realize Lannie could tattoo better than anyone in Toronto.

A similar response came from almost every shop. Toward the end of the day, I was feeling defeated. I went back to the house, way up on Islington Avenue, and found everyone wasted. Up to my room I trudged, closed the door and listened to them drunkenly talk about me. I lay on my bed and closed my eyes. *You haven't seen the last of me, tattooing. That I can promise you.* I had told myself my drawings were better than they really were, so much so that I convinced myself not to take Lannie's advice and simply draw some things that weren't so strange. The ironic thing: I knew birds, and could easily draw them. I was just being defiant, and instead of doing what he told me to, I gave up. Deep down I was afraid I wasn't good enough and feared being rejected a second time. That was a mistake I wouldn't make again.

GARY

I shook off the dust and looked for the next best co-op placement I could think of: a record shop. Music was a close second to tattooing for me. Because I was always hanging around Classic Studios, I knew there were several record shops within walking distance of Ossington and Queen. So I took the subway downtown and went into Kool Kat. The owner, Dante, seemed nice enough and jumped on the chance to have free labour. So just like that, I was working in the record shop. Getting paid a little money from the agency and being around something I felt passionate about was satisfying. It wasn't tattooing, but it was music, and that would suffice. The placement even gave me hope and fuelled me to shoot for that goal of getting into a tattoo shop one day. The gig also got me out of the 'burbs and back into the part of town I wanted to be in. It was perfect: just a few storefronts up from the main punk club in town.

There was also a jam space in the back of the record store, so I got to listen to bands practise and learned how to set them up and tear them down. But as time went on, it became clear to me that the owner was as shady as they come. He once yelled at me for not taking enough initiative and told me to root through the millions of records piled in the downstairs crawl space and pull out the music I thought they could sell.

At the bottom of the stairs, the ceiling was maybe three feet high at best, and he was right, there was a sea of records down there. Because the concrete floor was uneven and sloped, the crates sat at different heights, giving the impression that the whole thing was a wave. I got to work, and after a half an hour, I had collected a stack of what I thought were gems: the Four Tops, some old punk like GBH, some

Stranglers 7s, and Cyndi Lauper. That's when I heard something move behind the furnace, near the back corner of the crawl space.

I already felt uneasy down there. I waited a minute before I continued rummaging around. Then I witnessed a movement, and another, and I realized what I was dealing with was a large mammal. I was frozen in my tracks as I squinted through the musty light, over the swell of vinyl and tried to make out what was happening back there. What I saw emerging from the darkness was a large figure, man shaped. Bushy hair. I turned on a dime and went scurrying like a field mouse, tripping up the stairs. I reached the top and closed the door behind me.

"What the fuck was that all about!?" I gasped. As I went to the front to find Dante and tell him there was someone behind the furnace, he didn't even look up from the book in front of him.

"That's Gary," he replied calmly.

"Who? What do you mean?" I asked. "Who is Gary? Why does he live behind the furnace?"

Dante put his pencil down on the book and glared at me. He had this way of looking up at you as if he were peering over a pair of glasses, like a stern librarian.

"What I mean," he hissed, tight-lipped, "is that Gaaary is my friiiieend, and he lives in the goddamn crawl space, all right?" He stared at me like I was a fool.

"Oh," I said. "That's a weird place to live."

"Jesus Christ. Did you find any records down there or what?" he yelled, his wild black hair shaking feverishly.

I reluctantly went back down into the cavern, eyeballing Gary from afar. Keeping a close eye on him, I grabbed my stack of records to bring upstairs. I wanted to make sure I would be ready if he came at me and tried to drag me into his lair and eat me.

A light shower was falling one morning as I opened up the shop. Ossington was quiet. I decided to put on a record, have a puff of a joint and sip my coffee with the front door open so I could hear the rain coming down. I put on something mellow and was feeling calm.

It turns out the front door was directly above where the furnace lay, so two puffs in and suddenly there came a noise up the basement stairs. *Boom, boom, boom!* Gary came skidding round the corner, slowing down as he got to where I stood, as if to make it look like he hadn't been running at all. There he was, the mythical Gary in all his glory, standing in the doorway in his dusty pink bathrobe.

"Hey," he said matter-of-factly. "Thought I smelled something up here."

He looked like Bobcat Goldthwait. His hair was long, frayed and thinning, almost as if a tumbleweed had blown in from the plains and come to rest on top of a pink hill. His face was rose, yet translucent and pale — from living in the crawl space, no doubt.

Without replying, I casually offered the joint to him. He examined it, placed it into position, then took three long, eighties-style, lip-protruding drags, eyes squinting. He finished, held his breath, choked slightly and exhaled a massive cloud into the drops falling from the awning. He then nodded, turned around and went, barefoot, back down to his dungeon. I often wonder if Gary is still lying down there in a crawl space on Ossington Avenue, wearing his dusty pink bathrobe.

RIVERS OF MILK AND TEARS

I couldn't stand living with the punks in North Toronto anymore. It had become a negative and uncomfortable atmosphere, so it was once again time to get going. I felt vulnerable, like someone had pulled the covers off me while I was sleeping.

Joe was living in a room in the basement of a little townhouse in Mississauga. The family was nice and took us both in like family. Joe was working at a dairy called Gay Lea Foods that produced all kinds of products. After my co-op placement at the record shop ended, my brother landed me a job there. It was an hour-and-a-half commute one way, so it made for long days. It was great pay, and though my brother and I didn't see eye to eye sometimes, in the end we worked well together and were two of the fastest and most thorough employees in the plant. I was grateful for the opportunity and wanted to make my brother proud, so I tried my very best.

I started on the bottom, loading and unloading trailers full of milk crates. I picked orders and did odd jobs. It was hard work. There were many times that I called Joe, distraught and at my limit, sometimes on the verge of tears. The stress was bad. He would calm me down and set me right back on track. He was good like that, such a great big brother, and I couldn't have stayed there as long as I did without his reassurance. Working there paralleled our childhood; we came together during chaos.

That job redefined what it meant to have a bad day. I still have nightmares about trying to organize the massive warehouse. The building was not big enough to house the amount of product coming in, and there were times when it just kept coming and coming, truck after truck. In my dreams, there I am, endlessly scrambling and rearranging,

stacking things as high as the ceiling, the phone ringing off the hook. I can never really get everything sorted, the job eternally incomplete. I wake feeling stressed and sad. The frightening part is that the job was actually like how it feels in my nightmares. More often than not, that's how a shift went.

Whoever said don't cry over spilt milk never worked where we worked, that I can assure you. We would have to pick orders and arrange them in an aisle according to what delivery route the product would go out on. It was the most feared job in the place. Routes had to be prepared the night prior and had to be perfect, otherwise you'd have the delivery drivers angry with you once they got back. And trust me, you didn't want that.

One evening, after hours and hours of strenuously picking the largest set of routes anyone could remember, we had no alternative but to stack the product to the ceiling because of the lack of space. The cooler was at absolute capacity. I put the final pallet way up on top of the front stack with the forklift, like the crowning jewel. The pallet must have been twenty-five feet in the air, and I managed to balance it just so. I lowered my forks, jumped off the machine and ran into the office, scrambling to get the paperwork completed. That was when I heard the most horrific sound: two hundred crates of milk, cream, ice cream, you name it, all crashing to the floor. It sounded like a landslide, like a mountain crumbling. That was the cue to cry. Rivers of milk and tears. Not only would I have to clean the unthinkable mess up (and don't forget milk runs underneath everything, like a horrible white lake), I would also have to pull out and clean all the product somehow, and then stack it again.

I got started, and all the while, a guy on the other side of the wall was driving down the pallets of cool whip coming off the line, dumping them in my space, clogging every avenue and crevice. The worst part was how the smug little prick looked at me. He stared at me, stone-faced, while backing his forklift out of the room, not even watching where he was going, his eyes still locked on me as if to say,

"Go fuck yourself, you motherfucker." I wanted to kill him. I knew I would not be going home come the end of my shift. I probably wouldn't be leaving until the next morning. Everyone was going to be pissed at me the following day, and maybe even the one after. It was a colossal, paralyzing mess, and it didn't seem possible to make it to the other side. Many temps would have disappeared into the night when the shit hit the fan, but not me and Joe.

How I did this for five years is almost unfathomable. I moved up, and eventually I was out of the cooler and managing the dry-packaging warehouse in the building next door, so I didn't have to deal with as many people. I had been desensitized to chaos.

I met some characters at the dairy who will be impossible to forget as long as I am still drinking milk. One of my favourites was a big, bearded trucker named Hal. When Hal would stomp into the cooler and started shouting, it made the days less tiresome. He would storm right in, cursing and carrying on, but it was just his way of saying hello. He was the human equivalent of Foghorn Leghorn. One morning, I was hungover. I was delirious and melancholy. I was in the office completing paperwork, rubbing my haggard eyes, when he came in yelling at everyone, almost as if a lone storm cloud had drifted into the office and started thundering away. I began to snicker, of course.

"WHAT?" he boomed. "What's so funny over there, Red?"

I smiled and looked up at him. He towered over me like Zeus. He was quiet for a moment while he studied my face before bellowing again, "Sweet Jesus, son, what happened to you?"

"What do you mean?"

"What do I mean?" He may as well have been speaking through a megaphone. "Your eyes look like two eagles' assholes in a power dive." Then he ripped the biggest bellow you've ever heard.

It took me a moment to process his eloquent simile. When I did, I had to leave the room, I was laughing so hard. I thought I might puke. Hal was a great guy and worked there for twenty-five years or so before they let him go for no other reason than that the company was

"trimming the fat" — the type of layoff that occurs when consultants are brought in to maximize your corporation's profits, and any cut they can make to save some money, they will make. It was devastating for Hal and reassured us all that seniority didn't mean a thing — and all our hard work didn't mean a thing, either. We were all on thin ice, and that was a feeling I did not like.

Out of all the characters who I worked with at the dairy, one in particular sticks out above everybody. His name was Johnny Forrester, and I looked up to him. He had long grey hair, a salt-and-pepper beard, and he was thin and tougher than nails. Johnny was a cowboy.

It was one of my first days there, and my boss had chosen me to do one of the dirtiest jobs on earth: cleaning underneath the loading dock. Whenever there was a big spill, which was fairly often, milk would get squeegeed out the loading-dock doors when there wasn't time or staff to clean it properly. The walls underneath the docks were caked in petrified, rotten milk. We popped up the docks and knew it was going to be a long, smelly day. I reluctantly jumped down and began scraping away at the congealed slime with a shovel. After we'd been picking away at the mess for a few minutes, along came Johnny Forrester to see what we were up to. He was smiling at our misfortune, observing our obvious unwillingness to get at it.

The hot morning sun poured in through the open shipping door, and sweat was beading across our foreheads. The severity of the mess had begun to weigh in, and we were feeling cheated. That's when a hero stepped from the shadows. The man we knew as Johnny Forrester curiously unbuttoned his shirt, slid it from his shoulders and ravelled it carefully, almost as if he'd done it before. He proceeded to tie it around his head like a headband, and John Forrester became John Rambo. He reached for a shovel, leaped down into the pit and began hacking away feverishly at the disgusting mess.

"Sometimes you got to get down and dirty, ladies!" he yelled, smiling through his silver moustache. At that moment, as I stood

ankle-deep in a trench of rotten milk, I realized I was never going to be half the man Johnny Forrester was.

He was fearless and would take on any job that nobody else wanted to do, just to prove a point. The point being: he was a badass mother-fucker and a harder worker than you, and you just needed to accept it.

The blast freezer was located near the far end of the cooler. Being inside was similar to being in an Arctic blizzard. One day, the boss needed someone to rearrange and clean it, and as we all looked down at our boots, hoping we wouldn't be selected, Johnny Forrester promptly spoke — "I've got this one, boss" — grabbed his gloves and walked out of the room before our boss could finish listing the day's game plan.

I swear he'd been in there for an hour before I walked in to get something. I watched in awe as he zipped around on the forklift, moving pallets around in a frozen fury. I gazed at him through the misty frost and told him he should come have a coffee and warm up. He spoke loudly and calmly over a spitting reefer with an amused look on his face.

"I'll have a coffee when I get cold, Chris!" The words came out like a cloud from under the icy moustache.

Johnny was truly a beast among children. Whenever I am con-fronted with a daunting job, I think about Johnny. *What would Johnny do?* Then I take off my shirt, wrap it around my forehead and start chipping away.

THE FIRST CUT IS THE DEEPEST

Finally, I had a steady income and was able to afford a place of my own. I moved up to a one-bedroom apartment on Weston Road. It was an old, hard part of the city, where shouting and brawls outside the Irish pub could be heard echoing up through the night. Where the smell of dead cattle from the nearby slaughterhouses wafted in on hot days over the desolate storm drain, which ran at the bottom of the hill like a concrete gash severing the neighbourhood in two. Despite the gloom of those streets, I had a clean living room, a bedroom, food in the fridge and a warm shower, all of which brought relief, promise and even inspiration. Angie and I were still seeing one another, and she would wait for me to come home after working many hours at the dairy. I remember how nice it felt to sleep in that apartment after those long days.

I had a little money set aside, so I decided I would put it to good use and buy myself some quality tattoo equipment. I knew that would be a step in the right direction, the motivator to actually see it through to start tattooing.

At the time, the only tattoo supply shop in Toronto was called Studio One in the East End. Others have come and gone since, but Studio One still stands today. I headed down one Saturday morning to Queen and Carlaw with the streetcar rumbling the whole way, and waited for the shop to open. As I walked up to the dingy window where the trademark neon knife hung, I was filled with nervous exhilaration, waiting for the lights within to flicker to life. Once inside, I spent a few hundred bucks on supplies. I bought a Spaulding Puma tattoo machine, a power unit that plugged into the wall, which is pretty amusing when I think about it now. The adapter that plugged

into the outlet allowed the machine to adjust to four or five different voltages. I got tattoo needles, ink in various colours, ink caps, everything one would need to perform a basic tattoo. The owner, Gary Chynne, was super cool and gave me a twenty-minute crash course in tattooing right then and there, explaining how to set up the machine, along with some lining and shading techniques. I went straight home to play around with my new toys, inserting the adaptor into the wall, sliding the stainless tube into the machine, and listening to the ragged noise of my new tattoo machine for the first time.

I was playing in a punk band called Bombshelter. We used to jam in a storage unit beside a field in Woodbridge. It was fun while it lasted, and I have some fond memories of playing music with the doors open and watching the sun go down over the fields. That night, when I got to practice, I was stoked to tell my buds that I bought some pro tattoo equipment. My friend Mark Harpur, the bassist, promptly informed me that following band practice, I would be tattooing him. I thought it was a joke, because Mark is seldom serious.

After practice, we piled into Jason's van and headed back to my place. We listened to music and drank beer and started talking about tattoos. That's when Mark got really revved up. He was dead set on getting a tattoo that night and became insistent. I told him I had no idea what I was doing, and it was the truth, but that didn't seem to faze him. From watching my brother at work, I knew the conditions weren't ideal to begin tattooing right then. But when Mark gets set on something, well, there's no talking him down. He was going to make sure there was some tattooing going on that night. And if he wanted a green the shade of steamed broccoli, well you had to make it happen, or you would never hear the end of it.

After a few beers, I finally gave in to Mark's incessant nagging. He wanted to get an ace of spades on his chest, thankfully just in black. (The steamed broccoli thing didn't happen until sixteen years later.) I was nervous about the needles not being sanitized and knew little about that aspect of things. Mark assured me that boiling them was

our best option. We carefully put them into a clean pot and let them boil for a half an hour, then laid them to dry on paper towel. While the needles cooled, I drew the design on him with a pen and set up my machine like I had been shown. I set up all the equipment and tried to be professional like my brother and keep all the areas as clean as possible. And just like that, my life changed forever, down in a basement on a side street off of dirty Weston Road. There was no turning back. With punk rock playing on the radio, beer bottles clinking, cigarettes smouldering in the ashtray, I cut my teeth in tattooing with Mark Harpur.

I remember the sound of the machine, like a cicada, and my heart beating fast. Mark's grimace was constant, and his eyes were wild with pain as I dragged the needle across his bony chest. I was able to get most of the lines fairly solid, and had begun to sculpt them. One of the singers of the band, Jason, kept telling me to go deeper, even though that wasn't how my brother tattooed. I tried not to listen to him, but it proved difficult. It was hard enough to concentrate on the task at hand, let alone with someone talking in my ear the whole time.

Angie was a talented photographer and managed to capture that moment. Two amazing, gritty black-and-whites from that night are still hanging in my studio today. I am so thankful she was there with her camera. The whole experience brought Mark and me together. Even though we weren't best friends, we'd always had a good connection, and it got stronger that night in my little apartment.

I did three tattoos there and began to see that it was much more difficult than my brother made it look. I was never impressed with the immediate outcome, or, more importantly, with how those first tattoos looked when they healed. They just didn't have the finesse or appear as solid as my brother's tattoos. They were clunky, splotchy and sketchy. I became discouraged, ultimately deciding that maybe tattooing just wasn't for me. I put my equipment away and began to think about how Industrial Design at OCAD would be my fate.

My landlord gave me two months to move. He said that his mother would be taking over my apartment. So, like a discarded newspaper in

the wind, I tumbled down the sidewalk again. I was getting used to it. I ended up close to where Joe, Dennis and I shared the little roach-infested room. I had scored a tiny bachelor apartment at Howard Park and Dundas. On the side of the building it read: "Believe it or not, this is the place!"

This is where Angie and I broke up. At the time, I wasn't very nice to her. She would have stayed with me, but I just wanted out. I hurt her badly. I wish I didn't. She was a good person, loyal. I wasn't.

The night I broke up with her was one of the longest nights I ever experienced. At one point, I left to go skateboarding because I couldn't deal with the distress anymore. I came home hours later, late into the morning, and there she was, still on my doorstep with her head buried in her arms. I stood staring at the scene, sparks crackling from the cables above a streetcar. Then it was dead quiet again. The streetlight washed over Angie's shaved head and her boots. She was trying to keep warm against the cool 3 a.m. breeze drifting off the bridge, over the tracks and down the road. I don't know how long I stood there. Hearts eventually healed. Time passed.

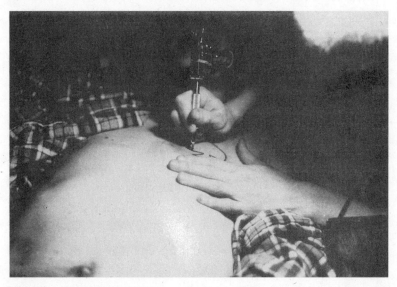

Tattooing for the first time, 1998.

DABZ

Although I collected some new tattoos along the road, I wanted to have an experience from a shop other than my brother's. Tattooing had really taken flight in Toronto, and there were now shops all over Queen and Yonge street. I first went to Abstract Arts, a key Toronto shop still standing today. I talked to a guy who was fairly helpful, and I put it on my list as a potential. The next place I went to was Way Cool, a popular Canadian franchise really pushing to become a Canadian household name then. They even had a commercial on television. I went in feeling nervous. It was really busy, and the vibe was way off. I wanted to get a motif in the style of art from the Haida First Nation on the Northwest Coast. For some time, I had been learning to draw the structures and trying to understand the mythology behind this art from books I had at home. I was constantly brought back to an image of a mountain goat created in 1977 by Clarence A. Wells, an acclaimed contemporary Pacific Northwest Coast First Nations artist. I loved it. Rob had originally introduced me to the beauty of Northwest Coast art, and it has captivated me ever since. For me, getting a tattoo similar to what Wells created was to simply celebrate this incredible artform. These days, we are aware that tattooing any style of First Nations art should be performed by an Indigenous tattooist, and any person requesting this style of art is urged to seek out an Indigenous artist for the tattoo or for consultation surrounding the artwork.

When it came my time to talk to the receptionist, she was abrupt and rude and seemed put off that I wanted to get a tattoo at their establishment. She rolled her eyes at me and dragged the image off the counter and disappeared around back. She came back after a while, slapping the image back down in front of me, and said the

artist wouldn't be able to do the tattoo for another month. The waiting didn't bother me, but I was taken aback by how unfriendly she was and decided I didn't want to get tattooed in a place that me feel uncomfortable like that.

With the fond memories I had of my brother tattooing me, I needed to find something similar, something that felt more personal. I decided right there and then that if I were to ever make it as a tattooist, I would try to create an environment that made people as comfortable as possible.

I ended up trying my luck with a newer place down the street called Stainless Studios. Though it no longer exists today, at the time it had a budding reputation. When I went up the stairs, the shop was bright and clean, and their front room had style. The person at the desk was friendly and made me feel welcome. After looking at portfolios, I chose an artist who had some pieces in his book similar to what I was looking for. The artist's name was Dabz. He made tidy-looking tattoos and was so far the best I'd seen in my search.

The style of tattoo I wanted was very technical to apply because of its specific, repeating forms, symmetrical lines and use of areas where there is solid red without a black outline. So choosing someone who did tidy lines and took pride in their work was important. I set up the appointment for a few weeks later. I couldn't wait.

Finally, the day of my appointment came. Dabz, whose real name was Ron Boudreau-McLellen, was very friendly. I could tell he was kind and genuine. We had a great time tattooing, and he told me all about how he had got into the industry. He started out as an airbrusher and graffiti artist, apprenticed at Way Cool and later helped his friend open Stainless Studios. It lit me up. Imagine your friend opening a tattoo shop and inviting you to work there? These were things I dreamed of. Still do. I told him I wanted to be a tattoo artist as well, and he actually took me seriously. He listened to me, and we shared stories. I felt charged up after getting my new tattoo from Dabz and was thankful for the fleeting hours I spent with him.

Some while after he did my tattoo, in 2004, I was informed of his passing: the cause was cystic fibrosis. Ron had already defied the odds of his life expectancy with the disease. At some point during his battle, he underwent a double lung transplant which bought him some more time, but eventually his illness took him. When I'd learned of his death, the news put me in a reflective state. I didn't know him well, but that day in the shop was memorable. He made me feel cool. I thought about the way he called Jen Black over to introduce me and told her I wanted to be a tattoo artist, and how genuinely supportive the two of them were of my dream. They had no reason to, but they believed me.

I thought about the mark you leave on people, even just while passing through. People drift in and out of our lives. Some stay for the whole show, and some just for the first band. We are never fully aware of how our interactions may affect other people. We never know what a simple conversation can bring. I may have been one of five people getting a tattoo from Dabz that day, but his encouragement and zest for life struck a chord with me. He was a good person, and he may not have been aware of it that day, but he helped me. He gave me hope that tattooing might be something I could obtain with some hard work. And when I look down at my arm, I have the memory of the days leading up to and following getting that tattoo. I also have a memory of the person who created it for me, who inspired me, who gave me a stepping stone to throw down in the river. One day I would cross it and see what I could see on the other side.

THE WOMAN IN THE WINDOW,
AND THE WRITING IN THE CLOSET

I snapped my pictures back off the wall, packed up my cats and moved again. This time into a big warehouse on Ontario Street with two friends. We lived for trouble, skated, drank too much and were as reckless as they come. Through the chaos of this time, I managed to keep my job at the dairy and make decent money.

The big studio came to feel small. I missed having solitude, so I packed up my sack on a stick and went looking for my own space. It was two days before the first of the month when I finally found something.

I walked in, stood there for a minute and said I would take it, just like John Dalton in *Road House*. The only difference was this wasn't a charming open-air loft in a barn. It was a tiny bachelor apartment in a spooky basement up by Rogers and Oakwood Avenue. I remember the landlord was nervous, maybe because he wasn't telling me about the apparition who already lived there — and just in case you're wondering, no, it wasn't Gary behind the furnace.

Someone or something did not want me in that apartment. It began the day I moved my things in and noticed a door near the bathroom, which I hadn't seen before because the previous tenant had blocked the evil in with a bookcase. If you ever stumble on a portal in your space, blocking it with a bookcase can be effective in trapping in the horrors that may lurk on the other side.

I opened the door on a cement cold cellar. It was empty except for a lacey, antique baby carriage in the corner, covered in dust and spiderwebs. The pram's presence startled me, but not as much as you might think. I just knew it couldn't stay; it was too weird. So without

thinking, I walked over to the stroller, yanked it from its resting place, carried the thing outside and put it on the curb. I don't think I was supposed to do that.

Within the first week, the new space flooded. A pipe burst, filling my spirits with dread and destroying any of the furniture that was touching the floor. You could have put a canoe down there and paddled around.

I remember lying on the couch with my two cats, staring at a piece of paper floating downstream in the grey water around me. It was grim. Working at the dairy was taking its toll: I had given so much at the company but was getting little in return. I was reaching and reaching, my fingertips grasping at air. Something was slipping away from me and drifting downwards.

There were people I worked with who had no alternative: they needed their jobs desperately; they had families to feed. I looked long and hard at some of the faces in those big hallways, languid, beaten by this thing. I remember a fellow in production who must have been in his sixties, maybe seventies, and was clearly going to be working until he couldn't work any longer. Management had him pulling these pallets around with a hand truck. He wasn't afraid to work hard, but I thought it was wrong nonetheless. He was a tough old guy, but I could see the strain and beads of sweat across his face. I would always try to help him when I could. Eventually his heart gave out, and he passed. I can't say I don't believe the company had a part to play in that, considering how hard they were working him. The only thing I can recall the company doing was posting a piece of laminated paper with his picture and a small obituary up beside the punch clock, as if to say he had clocked out permanently. Bad taste. It said he would be missed.

His death was a reality check, giving me a real sense of urgency. I couldn't entertain the thought of dying in a place like that. I couldn't die for that cause — or for somebody else's cause, for that matter. That place, in its forever hum of industrial lights and alcoholic bosses, fast-talking management and endless bottom line. Where honest workers

passed in the night like whispers. While we punched the clock, the managers monitored our time. I wonder, were they monitoring that old fella's heart? In that place where our questions were answered in grunts. And where the more you did, and the more you were capable of doing, the more they expected of you, and the more you were penalized when you couldn't keep up. And the Weston Road bus, creeping along the tired streets. Seats full of people who didn't talk. They just stared down and closed their sleepy eyes and rested their nodding heads against the windows. Out in the dark, the smokestacks puffed endless streams of grey smoke out into the morning. Giant pharmaceutical buildings and upholstery warehouses slid by in the blue light, where the hands and faces of men and woman were carved deep with the days that never seemed to end. Overtime was all the time down there. They didn't care about the families at home, that those workers hardly got to see their kids, as long as the job got done. But the job was never done, was it? The days would just keep turning like a tremendous iron wheel. Where every day was the same and every day was a battle. My skies were darkened, and the fire in me was smouldering under the coming rain.

As I sat there, with my cats huddled around me in the dampness of the flooded apartment, a desperation came to me, and for the first time in a long time, I broke down. For the first time since I was young, I prayed, I don't know to whom, but I did.

After my landlord cleaned up my apartment, I went back down and got to work. Even though he steam-cleaned the carpet, I decided to rip it all out, which revealed a tiled floor beneath. I also decided the walls needed a fresh coat of paint. After I got most of the floor cleaned up and all the carpet tack removed, I began painting. I was determined to bring a change, and it started with making my surroundings nicer. But soon after I began rolling the paint onto the walls, I noticed something strange etched into the bulkhead. I put the roller down to take a closer look, and it appeared that there was some sort of faint writing crudely scratched into the wall.

I couldn't quite make out what it said beyond "Mommy please . . ." I immediately thought of the Misfits' "Mommy, Can I Go Out & Kill Tonight." I thought the writing was strange enough that someone should come over to take a second look, so I called my friend Chad from down the road.

When he arrived, I led him over to it and asked what he thought. He took one look and said, "Mommy . . . please . . . don't hurt me anymore." We both looked at one another and I got the chills. A long, exaggerated *fuuuuuuuuck* escaped his mouth.

I painted over the cryptic plea and tried not to think anything of it. The place had begun to feel a little better with the carpet gone and freshly painted walls. Then the roaches came. I'm not sure where they came from exactly, and how there got to be so many, but it was awful, almost worse than the place on Dufferin. One evening, I got home from work, and they were all over my kitchen counter. It may be unlikely that you've ever seen a cockroach egg hatch, but I have — it will make your skin crawl right off your bones. Watching those tiny specks scatter everywhere was a sure sign I was going to lose the battle.

But it wasn't until I saw the great albino queen, the matriarch of the *Blattodea* kingdom, that I knew I was truly doomed. I had never before seen a white cockroach, and I never want to see one again. At the time, I believed the infestation was so bad it had miraculously produced a new species of super-roach. I later learned that a white roach is a fairly common sighting and is generally what you see when an ordinary roach has outgrown its shell and molted. But that unto itself is a frightening thought: they were increasing in size.

Between my home environment and work, I felt like I was being backed into a corner. There was nowhere left to run. For a few years, I had been dealing with a persistent self-doubt telling me I didn't have what it took to become a tattooist. This was becoming unbearable.

Enough was enough. I got out the pencils and my watercolours and began trying to put together a quality tattoo portfolio right there and then. Hopefully, when all was said and done, it would be good

enough to get me an apprenticeship. Making art at that apartment became an escape. It was an outlet to stop thinking about my job and my sketchy living situation.

When I think about that time in my life, I realize I am still very much the person I was then. My will to create rises from negative circumstances. If a sun is buried in the haze, I will wait patiently. If too many ugly words are being spoken, I will sing a song that can't be refuted. I withdraw into that place untouched. Quiet. Away from contamination. Art is pure, expression is truth. Negativity is a thief, creativity is fortune.

I immersed myself in my illustrations and paintings. I needed to force a change and turn all the bad energy into something tangible. I spent countless hours in the lamplight, under the little window with the darkened garden outside, drawing hearts and daggers, skulls and flowers, trying my best not to think about the things that went bump in the night.

Though I was focusing hard, the spooks continued to capture my attention. There were times when my cats, Hops and Barley, would sit and watch an invisible something or other slide around the room, their eyes moving in unison from shadow to shadow. I would watch them closely, trying to see what they saw. There was a time they followed the unseen visitor around and around the dim room, how they both looked to the empty space directly beside me on the sofa, as if the visitor came to sit next to me and say hello. I got up and went to do something else, trying not to think about it.

I began to rationalize the strange happenings, these ethereal occurrences, as a manifestation of my own uncertainty in life. I convinced myself it was in my head. But the vibe was growing increasingly strange. And the weirder I felt about being there, the more I put my nose in the books. As the shadows grew taller in the corners of the basement, the art got better, and I was beginning to produce things that just might work as a viable portfolio. The days swept by in a blur, and I drank my share of booze to make it through the unsteady evenings, until an hour

came when the creeping feeling spiralled into something powerful and frightening that began in a dream.

My bed faced the kitchen counter and two small, high windows that were level with the driveway. In my dream, I lay flat on my back with my arms stretched out as if I were Jesus on the cross. I could hear someone coming, a pair of high heels approaching slowly up the driveway in the sun. *Click . . . clack . . . click . . . clack*, the steps echoed. Then came a clanging — hollow, tinny and distant — every three or four seconds. My heart raced. Suddenly, the high heels appeared in the first window, scraping on the concrete — *click . . . clack* — only to disappear again behind the wall. *Click . . . clack*. In my dream, I turned my head to the side to see the shoes reappear in the second window. The banging became unnervingly loud, almost drowning out the sound of the high heels, which disappeared again as I turned my head toward a third window, which looked out into the garden, waiting. More banging. When the high heels appeared in the third window, they stopped. *Clang . . . clang . . . clang*. There was a long pause, and then a woman's face dropped into the window, her hair falling down toward the garden. Her face was blurred, her mouth like a broken branch. The sound of a cello resonated through me.

I awoke in pure fright to find myself in the same lying position as in my dream. It was dark, and even though I'm sure my eyes were open, I couldn't see a thing, just a heavy black blanket. I was aware of only one thing: I wasn't alone. There was something hovering maybe a foot above the bed, mirroring the exact position I was lying in. I was face to face with my visitor. The thing's weight and energy rained down on me, humming. When I finally broke from the paralyzed state, I rolled toward the side of the bed, fumbling for the lamp on the nightstand. The bulb popped in a flash and a fizz, leaving the room dark again. I scrambled from the bed and was startled to realize a pot had fallen from the dish rack and was bouncing off the tiled floor, making the same clanging sound as in my dream. This is what coyotes' prey must feel like, disoriented by their ghostly howls. I turned on the

overhead light, found my clothes and put them on. The pot spiralled in its strange calamity across the tiles. It bounced off the corner of the wall, near the bed, the intensity of its sound rising before finally coming to rest, leaving everything in an eerie quiet and a faint ringing. I left and didn't return for hours.

The sun never quite came out that day. It was grey, humid and overcast. When my nerves finally calmed, I returned to the apartment, full of anxiety. I walked right down into the place and stood at the bottom of the stairs and looked around. The pot was still by the corner of the wall near the bed, and the cats were snuggled on the couch. I began to speak, telling whatever or whoever was in there — if there was anything there at all — that I would not be moving. I told them that this was our home now and that I was going to be making art here and would be respectful and peaceful and that I demanded the same in return. I felt absolutely strange saying these things to an empty room, but I was out of options and this was my last stand. I fed my cats and went to work, dreading another day at the factory and dreading another night I'd have to spend down there.

Upon returning that night, I noticed a change in the apartment. And when the lamps were on, it seemed a little warmer than usual. I put on some music. It sounded good. I petted my cats and began working on more flash for my portfolio, which was beginning to feel complete. The dream and the encounter of the night before still rang in my head. The shadow. The clanging. The woman. Her face — who was it? The mother of the child whose writing I found? My mother? I tried not to think about it. I put my head down at my desk, but kept looking over my shoulder.

I haven't felt as full of despair again until now. Here I am, twenty-two years later, sleeping in bed and dreaming. In this dream, I am very young. I am in my brother Joe's large walk-in closet in our house in Alliston. In the darkness, I hear something sliding along the cement

floor. I fumble for the cord to turn the light on. I feel the end of the chain bounce on the tips of my fingers. I am not alone. Finally, I grasp the cord. With a click, the single bulb floods the closet with soft light. My mom is lying on her back, and her legs stretch into the darkness under the stairs. I call out and clutch at her clothes. She is slowly being dragged away. I yell. She slides faster. I am helpless. Her expression is blank. My heart pounds. I lose my grip. Then she is gone into the abyss of the closet.

I am awake now in our room in our blue house, soaked in sweat. I lie there for a long time with my eyes wide open. I remember that dream from long ago: the woman in the window. I feel haunted again. The next morning brings grey skies and great unease. I am truly rattled and struggle with the feeling for days.

ALL THE BEER IN EUROPE

I had to shake the dust off my wings and clear my head from the perpetual fog that surrounded me. I decided to go backpacking through Europe with my friend Jason, the singer from Bombshelter. We had been talking about it for some time, and I really needed to find some perspective. So, unprepared, with just our backpacks, we embarked across the Atlantic in search of many things, most of all; ourselves. A few days found us hungover in Prague as we headed out into the grey European light to explore.

Across the Charles Bridge beneath the looming saints into the downtown area, up a steep hill, we stumbled on a tattoo shop tucked in a little courtyard. We were surprised to learn that the owners were from Texas and had moved here on a whim, probably because of how inexpensive the cost of living was in comparison to America.

These characters from the Lone Star State, with their thick Southern drawls, had a captivating story. I was quite taken by the idea of being able to pick up and move, especially to a special place such as this, to practise your craft. It was utopian and nomadic — the type of thing that made my heart beat fast. We got to know the owner and his apprentice, as well as the other artist who worked there, who was Czech. We booked some appointments, mine being with the apprentice, mainly because we got along so well. I was also thinking that maybe if I helped this apprentice out, whose name was Travis, by getting a tattoo from him, some good energy and fortune would come my way. That old thing: be good to tattooing and it will be good to you. The notion may have been naive, but the trip had me feeling romantic. I picked a black, Japanese Kanji meaning "Dragon" from one of the books. After all, it was 1999, and yes, I

was one of the many that made this debatable decision. I chose it because it was a simple image, and I knew I had to keep it relatively easy. But also, I liked how it was rendered to look like it was a brush stroke painting, or calligraphy. It was a pleasing design to look at. I do wish I would have taken some more time to think that one through, but I was caught up in the moment; as we all know, this can be one of the follies of tattooing.

As we began the tattoo, I realized how different it was being tattooed by my brother or Dabz. I knew Travis's skill set wasn't the same, but what I didn't expect was that it would hurt as badly as it did. In those moments I understood that precision was key to tattooing, and unfortunately my apprentice friend was lacking in this. It took much longer than it should have. I remember looking down at the tattoo and wishing I could borrow his machine and finish it myself. By watching my brother Rob so intently while he tattooed me, I was certain that I could do a better job. It wasn't so much arrogance as it was faith. You can learn and absorb so much by being a spectator; sometimes you can learn just by watching what not to do.

We did get to talking about how he got his apprenticeship. In the end, both the good and the bad about the experience was fuel for me.

The most valuable aspect of the little studio in Prague was its vibe. Here was this quaint little tattoo shop nestled in a picturesque courtyard near Prague's city centre. The square looked like Melrose Place, where white balconies overlooked a garden. But the most interesting thing about the place was that it was an open-concept shop, with no private rooms at all, something I had never been exposed to. I was drawn to this idea, which seemed forward-thinking, seeing as this style was practically unheard of at home at the time. What I noticed from this airy, roomy setting — besides how much better the space looked because it wasn't so closed off — was how everyone was communicating. It was like a barbershop. It was a friendly atmosphere for people to enjoy their work. I decided

right there and then that when the day came and I had my own shop, I would want an open concept as well.

I didn't want to come home from that wild adventure, but I missed my cats, and my bed, and I needed to finish my tattoo portfolio.

FORTUNE FAVOURS THE TATTOOED HEART

It wasn't a surprise that the tattoo that I got in Prague didn't heel well and needed a touch-up. Once back in Toronto, I picked up the phone book and chose the tattoo shop with the nicest-looking ad. That happened to be Lucky 13. I dialled the number and the pleasant fellow I talked to set me up with an appointment the next day.

Lucky 13, at the time, was at Bloor Street and Markham Street. It was really cool, and even though it was downstairs, it still had a nice window at the front, so the waiting area had plenty of natural light. They had lots of flash on the wall, and they used a long retro Coca-Cola cooler for their front counter. Overall, the shop was cozy and had a good energy.

It turned out that Eric, the owner of the shop, was going to be tattooing me. He had a wide, friendly grin, and he flashed it often in the hour or so we spent fixing up my tattoo. We quickly figured out that we knew each other in a roundabout way; he had worked with my brother at Lower East Side. Then we realized he was the other tattoo artist who'd come with Rob to my party that night back on Dufferin Street. We were both stoked about the funny twist of fate that had led me to his shop.

He told me he remembered looking over my art at my apartment, and that he had liked what he saw that night. After a pause came the words I never thought I would hear from his mouth: he asked me if I had ever considered tattooing. My heart skipped a beat, and I responded quickly that, yes, I wanted very much to learn to tattoo, ever since Rob had given me my first one back in the day.

Eric asked me if I had a portfolio he could take a look at, to which I responded confidently that I did.

"You should bring it by and let me take a look," he said.

I told him I could come the next day. I was beyond excited as we shook hands. He knew he had made me happy, so he flashed his big grin again before I left.

Anticipation is a gift, a feeling, that comes down from the clouds and picks you up. Like hanging up the phone after talking to a pretty girl, or being on a train watching the landscape go by, or hearing a great song for the first time. It's the hope that will save a ragged soul, and that day, it saved a wretch like me.

I went straight home and got to work putting the finishing touches on my portfolio. Flipping through the pages a hundred times, I tried to see it as Eric would be seeing it the following day. I rearranged the order many times, seeking the perfect flow. It was difficult to keep my mind from wandering to our meeting the next day. There was little sleep that night. I was restless and uneasy, and left the lamp on, hoping that what happened two months earlier — the woman coming up the driveway, her face in the window — wouldn't happen again. But this morning there was a peaceful aura, and the sun trickled through the basement windows and onto the kitchen counter. The birds were singing outside the window in the garden. I woke up, took a shower and ate. I could hardly wait.

I went to meet Eric at his shop. We sat down in private, and he looked over what I'd created. He seemed to genuinely like what he saw and flipped back and forth examining my art for a short while. He told me he thought it was cool that I was the younger brother of someone he respected, and that it was clear to him by the attention I had put into my art that I was interested in tattooing. After a few moments of gruelling suspense, it came just like that: he offered me an apprenticeship. Over the last few years, I'd hit points where I never thought I'd get that far. And there I was standing at the cusp of the thing I'd wanted for so long, in a shop I thought was really cool. It was one of the finest afternoons I can remember.

I was to come to the shop as much as possible. My shift at the dairy was from about six in the morning until two in the afternoon.

Then I would head straight to the tattoo shop and stay as long as I could, generally until closing. It was going to be a hard road, I knew, but I was ready for it. I didn't see my friends for two months following that. There was just no time, and besides, I had to stay focused. Those were the most tiring two months of my life, but did it ever feel good. Or maybe that was the delirium.

The first day of my apprenticeship felt like I had just climbed a mountain and was being rewarded with a view. I felt nervous, powerful and humbled. Eric was a great teacher and mentor. He knew a lot about the trade, from its art and history to machine-building. Just him and me in the shop, we would talk for hours. I loved learning about tattoo machines and how they worked.

My dad used to have a fully functional miniature boat motor made from tiny metal components. I would sneak into his room, open the top drawer of his dresser and remove it from its cardboard box to examine it whenever I could. I'd take the top cap off and marvel at the intricacies that lay inside. I realize now that this little motor is one of the reasons I love tattoo machines so much today. When the tube is attached to the tattoo machine, it is the same shape as my dad's little motor.

Eric and I would pull out his boxes and cases filled with washers, bolts, old copper coils and spring stock, capacitors, anything you could think of to build a tattoo machine. We'd lay out all the parts and build machines together, like playing Lego with my brother when we were young. Eric taught me the working mechanics of a tattoo machine and about the cycle of electricity and the magnetics. He showed me how to scrape the coating off copper and went into detail about soldering, which I already had a pretty good grasp of from electrical class in school. He explained how the springs worked in relation to the cycle, how to cut them by hand from stock steel and form them perfectly to the machine you are building. I thought it was amazing that you could build a proper tattoo machine right there and then. He taught me that I needed to know this because a tattooist should be able to fix their machine if it breaks in the middle of a job, especially if they're

travelling. I thought about the Texans in Prague, and the idea that my new life could potentially carry me around the world made me smile.

I loved the way all these components set in different configurations completed this cycle of electricity to make this little machine run, that you could fine tune this to get it to run in different ways. Eric made me take my machines apart and put them back together again, over and over, until I became adept. We looked through catalogues at what type of machine I should buy. I needed a shader. I already had the Spaulding Puma I had bought from Studio One, which he told me would be good enough to use as a liner for now. We picked out a National Deluxe Swing-Gate, a reproduction of a famous machine fashioned by pioneer Bill "Jonesy" Jones, who died in 1969, and whose machine-building skills revolutionized the trade.

To be learning this history, and to now be a part of this way of life, meant the world to me. When my shader came in the mail, we got out the soldering iron, files and snips and got to work. After we cut the springs and soldered all the coil wires and attached them to the frame, we found a suitable armature bar and proper capacitor, fine-tuned them, and there it was: my first real, self-assembled tattoo machine. It was so satisfying to hear it buzzing and working well. I was buzzing, too, almost as if I was finally running smoothly after sitting disassembled in a drawer for so many years. It was tarnished brass and very pretty.

Eric also had me trace flash to no end with a fine black marker, getting my lines crisp and without waver. He showed me where I should break a line in tattooing in relation to the drawing, that I should always break it at an intersection with another line, which would keep my lines nice and tidy. It's a practice I still use to this day. Going over the flash, I was learning the structural elements of a tattoo, which ranged from simple formulas to the importance of repetition.

He told me that because I had tattooed some friends already, we were going to fast-track things and skip tattooing melons, which you would normally do during the course of an apprenticeship to get your hands accustomed to pulling lines and adjusted to the weight of the

machine. I had been tattooing melons for years and could definitely hold the tattoo machine without difficulty. This meant I was going straight to performing a test tattoo on my own leg. The test tattoo is the only real way to find out if you actually have what it takes.

I chose some Old English font, a fairly complex tattoo for me to try as my first one in the shop. Old English has straight as well as curved lines and is very angular and precise. The structure of the font is challenging; it seems daunting to fill with a liner needle and not quite big enough to fill with a shader needle, especially at the size I would be applying it. It's easier for me these days, now that I know how to do it, but back then it had me sweating. Luckily, my tattoo was small enough that a loose liner needle worked just fine for filling it in. I thought about the day I got tattooed back in Prague and pretended I was taking the machine from the apprentice to show him how it's done.

I slid into a zone that day while making my first piece in the shop, and for a few minutes I was carried to another place. It was just me and this tattoo that lay before me. I was breathing life into it. The rest of the world slipped away; it was just here and now. It was a natural transcendence, a peaceful space to be. That surreal feeling would change everything forever.

Overall, I did a good job. The test tattoo turned out very tidy; my lines were straight and surprisingly it healed solid black without any problems or touch-ups needed. I remember everyone in the shop hunched over me, watching me intently as I sat in the hot seat. Whenever I was unsure about something, Eric would show me what I had to do. He showed me little things, like to spray water on the tattoo so that, through the water, I would be able to see the areas that needed more black. I thought that was clever. I could only have learned these little tricks from an established professional. Eric encouraged me in the way that he explained things, and I responded well to that. When I was done, I felt the rise of satisfaction within me that I had done a good job, with the approving smiles and pats on the back. It was a grand feeling. And then there was poor Johnny, Eric's other apprentice, who had

tattooed his whole lower calf with about fifteen small black tattoos, attempting — and failing — to get it right . . . I felt badly for him. He must have been a little bit cheesed, but because of his good nature, he didn't let it show.

I witnessed the power of tattooing for the first time the night my brother tattooed me. This time, it showed me something very different. I was standing at its gates, in awe of its presence, but not scared to look into its eyes. I could feel its wing across my shoulders, and it felt like home. I had spent many years in no man's land, roaming, looking for something to lift me up. I found a new feeling, unlike anything I had experienced yet. When I tattooed, I was somewhere else. Everything disappeared. It was like travel, leaving one state of mind for another. I loved it.

For two months, the days blurred to nights, and I began to feel like I was living in a dream world. My engine was sputtering and shaking, but I kept going, just long enough to see the gas station sign in the misty darkness.

I was sitting at the desk, working on a drawing, when Eric came in and tossed a piece of paper with a black tribal sun motif in front of me and said, "You're up. Go set up." I looked at him. When he wasn't wearing his trademark smile, he was wearing a serious face that reminded you of his hard-knocks tattoo-shop upbringing and that he wasn't fucking around.

"But . . . I don't feel ready," I said.

"Sink or swim," he said, fixing his eyes on me. I couldn't look away. This stone expression rattled me because I'd never seen that side of him before. I had tattooed some friends and myself, but never a paying customer, and I became wrought with nervousness thinking of what I had to do next. He spoke again sternly, "Go say hi to him, and then go set up."

I had come all this way, and now my moment had arrived, but hadn't come down the pipe the way I imagined it. I walked out and said hello to the guy. We shook hands, and I smiled and was conscious to appear

friendly, just like Rob, Dabz and Eric had been when tattooing me. We talked a bit about the design, and I told him I was going to set up and would be back in a few minutes. He was a nice dude and seemed excited, which made everything easier. I fed off his energy as I began setting up my station. Because I had my back turned to him, he didn't notice how badly my hands were shaking. With some struggle, I fed the needle through the tube. I put the equipment down and excused myself to go to the bathroom. I washed my face and gave myself a pep talk. There was no turning back. *You need to make this happen.*

Eric was right: it was time to sink or swim. Somehow, I managed to finish setting up my equipment without fumbling the machine, thinking about my brother the entire time. I thought about how he was probably setting up for a tattoo as well, about how he was probably making his client laugh right then. I tried to channel that and have more confidence.

We began talking and my nerves calmed. I put the stencil on him, and he looked down and agreed the placement was right, and just like that we were off to the races. Tracing the outer perimeter of the design in black lines, I then filled in the tiny spaces of the points with a fine needle. When that was complete, I used a larger round needle to fill the rest in solid black, just as I had done with my Old English tattoo. I finished fairly quickly and was pleased with how it looked — that is until he stood up to look in the mirror.

The whole design shifted slightly. I am fairly certain I made an audible gasp, though he didn't seem to hear it. Because I was so nervous, a crucial mistake had been made: I had put the stencil on him while he was sitting down, and this is the number one no-no. A stencil should always be applied while the person is in a standing position, when the arm is hanging naturally at its side, which Eric had stressed to me. My nerves were so shot and my mind so focused on not letting it show while we talked that I had made the fatal error.

I had fucked up on my first client. My heart sank into my guts. So, I sat and waited in horror as he went to face the mirror, where all

tattoo truths are exposed. He looked in, and there was a moment of silence, the neutral expression on his face unreadable, before he smiled, looked back at me and said, "Looks great! Thank you so much!"

I took a closer look, and even though the tattoo had shifted almost a quarter turn, it didn't matter that much because there was no definitive up or down to the design. The points were all irregular. I still felt awful about having made the error on a paying customer, but he reassured me how happy he was with it and even gave me a tip. We shook hands, and I watched him as he left.

Eric told me the tattoo looked alright and that I'd done a good job. After I told him what really happened, he smiled that big smile and said, "What? You did what?" His laugh was as goofy as his grin. He told me I'd gotten lucky and not to sweat it. "There you go, your first of many falls," he said. "Time to get back on the horse."

This was my first lesson on a hard road of creative endeavours that, without a doubt, assured me there would be failure before victory. Many would step out after such a lesson. You stay in if you're bold.

At the end of the day, Eric came to me and handed me the money I had made from the tattoo, plus my tip. Wow, that feeling — getting paid for a tattoo for the first time. I went home that night feeling wired. What a roller coaster. From the nerves, to the slip-up, to a triumphant end. I felt more alive than I had in a long, long time.

From there, I was thrown into the current and had to leap up the waterfall. Almost every day that I went to the shop, I got to do a tattoo. What I made working there would be enough to pay the bills. It began to snowball, so I waited and waited until I felt like I just might be able to sustain an actual living. I decided once and for all to take the leap into the great unknown.

NEW BEGINNINGS

My boss at the dairy wasn't happy about me leaving. After I gave my notice, I stayed for about two weeks. But the air changed between us, which surprised me. He treated me like a stranger, after all this time and all these years. I'd given that job everything I had, but for what?

The day I walked down that gravel driveway one last time, I didn't look back, not even once. I went to wait for the Weston Road bus like I had a thousand times. The big trucks passed me in the barren streets as I watched a lone worker walk slowly down the way. A sadness came over me as night fell over the city. I watched the worker carry his coffee and light his cigarette and thought about all the friends I had made there. I thought about Simon who always called me Flaco y feo (skinny and ugly in Spanish). I would miss him. For five years, I stood right beside them, swinging the hammer. I had stayed as long as I could. My heart said goodbye, and I lit a final cigarette before I saw those yellow lights, and the bus came to a stop with a squeak that rang out in the empty streets.

In a way, I felt as if I was giving up, although I knew I wasn't. I had tried to make Joe proud of me. In those five years, he taught me what it meant to work hard and to grapple with difficulties. He taught me not to go hiding when things seemed impossible. I was going to apply that ethic and all I had learned from working with him to the path I was on now.

The door of the bus opened. I took a seat and closed my eyes, and that was it. I was gone into the dusk. As long as my hand could hold a tattoo machine, you wouldn't be seeing me up at Weston Road and Steeles Avenue anymore.

It was the summer of 2000 in Toronto, and it was a good time to be alive. I was a tattoo artist working in a downtown shop, and I was on

top of the world. But once I sank my teeth into tattooing, I could see just how difficult it really was. I was beginning to wonder whether I had made a questionable life decision. I hadn't yet experienced this type of stress, and a bad day at the dairy paled in comparison to the intensity of learning to tattoo. I learned that at the core, the job was about how well-equipped you were to deal with all the things that are inevitably going to go wrong at all times. Very rarely is the situation ideal.

I thought back to how much trouble I had communicating in my childhood. Here I was in a career that demanded communication. When I was young, my pictures were my voice, and now it was becoming easier to talk because my life was about images. My words came out naturally when talking about the tattooing process.

One of the toughest aspects of learning how to tattoo — something that is still difficult to this day — is having to maintain a conversation with the person while tattooing them. It's hard to describe the balance that needs to be achieved in your brain to perform both of these tasks in tandem. If you can imagine steam billowing from a person's ears, that's what happens when I've completed a tattoo where I've had to keep constant banter throughout it.

Tattooing in a street shop is a difficult experience to put into words. You learn all about people. It's essentially an anthropology class.

The characters, though . . . I had a drunk argue with me about adding beady red eyes to his lizard silhouette tattoo in the final minutes, just before completion. I told him I didn't think it was a great idea, and we went back and forth until he started getting worked up about it. Finally, my boss had to take over and finish the tattoo because I clearly wasn't dealing with the situation well; to this day, I don't know if he put eyes on it or not. I had a woman who, after I tattooed a nice little butterfly on her, identical to the picture she brought in, boldly state her disapproval into the mirror, a look of disgust upon her face: "This looks like shit." Another person ran out on me after her tattoo was done, and I had to chase her down the road to get her to pay her $80 tattoo bill. It was a rough start. I was getting my ass kicked all over

the place and feeling weary. Part of me, to this day, thinks maybe I got thrown into the water too soon. Eric had me doing some larger pieces that I felt were out of my league. I couldn't avoid these tattoos because refusing to attempt them meant I would have to find another place to work. So I just tried to do my best.

The stress and chaos seemed to level out somehow, or maybe I was just becoming desensitized. I was figuring out how to tune my machines by myself, and I started tattooing a few pieces I thought were really nice and doing a good enough job that I even got some return clients. That made me feel great, and it was a thrill to see my work healing nicely, not like the pieces I had done back at my apartment. Because of this, my portfolio was growing. Greg, the manager, was encouraging with me about my progress, and I miss that guy's gentle energy a lot. I'll always remember our constant argument about how the toilet paper roll should go on the holder; whether the paper should be coming out at the bottom or the top. I can still see him smiling, shaking his head, saying, "Naaah man, naaaah maaaan, it doesn't go like that, Chris."

OLD'S COOL

I decided I would get a tattoo of my mom, and I chose Lannie Glover to do it for me. It seemed like he and Bill Baker were the only people who would be able to tattoo a portrait properly. I had a beautiful black and white photo of her, taken on her wedding day. Besides its timeless feel, the monochromatic image was full of contrast; it had all the makings of a perfect portrait tattoo. Lannie had moved his shop from Toronto to Peterborough by this time, and seeing him again was exciting for me.

I remember walking up to his shop to find him standing outside smoking. He had one hand up high, rested against the wall, and the other against his hip. He smiled and said hi, and I told him I was his appointment from Toronto. We shook hands and talked for a few minutes as he smoked. He towered over me and appeared even bigger than I remembered from when I first asked him about the co-op placement in the East End. His hair was a scraggly blond mess, and almost seemed more fit for wrestling than tattooing. I knew I was dealing with a different type of human when I noticed that the crude letters of the shop name, Fantality, on his muscle shirt had been written in magic marker. I couldn't figure out whether I was impressed or startled or both at the same time.

Lannie Glover is a quirky character who embodies yesterday's spirit of tattooing. I called him the dark horse of the Canadian tattoo scene, and I stand by that. He knows things I'll never know, and he'll make it clear when talking to me. In my opinion, he could still tattoo better than many in the city.

He mixed a lot of his own pigments, and he could tattoo colour like no other. I once brought my friend Skinner up to see him, and Lannie

did an extensive cover-up on him. I had never seen anybody make a tattoo disappear like that before; it was magic. He covered up the large existing bicep tattoo with a massive squid, using all his own pigments. (Later that year, Skinner was at the Toronto Tattoo Convention and couldn't believe it when Filip Leu, of the Leu Family Iron, stopped him in the middle of the aisle to ask who did his squid tattoo and what kind of pigments they used. Apparently, Leu studied it for quite a while. This is one of the highest compliments you could ever hope to get in tattooing: having Filip Leu examine, let alone be impressed by your work. Second-generation tattooist after his mother, Loretta, and father, Felix, Filip was tattooing at the age of twelve. He embodies the nomadic spirit of the trade and can take credit for elevating the craft immensely. His body of work is immeasurable and instantly recognizable. If there lives a wizard of tattooing, he would be it.)

I was learning great things back at the shop, but I knew I was receiving something of a higher order being in Lannie's presence. I got the portrait on the back of my forearm, and so I was able to watch some of the process. I was like a hawk peering into a field, trying to spot the mouse. I watched every single move he made. His hand was so light and delicate I could barely even feel it. My mind was boggled by how careful and precise he was. I could not figure out his system of grey ink; he had poured out seven or eight different shades into caps in front of him, and I couldn't crack that code. He seemed to dip his needle in a different cap in no discernible order. But I learned all about building tones and — almost more importantly — the importance of taking your time. At night, he taught me how to mix the perfect rye and ginger. I realized there were no fences around his knowledge.

Once he found out I was working at Lucky 13, he put two and two together and realized I was that kid who had come into his shop years before. He remembered the ramshackle portfolio I had brought in when searching for a co-op placement.

"The kid with the . . . the . . . the goblins, right?"

My experience with Lannie was a true adventure. Full of wit, knowledge, talent, he is as crass as they come — and I wouldn't have it any other way. To this day, the portrait of my mom is flawless.

Something about these black-and-grey tattoos really spoke to me. They have a timeless aesthetic, like black and white films.

I had difficulty expressing my appreciation for the tattoo. Getting the portrait helped me immensely, for I was feeling great turmoil about my mom. I missed her very much and was in denial I would have to live my life without her. The portrait helped to settle into the pain. It helped to set my fear at ease because now, no matter how lost my brothers and I had become, I had her with me at all times.

Around this time, I reconnected with Chris Johne, a friend of a friend. He was a well-known and talented graffiti artist. He had some cool black train silhouettes tattooed on his arms. We got along well, maybe because we were both troublemakers with an affinity for trains. He seemed interested in tattooing, so I told him he should come by the shop. I recommended him to Eric, who decided to take him on as a new apprentice after seeing how talented Chris was with his art. Chris brought an exciting and vibrant atmosphere to the shop. Being a graffiti artist, his understanding of colour theory was impressive.

Chris asked me if I would tattoo him. He wanted to get a silhouette of a bullet train to complete the collection. I was honoured that he had that kind of faith in me, but it was a daunting request. I had been tattooing for only about four months, and now I was facing a whole new pressure I hadn't even considered: tattooing another artist I respected. The train he chose was the type of image I would find difficult these days, never mind then. Plus, his other train tattoos made by Keith Stewart in Montreal at Tatouage Artistique were so well done. Let's just say the bullet train had me sweating bullets. Looking back on it, I can't believe I pulled it off.

At the heart of the matter, that tattoo represented a connection and the building blocks of respect. This was the good stuff, the real

thing making my wheels turn, making my engine coast the tracks. You can have many things in life, but if you are searching for true satisfaction, then you're going to need guts.

MORE DARKNESS

For the next while, it was smooth sailing. I learned a lot about colour theory from Chris, and I was starting to put some solid tattoos down. My lines were getting cleaner, and Chris and I had discovered the magic of using Eric's Spaulding Supreme machines as shaders. We were making considerable progress.

But just as everything was moving along nicely, some unsettling characteristics were beginning to surface in Eric. I caught a first glimpse one day after having a few beers the day before. I hadn't realized he was very much against drinking, and when I admitted laughingly that I was slightly hungover, a cold feeling came across the shop. I was on time and fully prepared to work — in fact I wasn't even tired. I was sweeping the shop when he began to grind my gears. Because he had worked with my brother, he knew some of our family history and had seen how wild Rob could be. He suddenly blurted out something about how I was going to end up an alcoholic like my mother and brother. His statement was clearly meant to sting, and it did.

Immediately filled with anger, I tossed the broom and walked out. I didn't know whether my mother was an alcoholic. There may have been rumours, but as a young kid I wasn't aware. And it was no secret that Rob enjoyed drinking, but I didn't see him as an alcoholic.

Eric later apologized sincerely, and I reciprocated, realizing it wasn't professional for me to be hungover. We were able to move on. But you don't say something like that to me without expecting that from that point on, I am going to do all I can to show you who I really am. I may like a sip from time to time. I mean, I was raised on Jack Kerouac (thanks to my friend Jason Yates). But I'm going to be a good tattooist,

come hell or high water, and it's not going to have much to do with alcohol, that I can assure you.

Eric decided to move the shop to Ossington Avenue and Bloor Street, which bonded everyone. The camaraderie of building a new shop together was a comforting experience. It was fun to see the place come to life and get off the ground so fast, and things with Eric improved for a short while. I tiled a two-tone nautical star into the centre of the floor of the front room, calling on some entombed math skills that hadn't seen the light of day since high school. I could remember us all sitting in grade twelve advanced math saying to one another, "When the fuck are we ever going to use this?"

The new shop was much bigger, and Eric hired more people. It wasn't long before there was a whole crew there. But as the good creative energy was blooming, the gloom I'd been noticing persisted, and Eric's once-playful grin gradually became something that made me uneasy. I couldn't quite put my finger on it, but my gut was like an alarm. There was another side of him emerging that didn't sit well with me, and everything inside me told me that it was time to move on. Although it was a tough decision, and it made me sad, I decided to leave. He'd nurtured me, and I felt a real loyalty to him, but everything had changed. I think about it often, and to this day I wish we could have worked things out. A part of me believes a tattooing career wouldn't have happened for me if he hadn't come along right when he did. I still hear Eric's voice in my head sometimes when I am tattooing.

It's a shame that we must say goodbye to some people at certain junctures in our path. I wished I didn't have to part ways with Eric, but I wasn't a stranger to saying goodbye. I was beginning to understand that we are all alone and we can't depend on anybody but ourselves. It's up to us to choose what we make of those encounters. I'm not sure if Eric knows the full scope of what he gave me. Maybe he does, maybe he doesn't.

YOUNG HEARTS, YONGE STREET

I had been tattooing for almost a year. I hit the pavement and started knocking on doors again, only this time I had a decent portfolio of tattoos to help me out. There were a few shops along Queen Street that I tried my luck with but was treated the same as before I had become a tattooist. In one, the largest of the Queen Street shops, they laughed at me when I asked if they were hiring. I wasn't surprised by the treatment and didn't think too much about it.

I headed up Yonge Street and landed a job in a newer place at Wellesley. It was a street shop through and through, covered floor to ceiling with flash, and it catered to tourists. The manager, Skinner, was this funny little wildcat with an unmistakable snicker. He was a loveable character who made friends everywhere he went. I got along really well with him and the other tattooist there, Charlie Whitlock. He was a real cool guy. This is where I met Joe Berry as well, someone who would go on to be a great friend of mine for years to follow. Though it hadn't been my first choice in shops, I needed to work, and it paid well. It felt nice to be making real money for once.

Some mornings, there would be a lineup outside the shop of people waiting to get tattooed. That was a stressful sight first thing. You knew you were going to be working really, really hard right from the get-go. Long gone were the quiet mornings of the record shop, misty rain falling through the trees as I smoked pot with Gary on the doorstep.

In retrospect, that pace was exactly what I needed at the time. It tightened up a few things I needed to learn. Speed and stamina. On average, I was doing ten tattoos a day. Some days, it seemed to never end. I remember lost souls wanting to get tattooed at nine o'clock on a Sunday night. It was absolutely maddening; didn't they have anywhere

else to be? During Pride, I tattooed rainbow flags on locals and tourists from all over from ten in the morning until ten at night. During Caribana I tattooed until the point of collapse, where the only bit of gas in the tank was when Skinner would flash the calculator at you as he pleaded with you to do just one more. You could somehow find the strength and patience to carry on as the digits showed you how much would be in your pocket at the end of the night.

Regardless, it was a fun summer, the shop chock full of colourful characters. I began to get a sense of this other side of tattooing, whose history was rooted in a sort of carnival showmanship, embracing all that is different and celebrating the unordinary. The shop also embodied the extreme practices often associated with tattooing, like piercing and body modification.

This was an eclectic time in tattooing. The art seemed to be searching for a new identity. It was branching out and was experiencing growing pains. Where its roots were heavily steeped in American traditional and realism, both tried-and-tested styles, it began testing its boundaries beyond these two. An abundance of questionable decisions came with such experiments. Perhaps the missteps were necessary to find out for certain what really worked and what didn't, like getting lost to be found.

From the early sideshow days, tattooing has always embraced characters who have pushed the limits seeking fame — from Paul Lawrence, better known as "The Enigma," the man covered in puzzle-piece tattoos; to Erik Sprague, "The Lizardman," covered in green scales with a split tongue; to, more recently, Rick Genest, "Rico the Zombie," who went from the streets of Montreal to modelling in Lady Gaga videos (RIP).

The lure of this path is strong for some, but surely a gamble. If you take it far enough, you might reach heights of notoriety; cameras will be flashing wherever you go. The piercer at the Yonge Street shop was one who had been captivated by this calling and begun the long road to transforming himself into a human tiger. For years, he'd been tattooing tiger stripes on himself from head to toe.

I found this amusing. He looked a little like Lou Diamond Phillips. He was super charming and the ladies loved him, I remember that. He went by the name Lobo, and was a nice enough dude, but we didn't get to know each other at all, even though we worked in the same shop. He looked at me through the corner of his cat-like eyes and slinked back down the hall after I politely declined his offer to add a few tiger stripes to his collection. In retrospect, I should've. Lobo, if you're out there, hit me up.

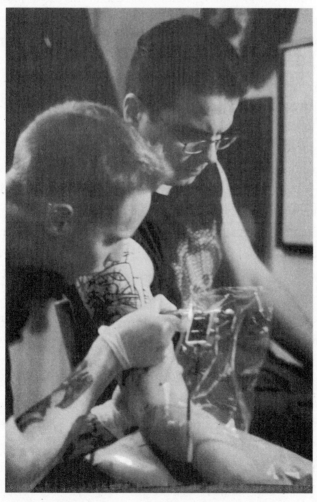

Tattooing Lukas in my bedroom, 2000.

REBIRTH

It was summer in the city again, and young hearts ruled. My friend Jodi, who worked at the shop, was having a barbeque at her place and invited me over. Jodi was genuine and had an infectious smile. We both enjoyed drinking. I accepted her invitation, and together we taxied over to her place. In the cab she told me, "I know you don't care, but your goatee is a little crooked."

We walked into the backyard. The party was already underway. I sat down at the table, and directly across from me sat the girl I was going to marry. I was blind to everything except her.

There she was, sitting, smiling with her messy red hair. Her green eyes sparkled in the sun. As hard as I tried to hold conversations with the new strangers around me, my eyes kept wandering back to hers, and when she would glance at me, something inside would boom low and heavy. I realized in that moment that the rhythm of hope is like a freight train. She told me her name was Megan, and I thought about how her messy hair paired with her name. Megan with Messy Hair.

The day was turning crystalline. The sun crept across the yard, leaving long shadows reaching across those cement porches and rusted tin awnings on the outskirts of Little Italy. Everyone smiled and the music sounded like power. We sat in chairs and on floors. We smoked and drank and talked about everything. Laughter echoed through the apartment as the lights dimmed, and I sat with Megan against the wall, listening to her speak French. I basked in her glow and watched the smoke drift toward her as if she was calling her spirits home. I had only known her for a few hours, but I knew she was so much smarter than me. I was hooked, instantly. When she laid those eyes on me, it was like moonlight spilling onto a darkened field.

I promised myself that by the time those long, crushing summer nights had spit me out into the gutter with the leaves and the slugs, she would come around. Mark my (inner) words, I would be buying Megan with the green eyes and messy red hair breakfast someday.

I left Jodi's that night with a head soaked full of whisky and beer. As I stumbled out, I was sure one of my legs was shorter than the other. Clouds — enormous white ghosts — galloped like wild horses across the black sky, high above a web of electrical wires. The streetcars were rolling thunder pounding across the intersection. I walked down the road and thought for a while about good things and felt the wind in my lungs. I walked through the park beneath the canopy of giant maples and thought about how great it would be to hold Megan's hand. I thought about how she had asked me to come outside and tell her about my tattoos. I thought about how we sat on the veranda with the streetlight beaming down as she pulled her knees up to her chest, a ribbon in her hair and flames on her shoes.

I walked for a long time that night in the quiet with her on my mind. Maybe I would get to see her again. I couldn't wait to see her again. Anticipation: a gift and a knife.

As I looked out from the tattoo-shop window, Yonge Street gushed by in a tidal wave of people and passing vehicles. In my memory, the lights were watercolour trails. It was cold in the shop, even when the sun was close. It wasn't my place, and deep down I didn't like it. Everyone was high or into strange things, and they talked like the shop was the big time, as if there wasn't a whole world out there. I felt like I was trapped in a strange twilight where nothing seemed real.

Some nights I felt better than others. I would go to Monster Video and buy old films on VHS (*Rumble Fish* and *Goodfellas*). I would go to my apartment — I was back in the East End — and try to cook something half-decent, drink beer and watch movies. I would play guitar, write and think about things. My cats — my boys — were always there for me.

Many days, I would stand at the window of the tattoo shop, beckoning the rain to come and wash the heat from the streets and send everyone home. Then one evening, Megan appeared across the street, standing in the wave of people like the sun, twinkling. She wore a green hat and knit skirt over her jeans, kind of like a hot granny. Beautiful. She lit a cigarette and waved with her fingerless glove from across the street. I could see her cheeks, round and pink, and her shy smile. I left the shop and walked straight into traffic, parting the sea like Moses with his staff. My eyes were locked on hers. She twisted nervously. I stood before her and looked down at her diamond eyes. Everything mellowed as she opened her mouth.

"Hi."

Wow.

"You should come out and play this weekend," she said, swaying.

I shuffled my feet and stared down. I said something in return, but I don't know what. We danced around each other as the wind blew for miles down the funnel that was Yonge Street. We said goodbye, and I watched her walk away and disappear into the crowd. I wished I could go with her. I could feel the pounding inside me again: *boom, boom.*

The next evening brought her to the shop window again. I could see her through the neon and the reflections. The buzz of tattoo machines surged in the background. She came in and had big hugs with Jodi. We talked. I was so nervous. It's always been a problem with me. I'm dumb and say stupid things. But her heart was big, and she knew I was just a fool. She must have been used to idiots tripping over themselves around her. She forgave me, and we made plans for drinks as she slipped away in her flame shoes.

A few days later, we met at the Living Well, which was cool and secret. We made friends with the bartender and found a nice dark spot at the back. We made up a strong blue drink and gave it a silly name. Our bartender friend was happy to make it for us. Megan told me about her career in television and that she didn't think she could do it any longer. She'd come to realize it wasn't for her. I told her everything

would be okay. As we hugged goodbye, I caught the scent of her hair and was paralyzed. Then she was gone again.

That summer had me spinning out of control, and Megan had the power to slow it down. I would act out. I would stay out late all the time with my friend Lukas from high school and Matt from the shop. We were reckless. We got into a lot of trouble. I was being haunted by my past. I was trying my best to bury how much I hurt inside about my mom, and it came out in the form of destruction. I was angry. The days blurred into nights, and every night I would drown.

My broken guitar and tattooing — that's all I had. That and the faint hope of seeing Megan again. I kept my head down and tried to make something out of nothing. Then darkness would fall again, and I would run off into the night. I would run from all the things that came to me in my dreams, when I would wake and think about how everything was fucked up. Those nights, I would press play on the stereo, light a cigarette, listen to music in the dark.

My mid-twenties were horrid. Everyone was messed up and confused. It's hard to even find the words. I knew Lukas was my friend, but the rest of them? I felt like a stranger. Some of Megan's friends were leery of me — maybe they felt like I was taking her away. It's like that when you're young. There was a night at the El Mocambo that it all came crashing down. Our crowds collided. There were bad vibes all around. I finally had enough and walked out. I was exhausted.

I headed back to the East End that night and was unsure about what was in store for me and Megan.

I let the subway take me back over the big river that divided us and them. I got off two stops early and went to the Hargrave for a midnight pint. It felt nice to be alone and to walk home after, the big wind up in the trees. I opened the door to my apartment, and Matt was there. Matt was friendly and fun, but he was young and didn't get that I needed time to myself. I shut up, and we drank and watched movies. But Megan kept popping into my head.

It was late when the phone rang. I heard her voice on the other

end, and she asked if I was still up. I told her yeah, and the next thing I knew she was on her way over. At three o'clock in the morning, I opened the door, and she was standing there with her green eyes, messy pixie hair and flame shoes in the shadows of my doorway. We went into my room, and she slept in my bed. We held each other in the darkness with the garbage train rumbling by in the subway tunnel on the other side of the wall. I was filled with a new vision; I was going to survive. That night, an angel came to me in the dead of morning when my head hurt and calmed me. I felt like a beast. She had me breathing to her rhythm, Bob Dylan and the Jack of Hearts in the darkness. The birds were singing as the morning blue crept across the strange and broken streets of the East End.

A week later, we met at the Hargrave. She said she had something to say. She told me she was falling for me. Then she fell off her stool. I was in love.

WEST END

There I was, in the thick of it. I had the girl, and my friend Dax managed to get me a job at Tat-A-Rama, out in the West End. I was happy to be away from Yonge Street.

Tat-A-Rama was the oldest standing tattoo shop in Toronto. Founded in 1987 by Bill Baker, a most important figure in Canadian tattooing who was ahead of the pack since day one, the shop had been in its original location for over twenty-five years and is still there today. Tat-A-Rama was a gateway. It was well known and seemed to pour successful tattooists into the stream. These days, it's looking a little worse for wear. The walls have stories, many good, many bad. Without question, there is an energy inside. It may not always have been a positive energy, but through osmosis it was passed into capable hearts and hands.

The shop was to be my home for nearly six years, and I met so many good people there, so many wild and wonderful characters, too many to list — you know who you are, and I love you all. Eugene was a good boss, and we became friends. When I started there, I was twenty-six or so, but looking back on it, I was still acting like a kid. I began to get cocky and tricked myself into believing I was a better at tattooing than I was. There were many stumbling blocks along the way while I tried to find my voice. When I got too big for my britches, Eugene would cut me down to size, and thank goodness for that.

I was biting off more than I could chew, which resulted in some questionable-looking tattoos, many of them still haunt me today. I was always trying new techniques and attempting to break the rules I'd been taught, which came at a price. Experimentation can be invaluable down the road but damaging in the present. It's a double-edged sword.

Eugene was always cracking the whip and trying to rein me in. I would stomp my feet and whine to my friends at night.

For an outsider looking in, it may have looked like my tattoo career wasn't going to amount to very much. I was trying to grasp many different styles, and in doing so, I relinquished my own identity. I had no clear-cut signature that would identify something as "my work." I wasn't concerned about that sort of thing at the time. I was only interested in learning. Eric's voice still rang in my head, and I was trying to be as versatile as possible. I kept chipping away. Eugene was the same as Eric in that regard: if somebody wanted to give you business, no matter what they requested, you would try your best to make it a good tattoo for them. And when you have a boss breathing down your neck to make money for the shop, you have no choice in the matter. I tattooed a thousand roses, a thousand names and birth dates, a thousand armbands. I tattooed people from every walk of life. You name it. They kept coming.

I kept my head down and tattooed at Tat-A-Rama. I got my ass handed to me twice a year by Eugene; the rest of the time he'd leave me alone. His sting was sharp when he felt like he had to tear you down. It was scary and disheartening. But despite the few bad days at Tat-A-Rama, I was still thankful. Retrospectively, I am grateful that Eugene was hard on me when he was. I needed it. From within the walls, I tried to soak up some of that old spirit of tattooing.

THE LIGHT THAT LEADS THE WAY

My stepmother, Karen, was dying. She had been diagnosed with breast cancer, which had spread. Even though I never fully accepted her in my heart of hearts, I did care for her. For months, Megan and I made regular visits to the house in Rexdale, where she lay in a hospital bed in the shadows of her room, her hands withered, her eyes sunken. She could still muster a faint smile for everyone. Her two front rabbit teeth pushed at her lips as she would lay her deep eyes on you. She had grit and kept hanging on. It became, strangely, almost amusing that she wouldn't let go. We all knew from how positive she remained after the MS left her in a wheelchair that she was tough, but now she seemed to be almost flaunting her spirit. She finally said goodbye to us on Dad's birthday.

It was sad to see her go, and it must've been devastating for my dad. The following days, I helped him clean the house. We opened the curtains, let the sun pour into the dusty room and played Fleetwood Mac loud on the stereo. We removed the hospital bed, vacuumed and dusted. Cleaning up her room gave me some closure.

With death came the realization of mortality. I became aware of the fragility of life more than ever before. In the shadow of Karen's passing, I thought a lot about how nothing stays forever and things are always changing.

The tattoos I did were no different. They only stayed in my life momentarily. I would make them, then they would leave. There was something poetic about that. But when I thought about the tattoos I wore, I began to see them as rocks amid a sea. The tides would come and go and come and go again, but my tattoos stood their ground.

They became worn by the water but were still monuments of their original selves. They remained loyal.

In a world where progress means change, sometimes we only change things because it gives us a sense of power. Humans want control, and yet at times I am attracted to things I can't control. It's like standing on the peak of Point Lobos, staring down into that canyon, thousands of feet above where the Pacific waves pound the crude, jutting Saint Lucia Range below. Land in its most brutal and beautiful form meets the mother sea, and the two rage far below and set the precedent for what true power is. Cypress trees stand in the thousand-year wind, ragged and resilient, and breathe and sigh in the twinkling California light. They were here long before us and will probably be here after we're gone. Anyone who's been to this spot knows what I'm talking about. It's humbling. We are insignificant, only passengers. The real power lies beneath our feet.

From a philosophical standpoint, it's safe to say that the tattoo dies with its wearer. But while it's here, it can only be manipulated so much before it becomes set and ultimately beyond our control. Tattoos stay with you forever and stay the same, and that thought comforts me. When they lower me down into that cool, damp hole, and dirt is pounding on the pine lid, I will have my charms with me. I will have the gang to keep me safe and guide me through the ether. That may sound silly and naive to some, but not to me. I'm a romantic and believe there is something else out there: there are eyes in the trees, another force unseen. I believe in karma, good will and loyalty. I believe in giving memories a life.

People say not to dwell on the past, but the past is the future because it tells us who we are now. The past holds the key to understanding why we do the things the way we do. The past is my peace, and the way I've chosen to remember things is what I want my world to be: endless silver threads that lead us back to everything that we have become. I believe in progress and moving forward, but I am always looking in my rear-view mirror as well. All of it, all those things that happened

to me are far too important to never think of again. Are we supposed to just constantly speed on, only looking forward, careening toward death? I won't live like that. To set an image to a memory is to give it strength, to set an image to a feeling is to make it real, to create an image is the light that leads the way.

THE LITTLE BLUE HOUSE

When Karen died, she left me some money. Megan and I decided to use it as a down payment to buy a house. We looked at many places before our agent brought us to a street by the lake in the west end of town. As we pulled up to the house, I took one look at it and knew it was the one. From the car, you could see the lake shining down at the end of the road.

I knew why I was drawn to it: it was small, just like the wooden house in Alliston, only with newer windows and nice siding. On some deeper level, I knew that one day I might be starting a family of my own. I felt like maybe this was my wooden house, standing out in the fields, and it could fill us with the same type of emotion that house had — but it was in better shape, maybe the love inside would be, too.

I put the money Karen left me into the house, and my dad helped us with a loan as well. It was a dream to have the little blue house by the lake.

The kitchen table is where I paint and draw, all the while watching the big, craggy basswood wave in the wind. I have written a thousand songs in the dining room. To this day, I still sing there. The acoustics are good, and the view is comforting. We have a deep lot, and the backyard is surrounded by a tall fence. In spring and summer, the gardens bring tall lilies and hostas under the lilac trees. There's a dogwood in the back corner; its green-and-white leaves are easy on the eyes against the backdrop of the charcoal shed.

My favourite season was spring, when on grey, overcast days I would play guitar and watch the rain come down. Grackles, black and iridescent, would swoop in from the basswood canopy to land in the grass below. I spent many days alone there. The solitude I felt was

healing. I was given space to think about all the things that I needed to think about, to sort through the things I felt needed sorting out. I was aware that I had unresolved issues, and I was trying my best to understand their meaning and effects. I lingered with my memories and turned them into words and gave them a voice. I would sing about all the things in my head. I celebrated the things I remembered, both good and bad. It helped.

Inside these walls I have found something important for my heart and mind. I have sat in this living room — Meg beside me reading magazines, the record player spinning — until the sun came up, until morning. We've spoken many words in this room, and it's where most of this book was edited. My dad came back for me when I was young, and I have never forgotten it. He then helped me buy this house by the lake. Megan and I have lost a lot here. We've cried. We've sung our hearts out. We've slept peacefully beside one another. We've lived a beautiful life in this house.

IMPERIAL

Meg and I did our thing, and I kept my head down and made a lot of tattoos. It seemed like I didn't look up for years. But eventually I had to make a leap. The shop was stagnant. Scandinavian black metal became a constant and turned the days into a haze. It was a struggle to get Eugene to let us put a fresh coat of paint on the walls. He was letting the shop slip, and I needed a different perspective.

I heard through the grapevine that a new shop had opened. There was a buzz about it, and it sounded like a big deal. The new shop, called Imperial, was branching off from a heavyweight studio by the name of King of Fools. The owners were friends of friends, and I managed to get myself an interview. I walked into the loft at Ossington and Queen, directly across from Classic Studios, where we punks hung out every other night. The space was one of the most beautiful places I had ever been in. I almost couldn't believe it was a tattoo shop. It was big, bright and airy with hardwood floors and white walls.

After an interview with the manager, Rob, who then discussed it with the owner, Ronan, they decided to take a chance on me. I was so stoked to be working there. It was the upper echelon of tattoo shops, the type of place I used to dream about. Also, my pal Damian Campagnaro (The Wizard) was working there, one of my favourite humans on the planet.

I gave Eugene my notice. He was totally cool about it and told me I had worked hard and paid my dues. Everyone leaves eventually, he said, and it was okay. Leaving a tattoo home always leaves you feeling melancholy. In many ways Eugene had been the boss who completed my apprenticeship where Eric had fallen short. I was like a bird with a broken wing: he took me in and nurtured me, and let

me get stronger. He encouraged me when I was low and yelled when I wouldn't listen. I am eternally grateful to him for giving me a place to gain the experience to carry me forward.

I started at Imperial and became close friends with Ronan and Rob. They were really good to me, and we connected on many levels. There was a lot of talent in the shop, which could make it intimidating to be there, but I sank my teeth in and tried my best. I worked hard on my drawings and was amazed how the gates were beginning to open in this bright new beautiful space. I was learning so much from everyone and had a lot of fun. This shop was a hub, and brought so many people together, which is a rare and beautiful thing. I used to look out the window, across the street to where Classic Studios once stood in the alley. All the things that happened there that nobody knows about. Just another alleyway. The spirit of youth was so strong then; if you listened close, you could almost still hear the punks on the corner.

STILL MORE GOODBYES

Soon, however, as things were looking up, Meg's father, Mark, was diagnosed with a brain tumour caused by melanoma, and it was terminal. Over the next six months we tried to get to the West Coast, where he was living, as much as possible. The family had him in a hospital bed in the living room. He had a panoramic view of the ocean below the cedars and pines and Mount Baker, painted pink, off in the distance. It was as pleasant as a place could be to say goodbye. The family gathered around his bedside during his last days, and we were each given our final moments to speak our thoughts with him. I thanked him for being so kind to me and told him I would like to marry Megan. His eyes shifted toward mine, and I could see a glimmer within. If you had only ever seen him in photographs, you might think Mark never smiled, but he always seemed eager to smile and joke around with me in person, maybe because I reminded him of his rascal brothers. He seemed to find many things amusing, but at dinner with a glass of red wine in his hand is when you'd witness the big laugh — that or watching *The Simpsons*. Total dad laugh. I loved it.

It was devastating for his family to lose him. He was a great and gentle soul. He never once treated me differently for being a tattoo artist — but am I really surprised? He was part of Megan's family, cut from the same cloth she was. This is a family that believes in kindness and the acceptance of others. I think he knew deep down that my intentions were true and that I was an honest guy who was going to try his best to take care of his daughter.

Mark was a good musician. I have a memory of him, Megan and me sitting on the porch in their old Mallorytown place: The wind sailed up in the big trees, and we played guitar. I tried to play him a

song I wrote about Jack Kerouac. It wasn't good, but he smiled and told me he liked it anyhow. He had on the hat he always wore and smirked his smirk that everyone loved, and we were happy. After he and Megan's mom, Jackie, moved out west to find peace in their new home, we'd visit and read books on the front porch and drink Honey Brown Lager, watch the deer and not say much at all, just smirk. Everybody misses Mark.

So I followed through and asked Megan to marry me. Years before, she had given me a ten-year window, stating that if I didn't marry her in ten years, she was going to leave me. I tried to wait out the ten years, just to see if she was serious. I made it to about eight and decided it was finally time.

The night I proposed, we actually got into an argument.

Anyone who knows us well knows we can both live up to that stereotype of the stubborn redhead. But when all was said and done, she was still standing beside me, like a rock. I was struck with a moment of clarity at what a loyal person I was dealing with. She was everything to me, I knew it from the start. I wrapped up a guitar string so the ball end was on top like a diamond and asked her in the darkness of the kitchen if she would be my wife. She rested her head on my shoulders and said yes, and I knew from that moment on everything was going to be good. We were married in Ruckle Park on Salt Spring Island by the ocean on a beautiful autumn day.

Two years passed in a flash, and after all this time I was feeling the need to make the big leap and open my own shop. After a decade of working for someone else, I felt I had earned my stripes. It was time once again to take a risk. My idea was that if I had more time, without pressure, then the quality of my work would increase. I told Meg I had decided to do this, and whereas she would usually talk me into waiting a little longer, this time she knew I was for real. She should really get paid for her uncanny ability for finding things. The day I told her was the day she found me a small loft at Dufferin and Dundas. I met with Jose Ortega, the landlord, that afternoon. Jose was an artist, very

involved in the community, and so when I told him the space would be a private tattoo shop, he smiled and said, "Coooool."

FULL CIRCLE

My new space was a five-minute walk from where I lived in the roach-infested room with Dennis and my brother in my late teens. It felt surreal to be led back to the old neighborhood, and the transformation from the old days was amazing. Gone was Tulip Donut (which would have given Galaxy Donut a run for its money), my rock of ages, where we would count pennies and buy single cigarettes for twenty-five cents, where on a good day, when the money was flowing, I would buy myself a cheese sub. Sub cheese is comfort. Sub cheese is victorious.

In the space that once housed the legendary Tulip Donut was now an upscale restaurant and butcher selling home-smoked bacon and expensive breakfast sandwiches. I went there a few times, but something just didn't feel right about it. It felt strange to have come full circle. I could tell the snotty server who was too cool for school had never heard of Tulip Donut, nor would she care if you told her all about it.

The loft was on the third floor and had a Juliet balcony. It was small and beautiful, with exposed brick and a wood ceiling. The space was a little unconventional to be a tattoo shop, but that's what people ended up loving about it. It was here that I was finally able to grant myself the time I needed to focus on my tattoos in the way I had always imagined. My art began to come to life.

Little Portugal in the summertime is a beautiful place to be. The neighbouring bars and restaurants come alive at midday with shouts and cheers for the soccer games on television. People would gather together to barbeque on patios, sending clouds of grill smoke wafting into the streets. On days like this, nostalgia was heavy. It would bring me back to fishing with Eddie and his dad. After a cool morning out

in the boat, Eddie's dad would stand at his charcoal hibachi under the shade of the trees all day long while we ran up and down the beach out in the sun. That smell of fresh grilled fish, spiced steak and peri-peri drifting through the country air was pure magic. The one thing I know about the Portuguese, besides how loyal they are, is that they know how to have a good time, and this is always most evident when the sun is out. I admire how they celebrate, like they're celebrating life. Well, that and soccer. I've tried to adopt that spirit over the years.

In the heart of the neighbourhood, tucked back on Gladstone, was the chocolate factory that I used to smell back in the day. Another one lies just west over the bridge beside the train tracks. I remember a summer evening walking across the bridge while a train came down from the north, black through the trees, winding around the bend and lighting the tracks ahead. Above, a pink, dusky sky stretched for miles. The coming night whispered the promise of laughter, beer, music and guitars. Riding the wind was that sweet smell, warm and reassuring, telling you that though you've travelled far, this is home. That smell can make any stomach rumble like a thunder when it comes drifting down the way. It was so nostalgic.

One afternoon, a peace came over the shop unlike anything I had ever known. I was working with a new client, Jose, who lived in the neighbourhood. Jose had lost both of his parents from separate causes over the course of a few weeks not long before our first session, and I could sense a hard pain deep in him. That day I had almost completed a portrait of his father, who looked like a movie star from the silver screen. Generally speaking, portrait tattoos bring a stress that's diffi-cult to articulate, but the tattoo gods were smiling on me that day — I think they liked Jose. This was an intense healing process for him, and I absorbed it all. The doors to the Juliet were wide open, and it had begun to rain. I could hear it falling beyond the doors and dripping from the overhang. I watched as the dark clouds — smoky, grey, blue and charcoal — rolled in over Dundas Street, over the gold turret of the church peeking out above the angled brick buildings and trees.

On the stereo, Johnny Cash was singing a Bonnie "Prince" Billy song about the darkness of life and failure. I can't help but to think of my brothers whenever I hear it.

There in the little studio, I experienced a real sensation, a moment that pulled me into the now. I was in my element. I had created this atmosphere, and I had been afforded a very special gift, an opportunity to make the best tattoo I could, every day — to make something real and to make it last. Every day I was offered the good fortune to try to make somebody feel good or to help them help themselves. The studio lamps cast yellow light onto the hardwood floors, and rain came down in streams outside the balcony doors. With the smell of July and the chocolate factory, life was pure poetry in this hour. Cars passed by below, wheels on the wet road and horns in the distance. Johnny's low voice, solemn and dark, sang of redemption. The buzz of the tattoo machine, the energy there in that space, was my religion.

I think about that skinny kid with grubby clothes buying single smokes from Tulip Donut. I think about that fire in his gut and how he spent five of his last ten bucks on a Hüsker Dü record. How those cheap smokes always tasted best in the morning. As he listened to Grant Hart singing, beautiful and brash, about that girl who lives on Heaven Hill, about the cabin still, about the lantern lit. Even though that kid was hungry and poor, he was alive and happy. Yeah, I think about that kid and smile.

I wish my mom could have seen that loft. She could have seen how far I had come. I thought a lot about her in that little room.

One night, Joe came in from Peterborough, where he now lives, to spend the night in Toronto. He met me at the studio.

Something was off with us, though. These days, it often takes a few minutes for us to feel comfortable around one another; some distance has developed between us over the years. Our words felt uneasy, like we were both stoned and paranoid. Eventually, the topic of our mom came up. I welcomed the conversation, because she is often on

my mind. He seemed uncomfortable with it, but we plodded on. We hadn't talked about her in a long time, but I knew he'd been thinking of her. I told him I thought about her a lot as well — all the time. Tears came down my cheeks.

"You're sensitive," he said. I was surprised he didn't try to hug me. Silence.

In this moment, it felt like we were young again. He was right: I was sensitive. When I was young, I saw him as tough; he still is. But something had changed. I couldn't read him now. He was better at poker than me.

"Do you think about her a lot?" I asked.

He paused. "This sounds strange, but I sometimes think of her as a water-soaked log out in the middle of a lake that sits just below the surface. It's like I'm in a boat and I don't see her coming and collide with her memory. I see her face briefly, then she's gone." He delivered this sentence with solemn intensity.

I immediately reinterpreted the image as a ghost under water, slowly rising to the surface. I saw her hair drift across her face as the boat rolled over her. It reminded me of the dream I had about her in Joe's closet. It rattled me hard.

His analogy felt cold. But clearly, there was a deep pain, as deep as the water I imagined his boat in. He held back a lot in those days. I've thought that maybe he is hurt most of all by our mom's disappearance, but just can't express it. But I also think he tries to keep a stoic stance that was passed down to us. Rob and I aren't like this. We wear our hearts on our sleeves. I learned years after this conversation that he used to watch *Beachcombers* with our mom all the time, and the thought breaks my heart.

I wish I could talk more with Joe about her. The conversation that day just dissipated, as if I was a boat out in the water, watching the rogue log disappear in the wake behind me.

One of my favourite tattoos, done in my first private studio on Dundas Street West, 2010.

THERE'S SOMETHING I
NEED TO TELL YOU

I will always remember in 2015, the day Megan sent me a text asking me to meet her at Sorauren and Queen, just down the street from where she worked in a small wood shop. She had been designing custom furniture for some time. She is so talented. Her ability, aesthetic and determination have always been inspiring to me. I always look forward to seeing what she has been working on.

I could see her standing there, just like she used to stand across from the tattoo shop on Yonge Street. I noticed her blushing cheeks and nervous smile from the small square window of the streetcar. I got off and met her outside the diner on the corner.

She was sheepish and shuffling her feet.

I knew, as she looked up at me and smiled, that I was going to be a dad.

We held each other there, nervous and overwhelmed after the short while we'd been trying to have a baby. With her head against my chest, I could smell the dust in her hair from working in the woodshop all day. Our hearts were beating heavy, and I couldn't stop smiling in fear and wonder. We went and had a nice dinner that night and began talking about all the amazing things soon to come our way.

I was going to be a dad; I was going to have to be a provider. I told Megan I needed to expand and I was going to find the shop I had always dreamt about. I was immediately on the hunt. After much trial and tribulation, I settled on a storefront at College and Dufferin. It was important for me to stay in the neighbourhood. I needed to stay close to the hungry kid I knew from long ago. I found the spot, signed the lease and started building.

HOME

I didn't choose tattooing; it chose me. And I wouldn't be the first tattooist to say that. All arrows pointed this way, so I just kept walking the path and letting it guide me. Once inside the gates, I fought for this career, and I got it. Achievement is the summit reached after struggle, where love, respect and appreciation bloom. I stood my ground in this fight, and I believe there is a place for me within the halls of tattooing.

Regardless of whether it was predestined that I ended up where I have, I don't think I could have strayed from this path. Whenever I did, I somehow found my way back. Now I was back in the old neighbourhood, the place I lived when I first imagined the life I've now found. Maybe it is a coincidence, or maybe someone was watching my back out there in the mist. Some things just work out the way they do, and the how remains a mystery. In the end, that's the beauty of life.

The lure of tattooing is magnetic. What keeps people coming back? I know that for me, getting a tattoo can be a hugely therapeutic process. It can be painful, yes, but it can also be strangely soothing once the body understands the process. When else are we offered the chance to lie back in the middle of the day, listen to cool music, have a good conversation and be with our thoughts for a few hours? We find ourselves immersed in the wait, which is followed by excitement and surprise. It's easy to find ritual in this. Some people will go to a walk-in shop every other Saturday afternoon and have an artist draw something right on the spot. It's a fun way to spend an hour or two with your friends. I know people who go to the barber every Saturday morning for the

same reason. Tattooing may not be for everybody, but the routines and social places make many of us feel good.

My friend Kevin and I built the shop at College and Dufferin over a few weeks. Kevin is an excellent builder, passionate beer drinker and great friend who has always been there to help me in times like that. I have been extremely grateful for his stamina and expertise. The space was large enough to fit a whole crew and it emitted the vibes of a real tattoo shop, the vibes of home.

I have done my best tattooing in that space. The energies have finally aligned, and I am riding a wave I've long been waiting for, like Bodhi, achingly anticipating the fifty-year storm and finally released by Utah so he can take his one last ride. (Seriously, what would a book be without a cryptic *Point Break* reference?) The space offers the balance I had always been chasing. It is an accessible walk-in shop, but with a semi-private atmosphere.

We have to protect tattooing. I said it earlier: if we are good to tattooing, then in return it will be good to us. *Let's fill these walls and bodies with art and smiles, and let us not take for granted the gift we've been given.*

In life, you need to do three things: take a chance, ask for what you want and have faith. On a whim one evening in 2015, upon seeing a job posting, I reached out to Mike Rubendall's Kings Avenue in New York City, not asking for a job, but instead if they'd ever consider having me as a guest. I was surprised when the next morning they invited me. It's hard for me to convey what it felt like when I got the news. The entire experience was exhilarating. Kings Avenue is a world-renowned New York staple that has elevated tattooing in a way that is truly difficult to formulate in words. Mike Rubendall has created something significant and resolute. When you are in his space, you can feel the spirit surround you. And everyone there embodies it; you can see it in their work. The first time I tattooed there, I looked up to see Chris O'Donnell tattooing next to me. For those who aren't familiar,

Christopher's owl sleeve, 2020.

Chris O'Donnell's contribution to contemporary tattooing might be unparalleled. He's a dedicated original and someone I've admired since my first years in the trade. I tried my best to perform next to him, but I'd be lying if I said I wasn't shaking in my boots.

Every time I'm at Kings Avenue, I see art I have only seen before as a small photograph on the internet. To then see these pieces in real life, the way they should be viewed, is surreal and enlightening. The first time I visited Kings Avenue, Zac Scheinbaum offered his guest bedroom for me to stay in. What a kind and talented dude. When I arrived, he answered the door in nothing but a pair of white briefs and a big smile. Standing in his underwear, Scheinbaum then turned and walked down the dimly lit hall. As he did, I could only stare at his back piece, I knew exactly who created it — Chris O'Donnell.

I sometimes feel like I don't belong when I'm at Kings Avenue. But Mike Rubendall allows me to come and visit, so I'll take it. To be a part of such an inspiring movement, even just a bit part for a short while, feels wonderful. Thank you, Mike, you're a king.

TATTOOING

Tattooing is a hulking chimerical beast, startling and beautiful when spotted. It's a shape-shifter: a cosmic, chrome scorpion; a crude, grey-scale beauty; a Zulueta tribal badge. It's the ghost up in the trees. It huffs and skitters on its hooves like a feral wildebeest, escaping everyone's grasping hands. Beware its briery fur — it draws blood at the touch. Tattooing comes and goes, and just when some declare its light is dying, it returns yet again, its hypnotic, swirling eyes peeking out from the darkness.

Tattooing holds the balance and will go beyond this current incarnation to find a way to remain controversial. Modern tattooing has leapt past what we used to consider contentious. Just take public transit and count the number of face tattoos that you see. Boundaries are being pushed as I write, and whether that's good or bad has always been in question.

The extremists claim the art has lost its edge. But there's only been a changing of the guard. Where once the divide between tattooing and mainstream culture was black and white, where acceptable society frowned upon it because of its unsavoury ties, the stereotype was that only people of a lower and cruder intelligence wore tattoos. It was myth, of course, but people always find a way to insist on class differences. These days, that attitude has come to change, and tattoos are worn by people from all walks of life. Still, some mourn tattooing's disreputable, rough-and-tumble days. But that rebellious spirit has really only manifested itself in a different way, showing us yet again the power of its reconstruction. Tattooing is simply reaffirming its independence.

Today, some tattoos are fashion. There is no denying this is the antithesis of what tattooing once was. It has become a victim of its

own rise in popularity and, indeed, its own worst enemy. But tattooing is strong, and it's going to take a lot more than a few bad television shows or Pinterest boards to bring it down. People mix their whisky with soft drinks; that doesn't mean the Irish are going to stop making whisky. And believe me, tattooing is as stubborn as the Irish.

The order of things is for society to condemn and turn its back on anything outside its set boundaries of normal and acceptable behaviour — until it becomes of use. What is considered counterculture is found out by the masses, and when it is, sadly, a part of it must die. Nothing can stay a hidden gem forever; sooner or later those who at first stood opposed begin to understand it — or worse, understand how to capitalize on it — and then slowly but surely, out come the wolves.

WHAT ARE YOU GOING TO DO ABOUT YOUR TATTOOS WHEN YOU'RE OLDER?

As my 11:00 a.m. appointment carried a rucksack of reference material through the door to my studio, I became both wary and curious, realizing that there are some people that treat even a visit to the tattoo shop as if it were a great trek. The seventy-five-year-old man unpacking his hefty books onto my table had the cool confidence of a professor who came prepared with the day's lesson fresh on his mind. I could only stand back and observe. As he finished arranging his various folders and printouts in the order that suited him, he raised his head to properly introduce himself. Ken then pulled off his sweater and unveiled a beautiful half sleeve of a red-crowned crane, a bird some have deemed to be immortal. He got the tattoo when he was seventy-two as a tribute to loved ones that he'd lost, and I immediately recognized it as my friend Chris Wellard's bold style. On his calf, he also had a tattoo of a bicycle gear made by my co-worker and pal Franklin Reeves. His energy quickly enveloped me, and I could sense that moving forward with him was going to be special.

I became fascinated as he talked about his recent foray to Uzbekistan, where he was purchasing fine art from Davlat Toshev, who is considered a national treasure there. He was extremely knowledgeable on the subject matter. As he turned his attention to the tattoo he wanted to get, I realized this was likely how Ken approached most things in life; carefully researched, and fully immersed.

Ken drew immense inspiration from explorer Ernest Shackleton, whose Imperial Trans-Antarctic Expedition of 1914 to 1917 was one of the greatest rescues documented in human history. His ship, *Endurance,* which Ken wanted tattooed, became trapped in ice before

it was slowly crushed. The crew escaped and camped on the frozen sea until the last remnants of the vessel disintegrated and sank.

Ken was thinking about getting the tattoo on his arm, but because of the amount of fine straight lines and meticulous detail involved, we decided its size should be pushed in order for the final product to not fall to ruin like the original. I also thought that the tattoo should be rendered on the flattest area that saw the least amount of sun, which we concluded to be his thigh. After our consultation, which was more like a history lesson, I felt revived, for I knew in that moment that Ken was going to annihilate the myth that tattoos are reserved only for the young.

There was mild trepidation as I attempted the first set of lines. Aged skin can be delicate, and one needs to be mindful, but on that day, a blind faith rode with me. An inner confidence flourished that told me it was going to work. I was more careful than ever when laying the groundwork into Ken's piece, but after a half hour, I could see that it would be smooth sailing. The tattoo took three sessions to complete, and he sat for a few hours each time. We got to know one another well. I learned that Ken had written a book, titled *Milestones of My Life*, travelled the world, was an avid scuba diver, and had sailed across the Atlantic in a four-masted reproduction of a nineteenth-century tall ship called the *Star Clipper*. To me, Ken was Shackleton, and I bragged about his spirit with enthusiasm afterward. His tattoo healed perfectly, with silky shading and crisp, fine lines. It was everything we'd hoped for. During those hours while working on Ken, an idea began to manifest; that Shackleton's story would now live on in a much different facet, almost as if it was granted a second wind, or had been reincarnated somehow. I think the truly important stories in the world have a way of doing this. They just keep finding a way to carry on.

As a tattoo enthusiast, I can't explain to you how many times I've heard people ask, "What will you do about your tattoos when you're older?" We've known the answer the whole time: that we will simply

enjoy them as intended, and in Ken's case, maybe get another, perhaps even a bigger one. Because we know that if constructed properly, approached with care and applied to the correct body part, they will last as long as the person does. Ken showed me that although time is fleeting, there's important work to be done and much adventure to be had as you grow older. He also helped reaffirm my suspicion that youth isn't just presentation, but rather a life force that some carry with them for the entire duration of their journey.

POWER

There are endless reasons people choose to get tattooed. It links as much to internal consciousness as it does to simple aesthetic considerations. We all carry with us a story and a lifetime of experiences and emotions, and to be let into another's world is at times both moving and humbling. It's as if your knife, lying around on the bench for so long, blunt and dusty, has just been sharpened. It awakens you. I can only speak for my experiences, and a tattoo is of course a much different journey for everyone involved, but for me, this is what makes tattooing a true force.

I met Stef through Mike Serrano, a good client and dear friend of mine. After studying his tattoos, pieces that we had worked on for many years, she made the decision to reach out to me. When I met her for an initial consultation, she gave me her backstory. She had been through some heavy experiences over the course of her life, which she was looking to come to terms with. No different than most, she felt the pull of commemorating her struggle; getting a meaningful tattoo would help set a firm foundation for her to accept what had happened.

For the majority of her upbringing, she mourned the absence of her father. He spent much of his life in and out of jail, and she went through long periods when he wasn't in the picture. This ultimately led her to act out, but more importantly, it led to a life of questioning and a long struggle with depression.

It can be a heavy business, life, and we can all relate to Stef on a certain level. We all need to heal. Moving forward and not dwelling on negativity appears to come easily for some. But just because it works for them doesn't mean it should be the guide every person follows. For

some of us, the pain of the past is always there; it's never going to go away. Desperation calls for survival, and survival becomes vital.

These events that shape us begin to dissipate. We're taught to sweep things under the rug and forget the past, to keep a stiff upper lip, to carry on. This can incite more harm than what some would refer to as "dwelling." Stifling your emotions is going to break you down in a different manner. I believe in looking both ways when crossing the street; it's healthy to look back and imperative to move forward.

The events of our life, good and bad, should be granted more contemplation and exploration. That will lead us to deeper understanding. The past and the future are tightly woven together. They are the balance and the key to what's inside us. Behind us lie moments that encompass mountains of gathered emotion; to ignore them would be unfortunate, though some choose to. Everyone has different coping mechanisms. Some will find a way through art, writing or some other craft to acknowledge, understand and simply document these moments. And that isn't meaningless; it is something, and it's bigger than you think.

When a tattoo becomes the documentation of human emotion, that is huge and important. This process takes an internal struggle and metaphorically transfers it into a physical healing. It's a transformation. It's a way of making a pact with yourself that you can't go back on, a way of never forgetting. It's a reminder that stays with you in the physical world and becomes your badge and your story.

Stef wanted a large Buddha that would span across her back and down her leg, representing a newfound path of health in mind and body. She lived in Seoul for two years and in that time travelled through South Korea, Japan, China, Cambodia, Thailand and Laos. During this period of great reflection, Buddhism made a lasting impact on her. Underneath the Buddha, across her thigh and lower back, she wanted a large dragon, rising from the depths. Its head would lie just below where the Buddha sat cross-legged on a lotus. The dragon would represent the beast that was the all-encompassing hardships of her past.

We talked for a long time about her ideas, and I was really drawn to how she wanted to explore the ominous element of the tattoo, give it a presence and bring it life to acknowledge and accept its presence within her. There was a certain clarity that came with this decision. After all, the past still existed and influenced her, but ultimately this new property of light would rest high above the darkness: triumphant, resilient and powerful. The Buddha accepts the presence of darkness and knows they must coexist in this realm with it but keep it at bay. And sometimes that's the best we can do.

Stef wanted to spare no detail to pay tribute to this declaration, and in the end, it didn't matter how long the tattoo took. To be asked by someone to come into their world, asked if you would help them with their process, and especially one of this magnitude, is a privilege. To be trusted by this person to deliver the vision of her story was staggering. The exchange of respect and trust is a gift, and to know that I may have helped this person pass a marker or lay something to rest was a gratifying experience beyond words. Stef and I were two humans sharing an experience, trying to understand, define, help, manage and overcome. We were turning this negative into a positive and celebrating the good darkness can bring and the peace that can be found in life. Some people need human connection, and I am grateful to be fortunate enough to experience that connection every day as part of my job. I am luckier than I can comprehend.

It took nearly ten hours to complete the drawing and roughly thirty hours to tattoo it. The finished product is a black dragon, coiling across Stef's thigh through dark grey smoke, its head resting in an aura at the base of the lotus flower the Buddha sits upon. Surrounding Buddha's head is an ornate halo and a laurel of white cherry blossoms. The Buddha was positioned off-centre so that a quarter of it resides on her other arm. It's an unconventional placement, but something just felt right about it, and we were both comfortable bending the rules.

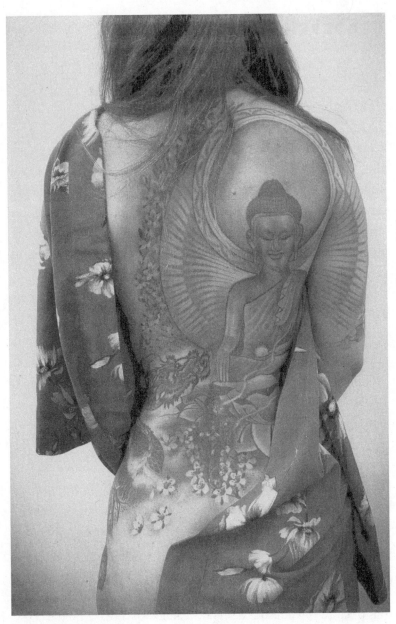

Stef's Buddha tattoo, 2017.

PERSEVERANCE

Large tattoos of this nature hinge on the stamina of the tattooist and the person receiving the tattoo. Completing a piece like this is an undertaking that requires an exceptional level of dedication and loyalty from both parties, from the initial brainstorming and conceptual discourse to the thumbnails and sketching, revisions, then more revisions — all in a naive search for perfection, or at least the closest we can achieve.

Then comes the actual execution — for the person getting the tattoo, an expedition of thought, a journey of coping and pain management. It's about seeing yourself through until the end, finding your peace in the midst, when it is just you in this dark, quiet place, pulling yourself along. There will be days when you don't feel up to it, but you push through. You reach the point when it feels like the tattoo will never be completed. But it has all just been groundwork, all just setting up for the grand finale.

And for the tattooist: an endless path of stress, trying to work with all that is against you. How well can you deal with all that could go wrong? Chipping away, little by little — satisfaction never comes easily. It's all slow and steady. You try to step away and see how your work will be perceived by other eyes, and from this comes a constant stream of revision, doubling back and fine-tuning. Adding contrast, embellishing, smoothing, perfecting the flow. Nothing comes quickly here in this place, so you put your head down and keep your eye on the prize.

As exhausting, strenuous and painful as the process may become, you can't just flee. You must learn to dig deep into the tank and when it seems the odds are stacked, you must finish what you've started.

It's within this transaction that tattooing has taught me the

fundamental importance of seeing through what I've begun in life. My friend Maru taught me this. Tattooing is triumph, in the sense that the ends justify its means. The road teems with devotion. There is plenty of opportunity to give up, but we find a way to endure because that's the human spirit, and it's the spirit of tattooing. Tattooing has an end goal: we're driving toward completion, toward making the nicest image we can with the time we have been granted; it's metaphoric for life. Difficult circumstances come up almost daily, and we have to navigate them to the best possible outcome. And when the process inevitably goes south and your choices become slim, you find a way to manage stress levels and keep a level of composure.

I tried to start this piece of writing many times. It wasn't until our daughter was born that I was overcome with inspiration. But I had realized that writing a book was comparable to applying a large tattoo. Doing those tattoos had shown me that large-scale, complicated design work that comes from the heart takes time, patience, persistence and revision. You have to keep your nose on the grindstone and stay focused on what you want to achieve.

And this translates into everyday life. It's so easy to get discouraged when things aren't perfect, but maybe things aren't meant to be perfect. Maybe we were meant to swim upstream. Maybe it's supposed to be difficult because that's how we develop our strength and perseverance. We take what we've been dealt and see it through with all our might to swing it around to the best possible result. And within that struggle comes a light, a satisfaction that is a rare find. It's what I'm constantly searching for. It's the thing I'm hopelessly addicted to: trying to do something positive every day, to make something out of nothing.

THE TIES THAT BIND

When I was young, I was so influenced and in awe of my brother Rob. But unfortunately, my family grew distant from one another throughout the years, and eventually Rob and my dad stopped speaking altogether. Stubbornness runs deep within our family and we have all been guilty of it. Rob and I have gone long periods without seeing one another, which was always difficult. My brothers are my only real connection to my mom. Rob is always eager to talk about her, and because of this, when I am with him, I can almost feel her presence, like how a religion only exists if people believe in it. He talks about her, and when he does, it's as if to reassure me my childhood wasn't all a dream.

Over the years, I slowly, steadily came to the realization that a part of me pursued tattooing because of its link to family. Being immersed in the same profession as Rob forms a solid connection that allows us to truly relate and understand one another. In a strange way, it's almost as if I put an invisible leash on him: this will be the beast that binds us; he can't escape anymore. The more I delved into this idea, the more I realized how many of my motives have been driven by the idea of family.

My family had broken apart. As mentioned, I lost connection with Rob for large stretches of my life, Kelly altogether, and after our dad took us away from the Alliston house, I only saw my mother three or four times before she disappeared for good.

Something I don't always admit to myself is that my mother was struggling with mental illness. I now know she was sick, but it's difficult because I didn't really see this as clearly as everyone else did. I was young and remember mostly good things. After the divorce, once I was in a different living situation, I began to see that the quality of

life we had been leading in Alliston was insufficient. But to my young eyes and this young heart, it seemed we had moved there with a hope, a full family, and, indeed, a happiness. Then slowly, we all left her. The thought is crushing, and I can't imagine the sadness she must have felt on that lonely farm in the middle of nowhere. At times, an anger rises in me when I think about how us leaving could have contributed to her growing sickness. At times I feel like we abandoned her, and this hurts more than anything I've ever known.

We are in our blue house. Megan and I flip through the binder my dad and Karen kept with various tokens from my youth: ribbons, school photos, hockey photos. I show her how I wore camouflage for my grade four school photo. She laughs at my long red mullet. Proud, I point out that I was ace captain of my hockey team two years in a row. I read her the book I wrote in grade three: *The Fish that Watched TV*. We both laugh hard; it's so good. Then I find a generic birthday card. I open it up, expecting it to be from my dad or Karen. It's from my mom. For some reason, I've never seen it before. It's like a punch in the gut. When I read it, I can hear her voice.

In all this dysfunction, I've always felt a longing for family. Tattooing, with its close human interaction and camaraderie, can create some of the same virtues people find in family, and this is one of the reasons I am so drawn to it. Tattooing is a home without walls.

LIFE AWAKENING

The day Megan and I would get to meet our new arrival — who we found out was going to be a little girl — was drawing nearer. The months passed by in anticipation. We worked on the house, which was beginning to feel like a nice little den to bring a cub home to. It wasn't a big house, but it was a happy house. As our daughter grew older, we'd have to figure something out to get a little more space, but to begin with, the little blue house was going to be great. We repaired the floors and worked on the kitchen, all when Meg was seven, eight months pregnant. She's so tough. I am in awe of her strength, her will and devotion. I learned so much about what it means to be tough from her, and it was an inspiring experience to see her bloom and grow this little child inside of her. She wore it so well.

The night it happened, Meg hadn't experienced any contractions, so we hung out like we always did. I decided to have a beer or two, and we went to bed. Then, the second we closed our eyes and I began to drift, Megan's words echoed through the quiet of night. I can still hear them loud and clear: "Oh my God!"

I knew, there in the dead of night, it was time for us to go forward into another realm. I jumped out of bed and collected what we needed. I was completely focused and completely scattered all at once. She asked, "Are you okay to drive?"

"Are you?" I asked.

I got in the driver's seat, and we started making our way to the hospital. It was a hot, muggy night in August, and it began to rain. Big water drops exploded on the windshield and all around. My knuckles were white on the wheel and above us the sky was black. We drove down the Queensway toward tomorrow and never looked back.

Once we reached the hospital and were admitted into triage, I held Megan's hand and watched her pretty face. She was already in labour, and there were no doctors to be found. There wasn't even anyone at the reception desk. St. Joseph's had let some staff go home because it was a slow night. I felt so scared when I couldn't find anyone. Empty hospitals are beyond spooky. I thought I was going to be the one delivering this baby, so I began to prep myself and look for various tools that might come in handy. Luckily, a doctor arrived just as Megan was beginning to howl with pain. The doctor assured us everything was fine. The doc confirmed Meg was in labour, and we were rushed into the delivery room.

The next two and a half hours came as fast as the rain did that night, and I'll never forget them. Almost every detail is in high definition. The emotion coursing through us was a constant trembling. Your mom gave birth to you without so much as an Advil in her system.

Everything was heightened. Mother Earth opened her eyes slowly and lay her fierceness down on us. Suddenly, I recognized a lucidity, a gravity, a shift through the frenzy as we witnessed a wild and untouchable human existence — the beginning. It was primitive. This was the higher state — life awakening.

After a long silence, we laid eyes on you for the first time, Frances. The doctor held you up under the delivery room lights. The universe slowed. Momentarily I lost all equilibrium and balance as we saw your arm dangling over the doctor's hand. I stared at your five slender fingers. All I could do was watch. After I cut the umbilical cord, they rushed you to a table and your mom instructed me to follow. Your hand reached upward. I put out my finger. When your whole hand gripped my finger, my knees went weak. You were crying with your eyes closed tight. Then they whisked you back to her, so she could hold you for the first time. I was told to open my shirt, and I fell into a chair. Then they pressed you into my chest as your mom craned her neck over the bar of the bed to look at you. The room went black, and everyone disappeared. The lights sparked and then dimmed. I felt

your tiny head resting on my chest. I wrapped my shirt around you, and for those moments, it was only your mom, you and me.

That night I had my first out-of-body experience. I was lifted from my physical self, up above the bed. A voice spoke to me through static about Frances. It told me I had been drifting further and further away from the place I was supposed to be.

THE REALIZATION

Sun pours through the window of my shop. It's not a big room, but it's a powerful room. Sometimes when the light is just right and the music strikes, revelations happen. There have been bad days, too, when the odds have been against me. But this is a room where you go to battle and have something to fight for, and that gives me a reason to rise every morning.

I've felt great peace inside this room. Today, the machines are buzzing and everyone is smiling. I look at the floor-to-ceiling pencil sketches I have made over the years. I think about my wall, back in my room in Beeton. I guess some things never change. The past week had been one of heavy reflection and meditation. I am glad to be back tattooing in the shop.

It feels good to slow down and make sure every dot and line are on point, that I layer my tones and build contrast. It feels so calming, the stereo playing my favourite songs. I'm tattooing trees on Tristen, who is leaving to join the military.

My mind wanders back to the day I found Rob painting trees on the wall of his room. Here I am, after all this time, doing the same thing he did so long ago. The feeling in my shop is as clear as that sunny afternoon I found them laughing, making art, with her encouraging him. Making something out of nothing. I am trying to make them proud. Like the trees on Rob's wall, the trees I'm tattooing are silhouetted, some lighter, some receding in the background. It feels right to follow in those footsteps.

It doesn't happen every day, but on days like this, I feel tattooing way down inside. There's something about the art that allows me to be close to things now gone, or at least to be in the same room as those memories.

I miss my mom all the time. Maybe if I had closure, things would be different. Unfortunately, I don't. I only have the things I came here with. And all I can do is the only thing I know how to do. I don't know what led me to tattooing. Sometimes it feels like an invisible hand guided me here.

Why am I always painting things on floors and walls? Is it because my mom was always painting things, altering their appearance? Do I get tattooed for the same reason? I learned guitar to show my brother I could do it and to tell him I've never forgotten the day he tried to teach me. I want to let him know that all the times he made me watch music videos, I was listening. Now I can play the guitar, and I understand what he was trying to show me: the power of expression.

Did I choose tattooing because it often draws on those images from my childhood — birds, nature, skulls and flames? I know I put things in an eternal safe. Don't we all? All these quieter mornings with Townes Van Zandt on the radio and rain on the windows. I've sat at my table under the light, with the smell of coffee, my illustrations. And I know the secrets I keep, way down inside of me. I used to draw birds for my mom, looking at nature books. Now I am here, thousands of roads later, and I've carried her memory down every one of them. These drawings, these memories, are all I have left, besides a birthday card. How curious it is that people come and ask me to draw birds for them. I accept their money and create their tattoos, and they smile with gratitude. Then we put on music and talk about cool things. And as we talk, I slip away sometimes, because that's just what happens. The coincidence gets washed away, and I feel the clarity rising, and I know why I'm here. I've come to this place, with everything I've been shown and taught, and I dig down deep and pull at those strings that make me move, and I give the tattoo all the blood I can bleed. There's been times when I'm aware that the bird I'm making is for my mom. Then when I'm done, I set it free.

This little girl named Frankie wakes up in the morning as the sun comes up and peeks through her blinds. I can hear her talking softly

through the monitor, her first words: "Momma, Dada, abo (her pronunciation of owl)." It sounds like it's coming from another world. I lie in bed and think of what a perfect sound it is.

I bring Frankie in to nurse with her mom, whose green eyes sparkle at the sight of her. She looks so beautiful, and Frankie reaches toward her excitedly with both arms. I place her in Meg's arms, and we all lie in bed together. Frankie sits up and points to Meg's shoulder and then reaches and pulls her shirt aside so she can look at the bird I tattooed there. Most days she does this, then points to the other shoulder, insinuating there should be a bird there as well. She is discovering her own ideas about balance.

I carry her downstairs, past the dappled, leafy silhouettes of the trees outside dancing across the wall at the bottom of the stairs. I can see by the shadows that a breeze is blowing this morning. The sun shines softly in the living room, making long, thin rectangles as it sifts through the open blinds. It's quiet. I put on Springsteen's *Nebraska*, and Frankie looks up at me from the carpet and smiles and waves her hand in the sign for music.

It feels good to be able to make a big breakfast and not be hungry. I remember what it was like to smoke cigarettes instead of eat. The smell of pancakes in the early morning is the best smell on the planet. It's imperative to make coffee first. That way you can drink it while flipping your flapjacks.

I walk out to the living room, and there she is, our angel of the morning, sitting in the rays on the carpet, the light glinting across her red curls. Bruce's dusty vocals emerge from the record player, from a hotel room on some lost highway in the middle of the States, emphasizing that "everything dies, baby, that's a fact, but maybe everything that dies someday comes back."

I stand in the doorway and watch her look at her books quietly. I walk over and bend down to kiss her head. The sun is bright and has warmed her hair. She turns around and lays those smoky blue-green eyes on me and smiles the biggest smile I have ever seen. I have never

seen anything so beautiful in my life. And we are here, in a little blue house by the lake with the trees waving outside the window and Bruce on the record player.

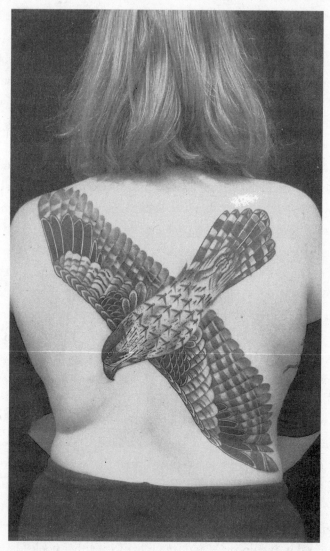

Falcon back piece for Shauna, covering up two black stars on shoulder blades, 2019.

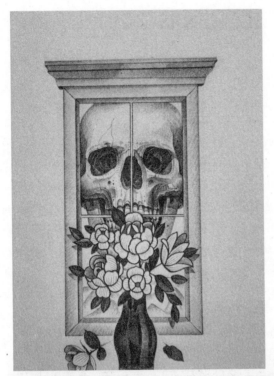

An illustration reflecting the cycle of life and death. Pandemic, 2020.

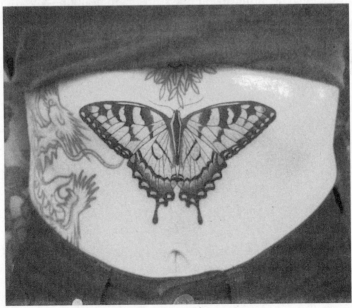

India's eastern swallowtail butterfly, 2021.

ACKNOWLEDGEMENTS

There are many people to thank for making this book a reality. So, THANK YOU to the following: My friends and family, who play a large role in all of this, for your patience, encouragement and understanding. Allison LaSorda, for the inspiration and for setting me on the right path. Nadine Sander-Green, for the mountains of advice. I'm so sorry about that first draft, holy smokes, that must have been awful for you. Liz Johnston, for bringing this to the next level. You're absolutely wonderful. Tyson Parker, for being a rad dude and bringing people together. My agent, Dave Bidini, for all you've done, it means the world. You're a very special and rare type of human. Long live Ballpoint Literary Agency! Janet Morassutti and Warren Sheffer, both, for helping bring a long-lost dream to fruition. My editor, Michael Holmes, for the reassurance and for helping me breathe on those mornings when I felt overwhelmed. To all the incredible staff and folks at ECW Press, for your hard work and for believing in my words. Lastly, thank you, tattooing, you're pretty all right.